For Catherine and Max

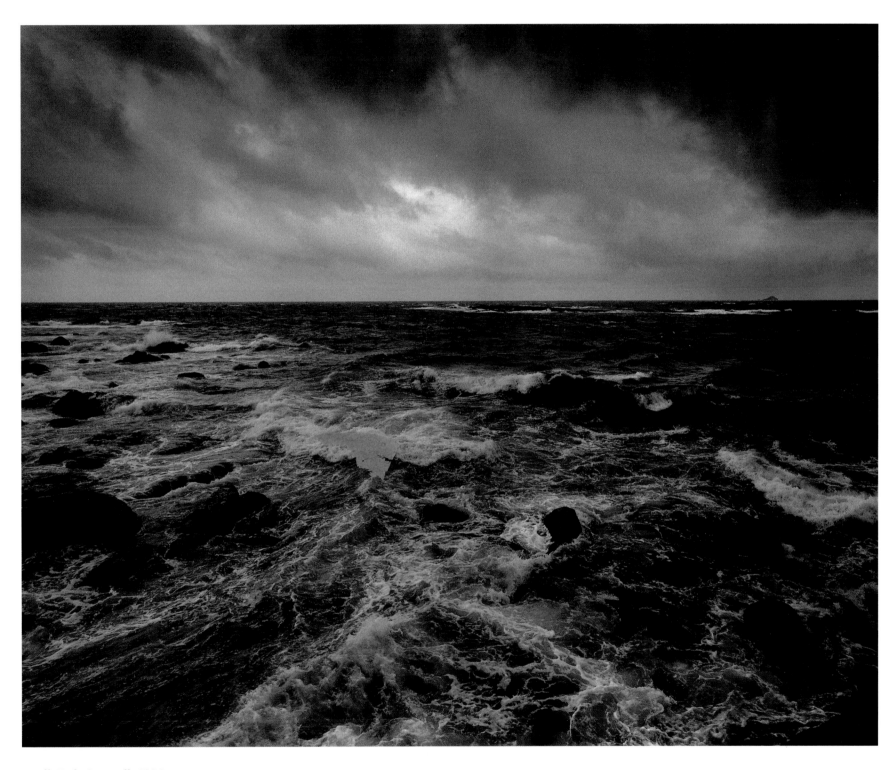

Land's End, Cornwall, 2006

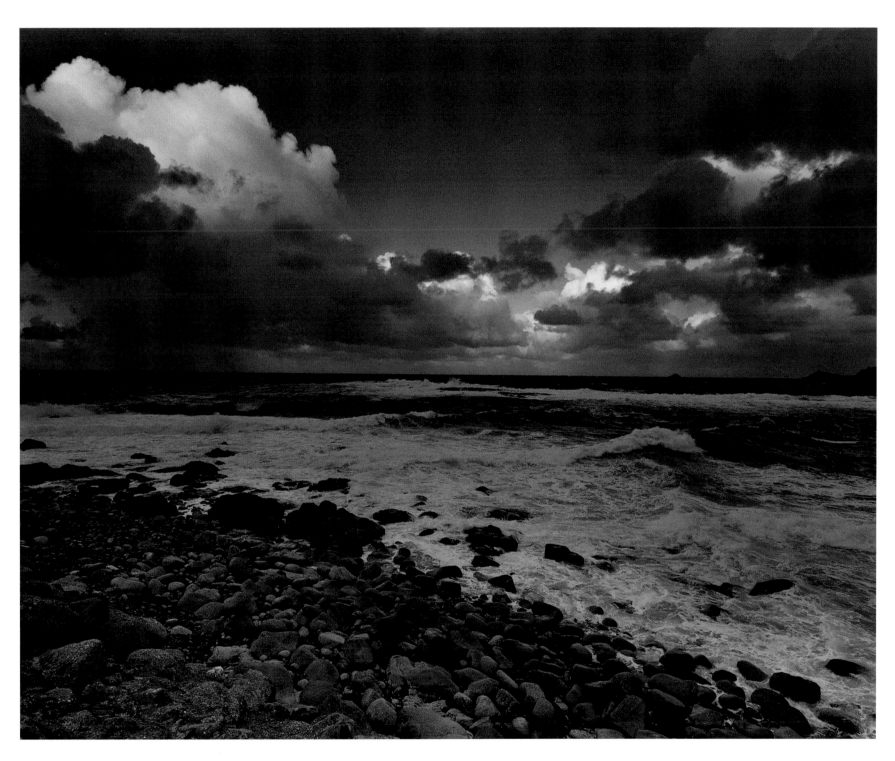

Land's End, Cornwall, 2006

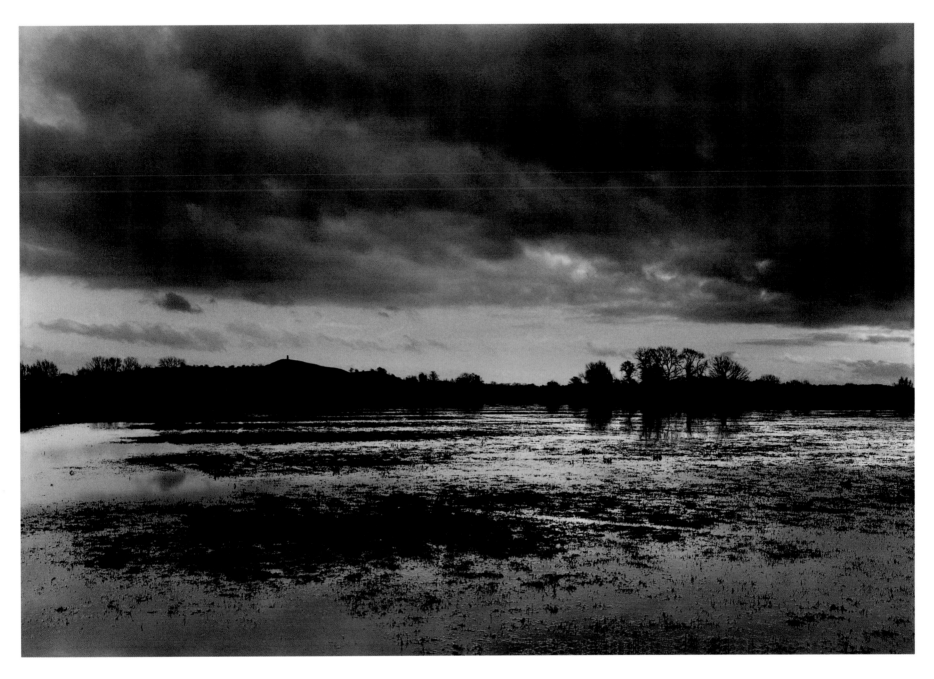

Somerset Levels, 2006

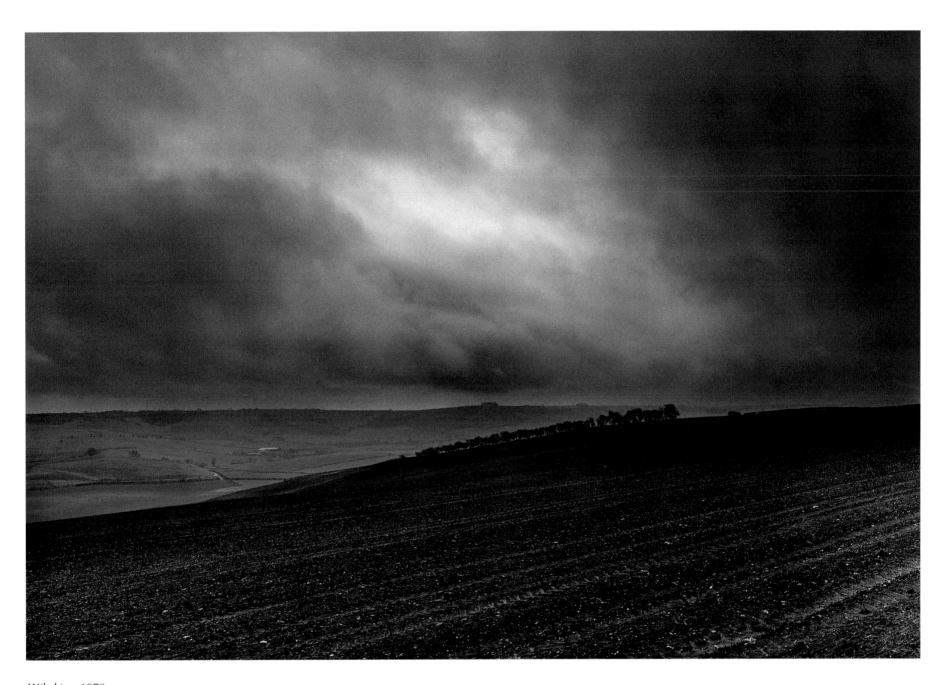

Wiltshire, 1970s

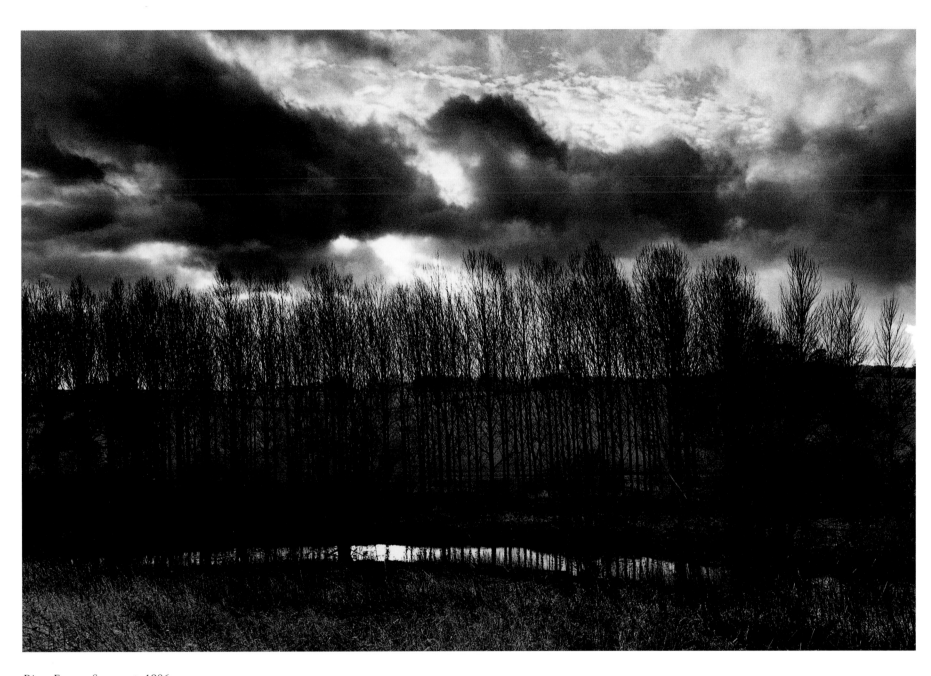

River Frome, Somerset, 1986

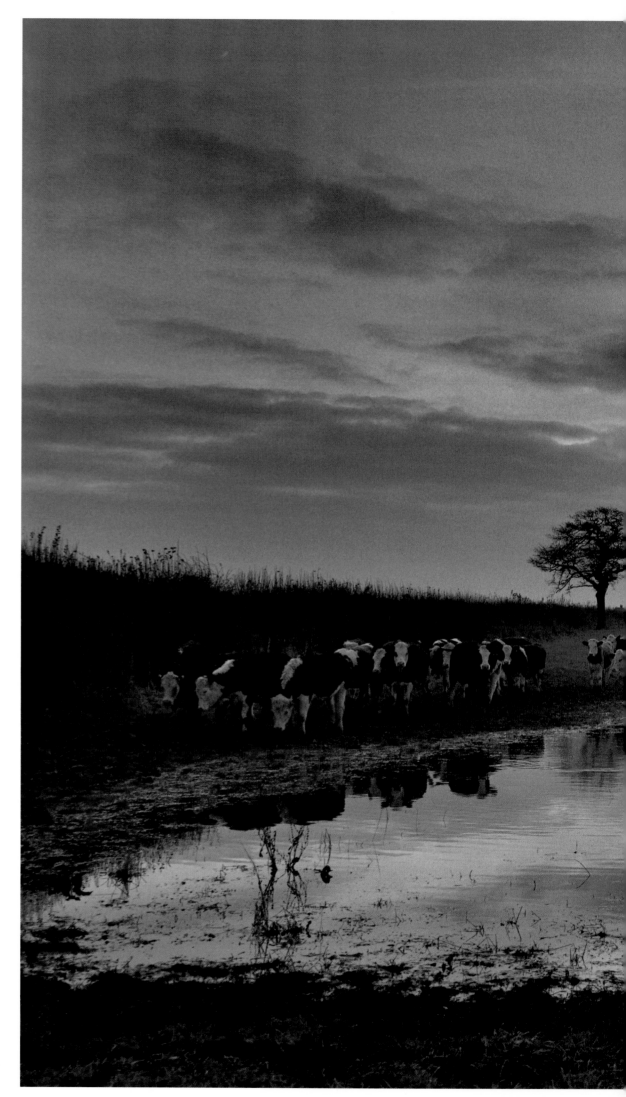

Upton Noble, Somerset, 1992

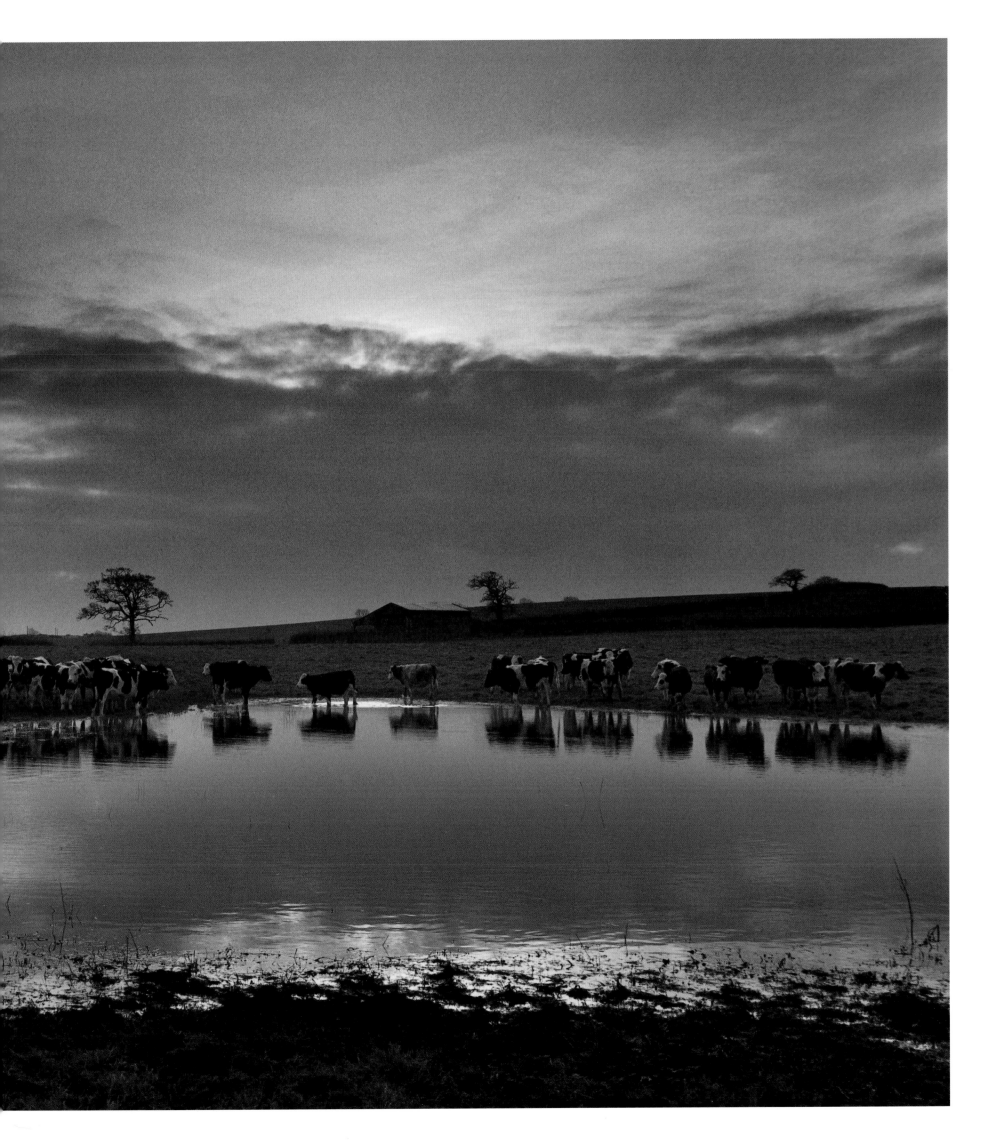

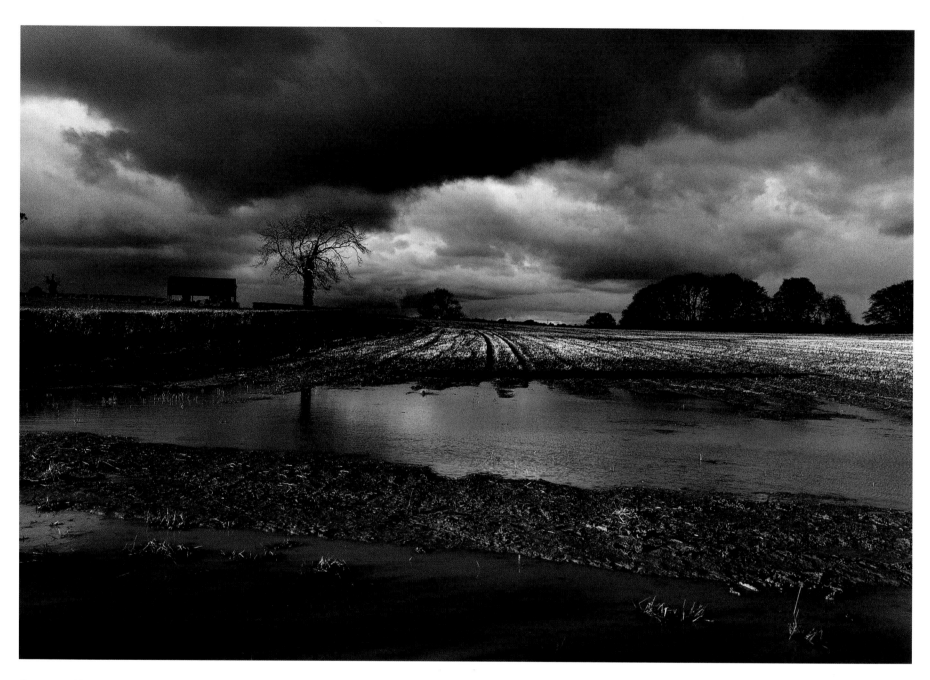

Somerset, 2003

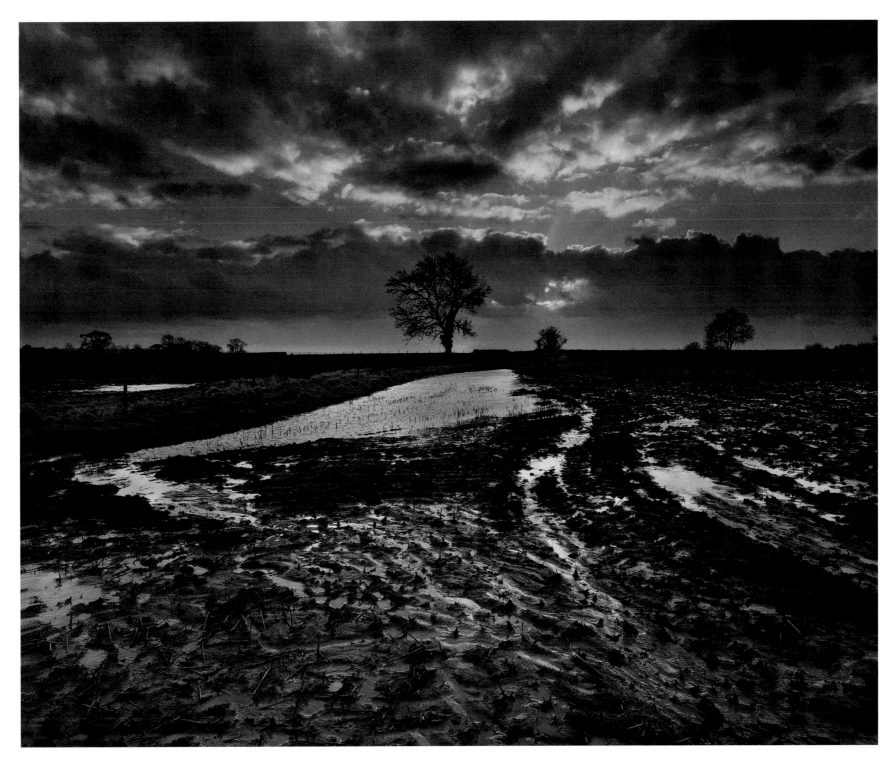

Somerset, 2006

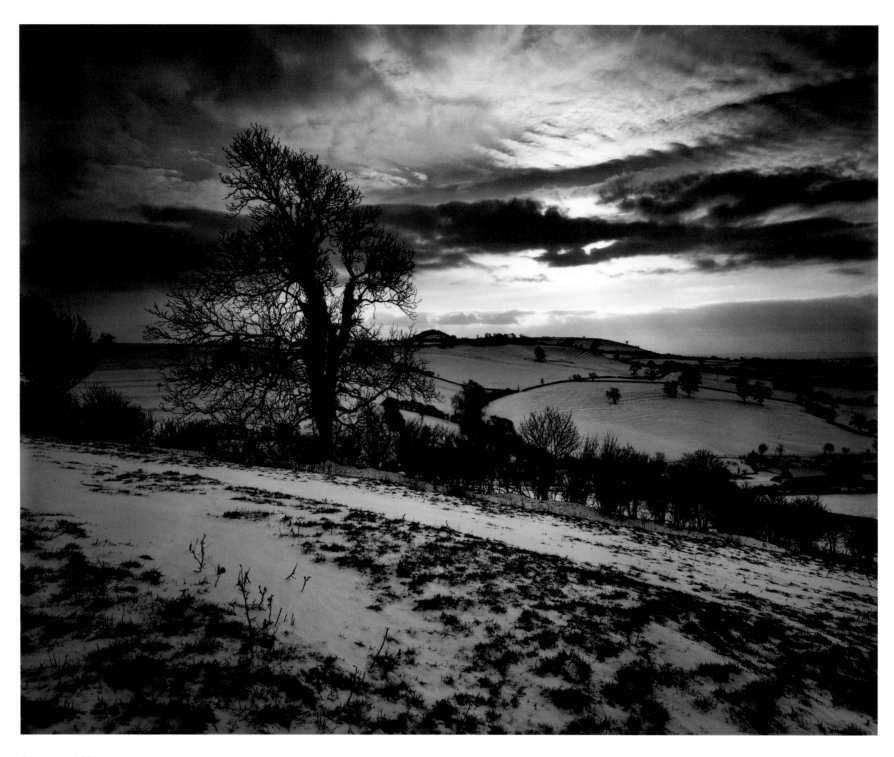

Somerset, 1991

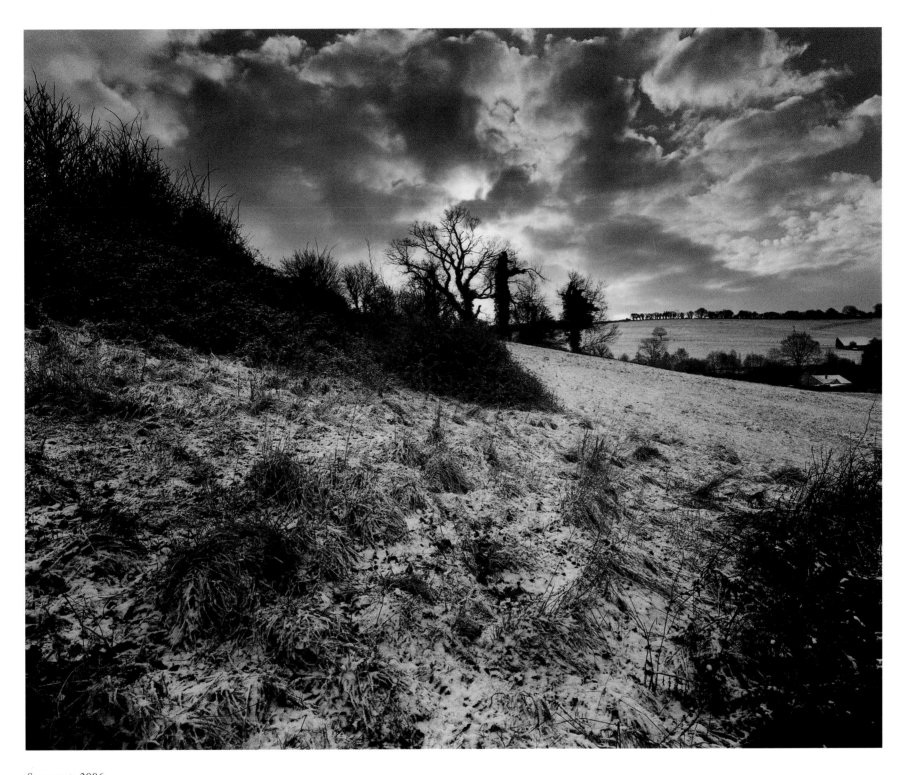

Somerset, 2006

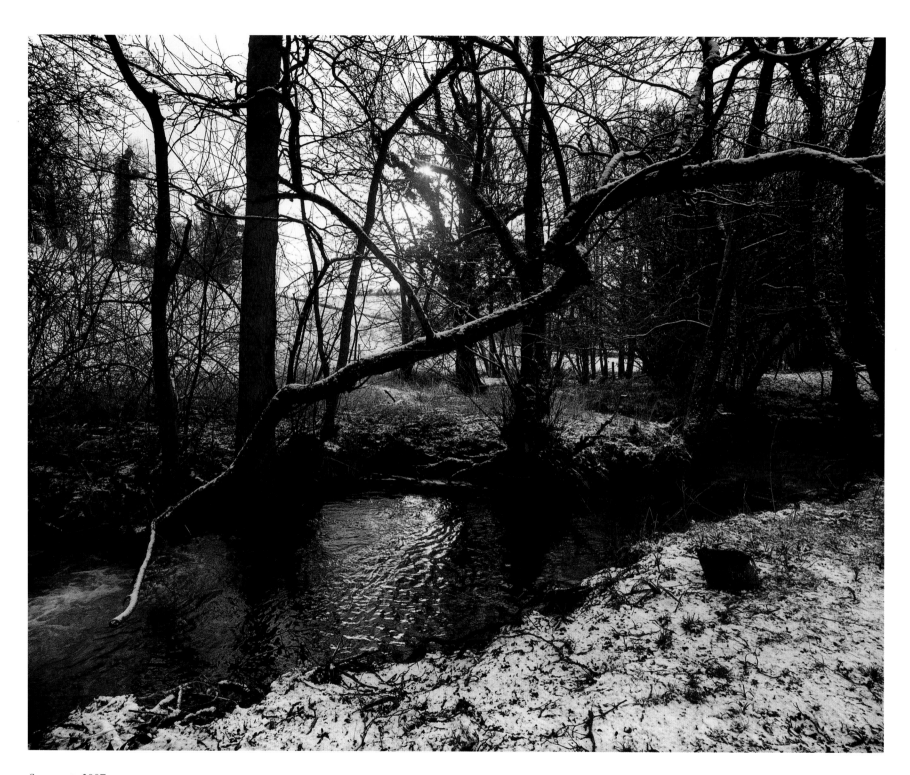

Somerset, 2007

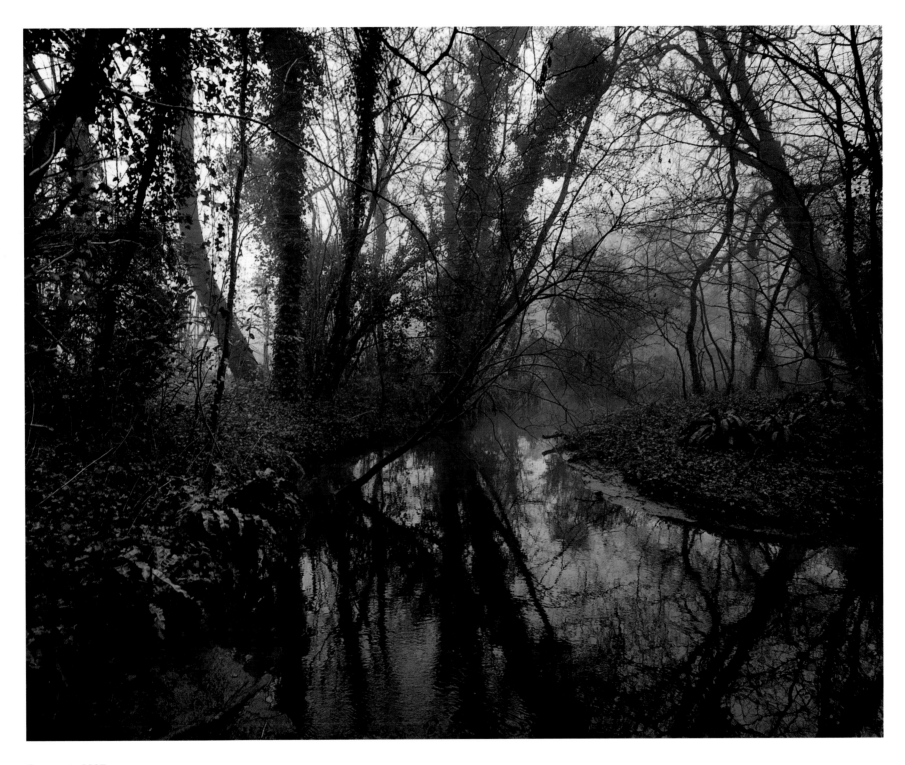

Somerset, 2007

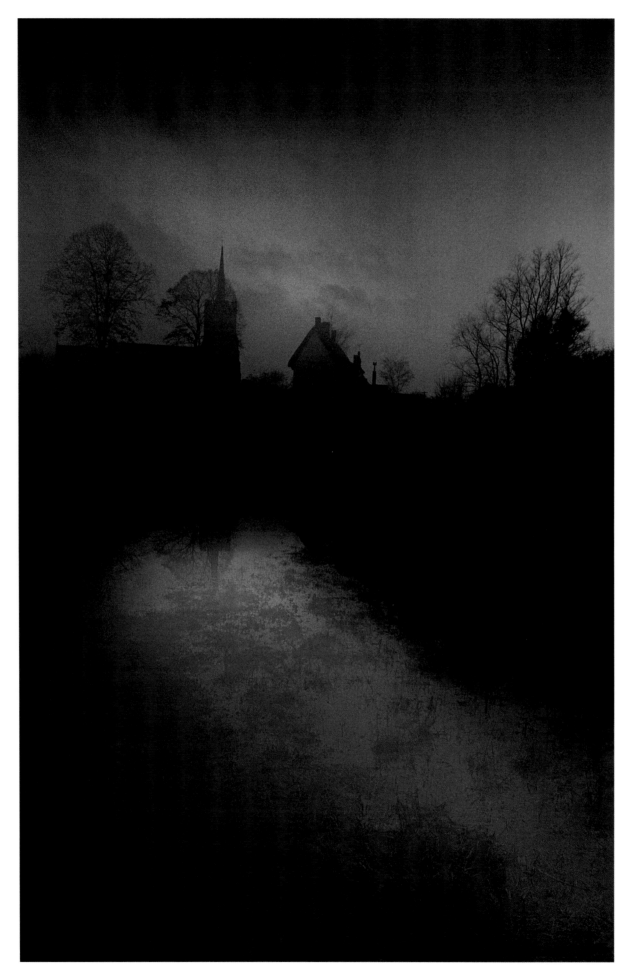

Hertfordshire, 1970

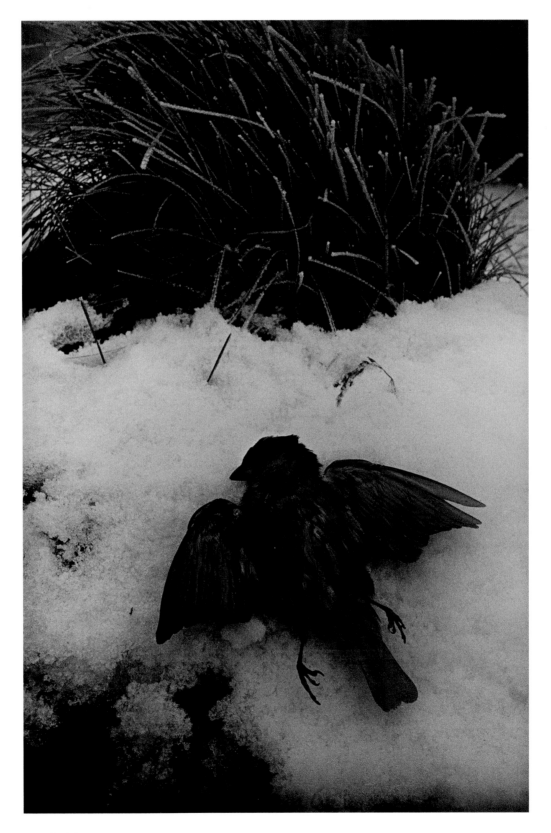

Hertfordshire, 1970

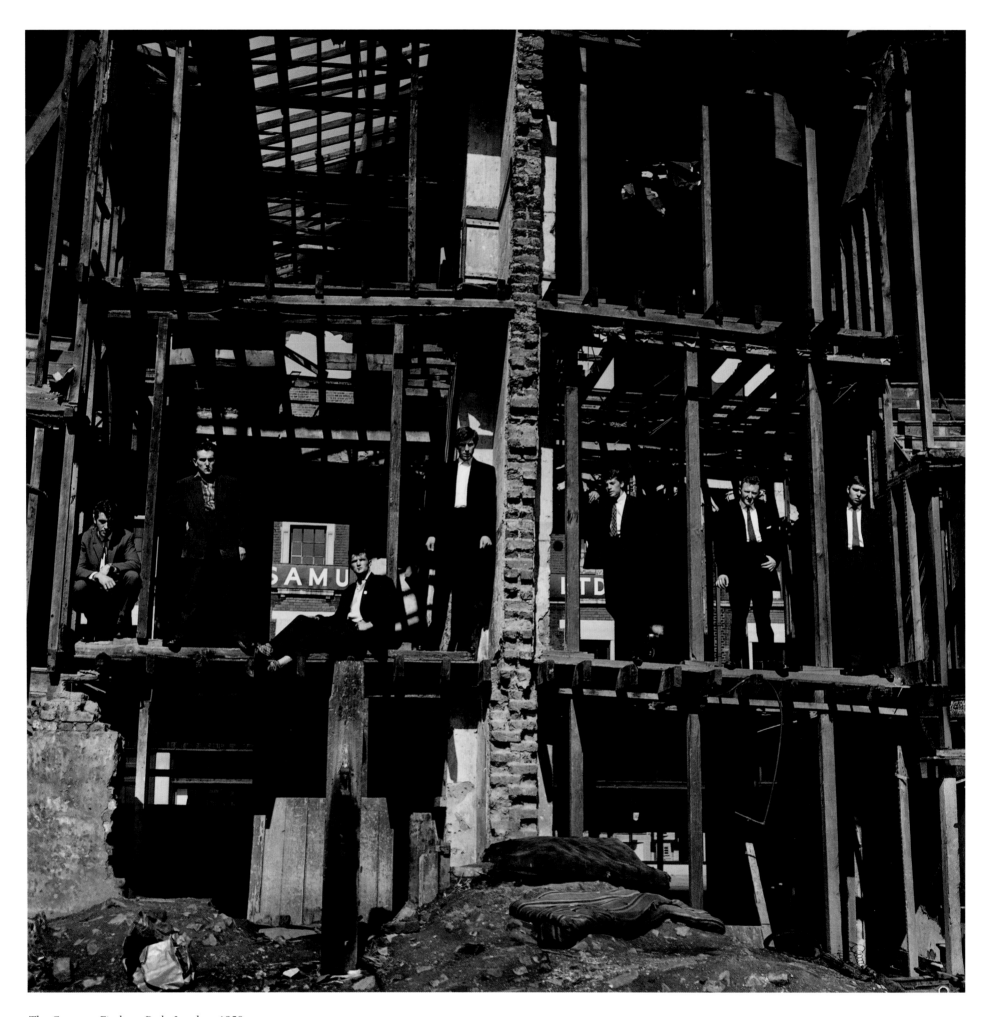

The Guvnors, Finsbury Park, London, 1958

DON McCULLIN
IN ENGLAND

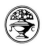

JONATHAN CAPE LONDON

INTRODUCTION

Don McCullin

For me, this book is about preserving my memories. Mine begin in conflict – in an England at war. I remember being sent away from London as an evacuee. I was dispatched to Somerset, not far from where I choose to live today. Though it was for my own good, at the age of four and a half I was wondering why I had been prised away from my parents. Even at the young age, when I came back to the city, back to the streets of Finsbury Park, I was very aware of the damage. I grew up surrounded by destruction and for a child it was exciting. I had some sense of the enormity of the change. Visually it was thrilling.

Those first post-war years were part of the last chapter of Dickensian London. The streets were still gas-lit and a lamp lighter came by every evening. The milk and the coal were delivered by horse and cart – the bread, the beer and even the salt and vinegar too. I heard the clatter of hooves as the horses trotted to their stables at the end of the day. The pathetic hovels where we lived in that part of north London were in fact part of an open world. Doors were left unlocked. There was a freedom you couldn't imagine – freedom from the fear of crime that shadows us today. The roads outside our home were empty of vehicles except when someone brought their lorry home for the night.

Suddenly there was a change like no change that had ever come before and it was true in every city, not just London. The bomb damage was gradually swept away. Men came flooding home, awkward in their ill-fitting demob suits, unaccustomed to 'Civvy Street'. Where I lived were the lost souls who had seen so much and were now stepping back into a white ghetto. People imagined a return to 'normality'. It was of course impossible.

In the new decade, the fifties, we started to receive the immigrants from the colonies. The Empire was crumbling, yet these innocent new arrivals, with full and open hearts, were seeking the mother country ruled by the ultimate mother, the Queen herself. West Indians moved in next door. Despite their impoverishment, their style was evident. Their suits were flamboyantly generous. There were those near me who were afraid of the changes and thought they could stop the wave of new arrivals by literally crushing them, as if that was realistic. The violence and resentment started to brew. You have to remember that life for a young male on the streets at that time was completely tribal. Parts of Islington or the East End were often no-go zones because of the rival groups of gangs. There was and remains an aggression peculiar to England. I photographed the boys I grew up with. The Guvnors posed for me in their Sunday suits in a derelict building at the bottom of my street. It was after an attack on the Guvnors by another gang that a policeman was knifed and a boy was hanged. Ironically, the publication of the photograph of the Guvnors by *The Observer* gave me a new life. The publication allowed me to escape that world and to leave the bigotry behind. The immigrants, meanwhile, became more deeply established, like their predecessors before them. Now there are third-generation families here and they are at the heart of England, which couldn't function as a nation without

them. We were so intolerant. I've seen the places from where the immigrants have come. I've seen how hospitable they have been, even when they've had so little to offer. They must have been shocked by the cold, indifferent English nature. But how different their arrival was from the modern migrant landing today with no papers from, say, North Africa via Sangatte, desperate in the search for economic improvement.

In the fifties I was obliged to fulfil my national service and I joined the RAF. I managed to be assigned to a photographic unit, which was an extraordinary experience. National service may have provided a cheap way for the country to police the last of the Empire, but for me it was the beginning of my way out and after leaving school at fifteen it was the first step of my education. When I had worked on the trains as a boy – the time of my first explorations and of the discovery of the strange dialects of the English tongue – I was taken beyond the patch of England I had known. Even then the glimpses of the dark 'satanic' mill towns and cities of the North spread out below from a passing train window left a lasting impression. But later, courtesy of my national duty, I travelled the world. I have been doing so ever since.

After the attention I received from publishing the photograph in *The Observer*, I thought I had to learn much more about how to photograph. I would go over to Chapel Market in Islington, which I'd always known, and I'd watch. The streets from the market to the Caledonian Road were extraordinary in those days. Animals, transported from the country to the railway sidings of King's Cross, were still herded along the roads to the abattoir in the early morning. The light was different and after dawn a fog descended as the smoke of a million coal fires filled the sky. Back on Seven Sisters Road, then a Turkish clothing district, and on the Holloway Road I photographed my friends with my old Rolleicord. I became quicker. If I saw something, I'd pounce. I especially loved going to Whitechapel, where the Jewish community had their own markets selling kosher meat and there were barrels of salted herrings on the street. I've watched it change over the decades as one community of immigrants was displaced by another influx, as the Bangladeshis have taken over Brick Lane and a synagogue has become a mosque. Recently, a Jewish stallholder recognised me from twenty or thirty years before. He said he remembered me saying back then how much I loved it. We've come a long way since the final years of Empire. There are poor white beggars squatting on the streets of Whitechapel today as the former immigrants, arms full of shopping, pass them by.

By the seventies I wanted to rediscover Britain. I had been through wars and to different continents and I wanted to find England again. I cast my attention too narrowly because I kept returning to the North and to Bradford in particular. For some reason in Bradford I found the most astonishing people. Everyone was charming and allowed my intrusion. There were many Polish and Hungarian refugees as well as the Asians. Then there was the unthinkable poverty. I was struck that this country, one of the richest

nations in the world, had attracted those looking for the promised land, only to leave them destitute. Nobody should be allowed to stagnate. I know the smell of poverty and I saw it in some of those Bradford homes, where I had to tread delicately. What could I bring to these people I photographed? Who benefited from these pictures I was taking? I hoped that I could do some good through the pictures if those in power could see them.

I also discovered the English have a way of celebrating the absurd. The English, who are in so many ways very reserved, also behave with utter abandonment. I wonder if the great events of the English calendar, which have survived for generations, will continue indefinitely. In England the gulf between the haves and the have-nots is enormous, just as it was in the days of Bill Brandt, whose photographs of England I so admired. Once summer comes, the English eccentricity surfaces again. I wanted to explore the other end of the scale, the opposite of poverty. At Ascot last year I photographed an elegant young couple whose parents, much to my embarrassment, in a gesture of absolute kindness invited me to stay and have lunch with them. I declined, then came across a man seated in the grandest of the Ascot car parks, who narrowed his eyes when I asked his permission to photograph and said, 'I'm just going to warn you' – and I waited for some legal salvo – 'I am not going to buy any of these pictures', said with the most malevolent voice. Almost screaming with laughter inside, I replied, 'Do you know, sir, no one's ever said that to me before?' I felt as miserably uncomfortable there as he probably did at my presence while waiting for his Filipino maid to serve him lunch. At Ascot, you see the English feeling themselves at their best – overconfident and assured, delighted by their dress. It provides a scene from another century, at which some are only too glad to be recorded, while others, as at Glyndebourne, icily resent the intrusion. At Henley, you see the elderly and the middle-aged dressed up in the blazers of their youth, trying to hang on and often looking ridiculous, but the English have a residual fascination for uniforms of all kinds. Uniforms seal the identity, which suggests a lurking English crisis. The wearing of the uniform can transform the ordinary, mundane life. This England is a playground. For the photographer it is a banquet.

If you come, like I do, from the market street where the van unloaded the second-hand clothes on to the pavement and my mother pulled the cast-offs from the pile and spent the rest of the morning scrubbing them clean for me to wear, you're going to come out angry and swinging. If you use that anger, you can make something of your life. I've known both poverty and privilege. The one can be every bit as crippling as the other. Well-educated, capable people fall because they have no horizon. I never feel I have arrived at some destination. There is always something ahead, another horizon. I still see the weaknesses of my work as a photographer.

I always return to the landscape of England, and especially the fields and woods around my home. It fascinates me because the landscape too is changing. If it is not global warming that is transforming it, then it's

the hand of the developer. We've also had the scourge of foot-and-mouth. Though I live in a farming community, I look across the fields and I see acres and acres of empty farmland. I long for the hedgerows and the patchwork quilt of field patterns. The land no longer gives itself to the rhythms of rural life but to the sound of industrialised enterprise, so village life itself faces a kind of destitution.

The book begins and finishes with Land's End. The sense of an island is established. I went to photograph Land's End in a gale. The wind literally lifted me up. I was carried by the updraught, by the huge rush of energy. I trod carefully down the rocks to the sea. It scared me because I know what the sea can do. I was looking at the danger of it, and felt as if I was clinging on to the edge of the land and of life itself. The landscapes in my pictures are hard. They are like war scenes. The Somerset Levels, so close to me, are not natural formations but man-made sites over which the sea has gradually encroached, the water slowly seeping in. I love these elements – the water combined with the dark skies. Whereas Turner's painted skies are on fire, mine are swamped by darkness and they are also filled with energy. Close to my home is Glastonbury Tor in the Vale of Avalon, the centre of Arthurian legend, and inescapably I see the surrounding landscape as part of the myth. Though I can't escape the darkness, I see it in every landscape and it is inside me, and though I turn all these country scenes into battlefields, I am never more happy than playing with the energy of light and water. Sometimes I wait for hours, standing in the fields, for these skies. Even if I photograph

nothing I'm never disappointed. This is my own kind of meditation. It is like the enjoyment of fishermen who catch nothing but still relish the time. Now my frustration is waiting for snow, which rarely comes and I'm denied the snow scenes in this landscape I love. A few drops fall overnight and by afternoon they've gone. This most beautiful landscape will no doubt eventually find its preservation in the falsehood of a theme park.

I leave my house in the country and know it is not the place of my childhood and I don't complain. I get to the station and come up to London as if I was embarking on some foreign travel. It is a rarity in this part of Somerset to see anybody from outside. On the platform are mostly retired people of about my age. As the train approaches London, through the scruffiness and shabbiness of the outskirts, I start to get twinges. This is not the England of 1955. There is a different kind of poverty. There are new phenomena sweeping the land – obesity, selfishness and the hand gestures and postures of the young that I cannot understand. I also know I have to make this book now because of my age. I don't have the tolerance or the stamina to continue much longer. I am not at the end of my work, but I'm close to the limits of what I can accomplish. I look forward to my return to the country, to leaving London. If I'm driving I have the experience of Stonehenge. The setting is timeless and I feel as though I'm in touch with the inextinguishable energy of its mystic power. At that moment I know it is the gateway to my home.

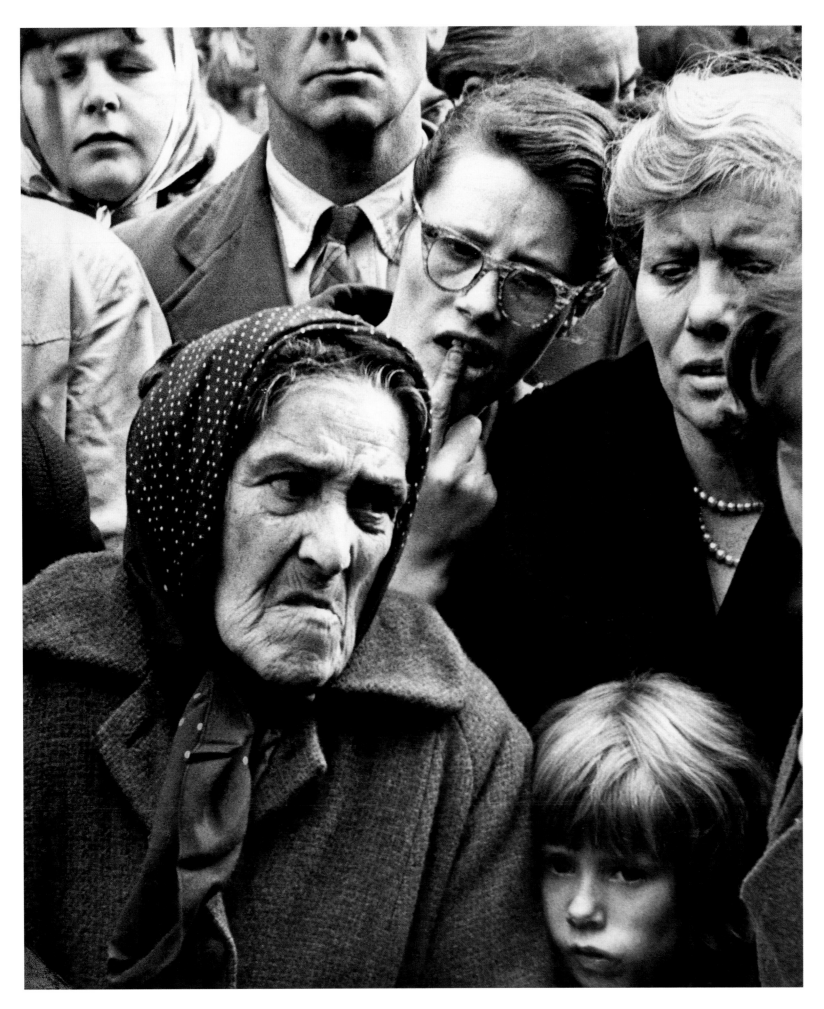

Chapel Market, Islington, London, 1959

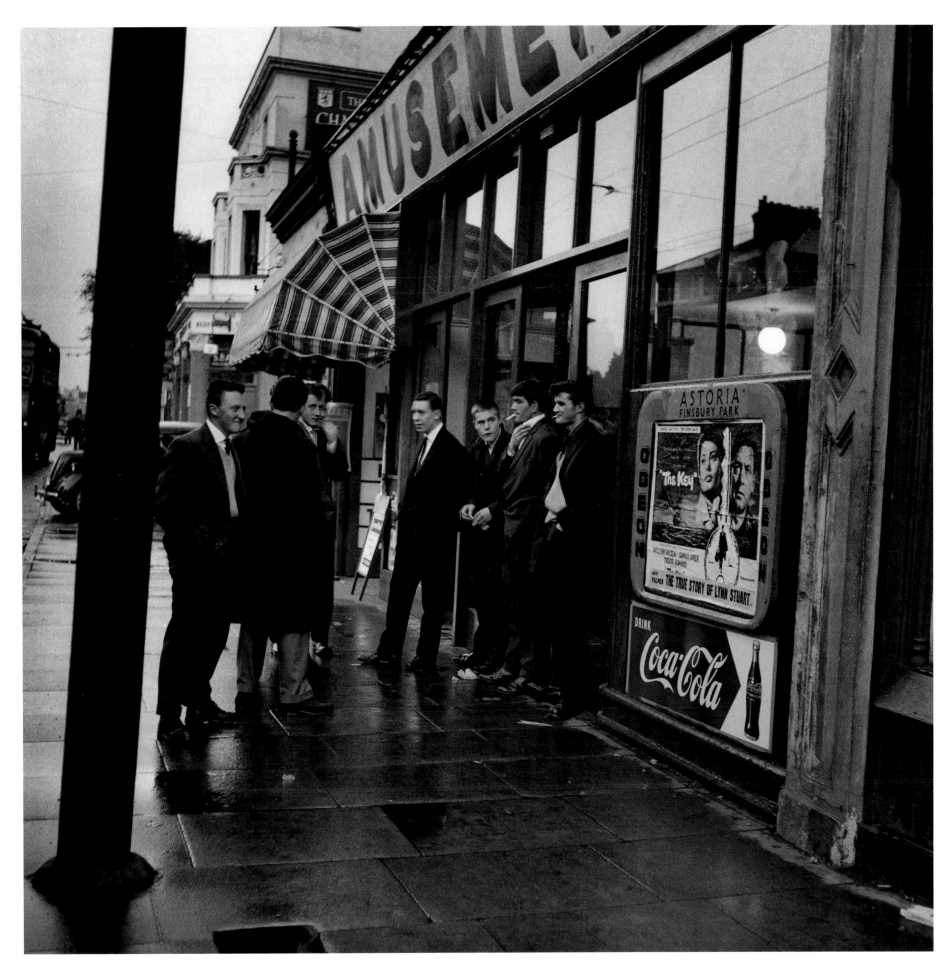

Seven Sisters Road, London, 1958

Finsbury Park, London, 1961

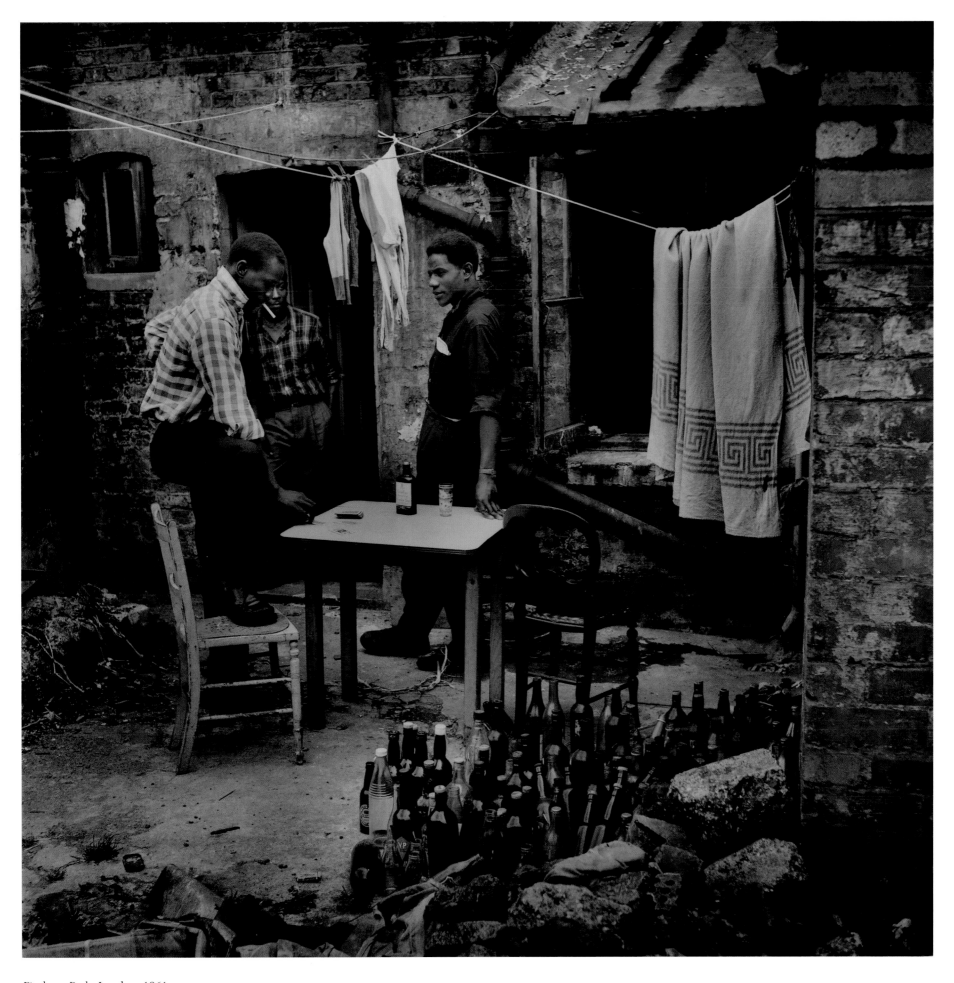

Finsbury Park, London, 1961

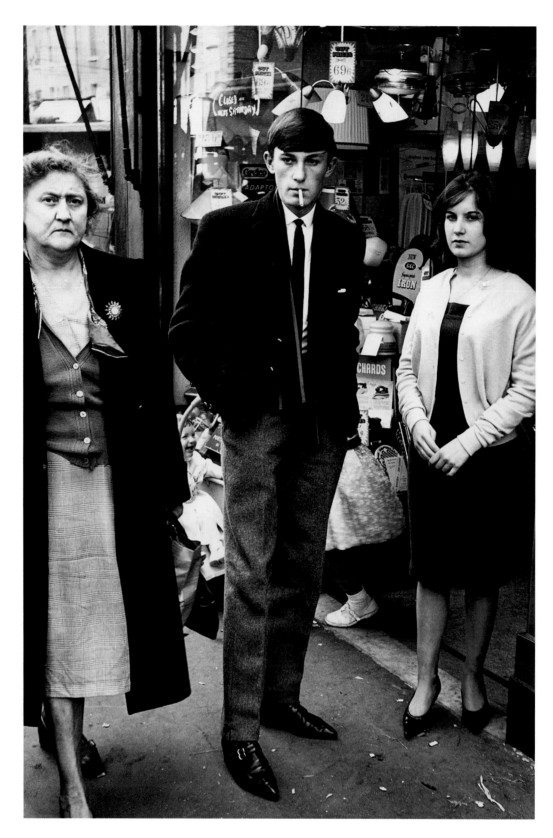

Seven Sisters Road, London, early 1960s

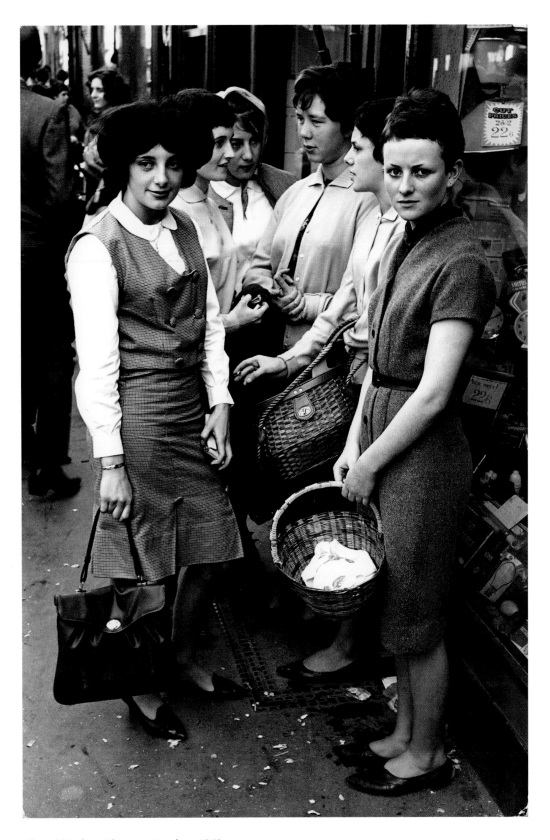

Chapel Market, Islington, London, 1963

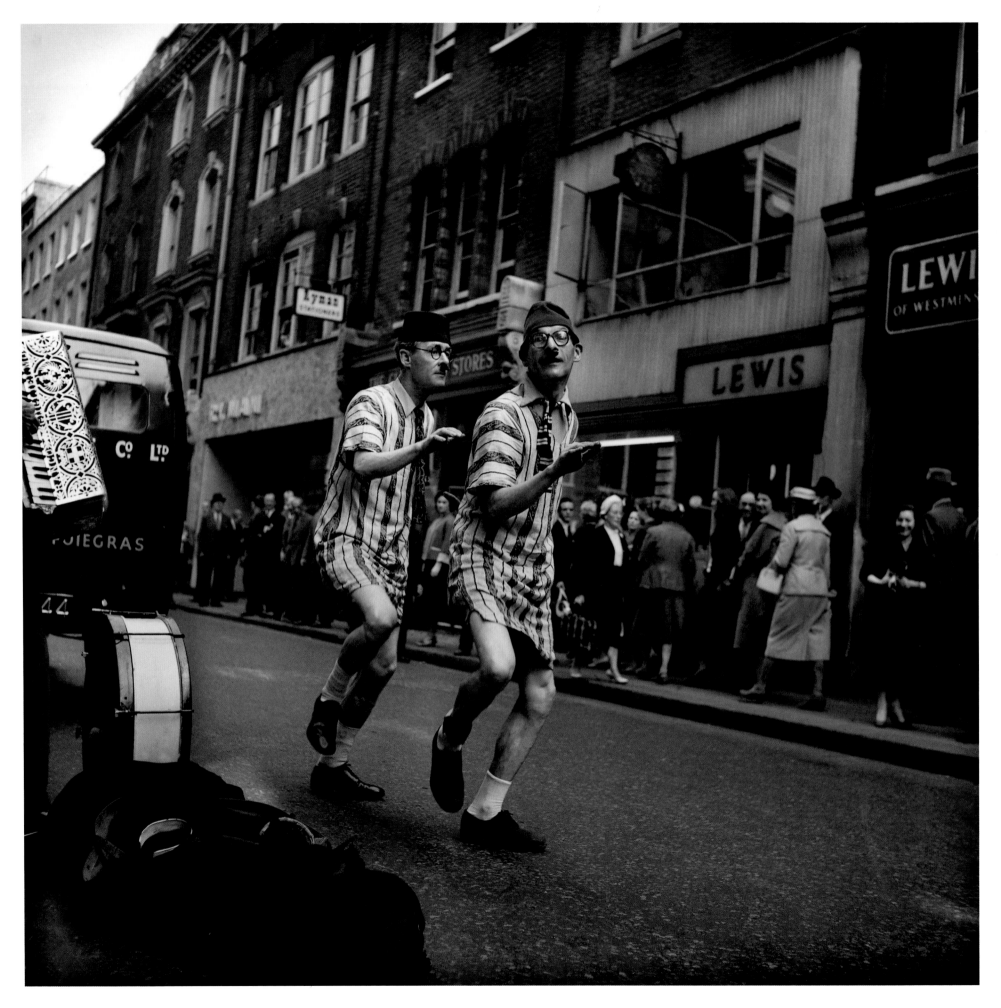

Piccadilly, London, 1960

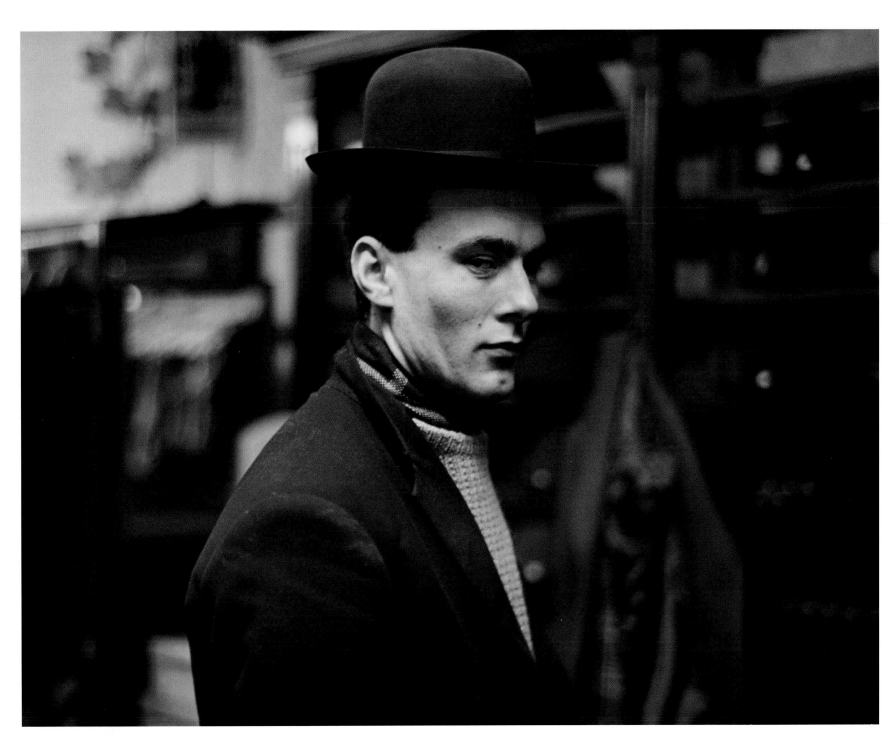

Holloway Road, London, 1960

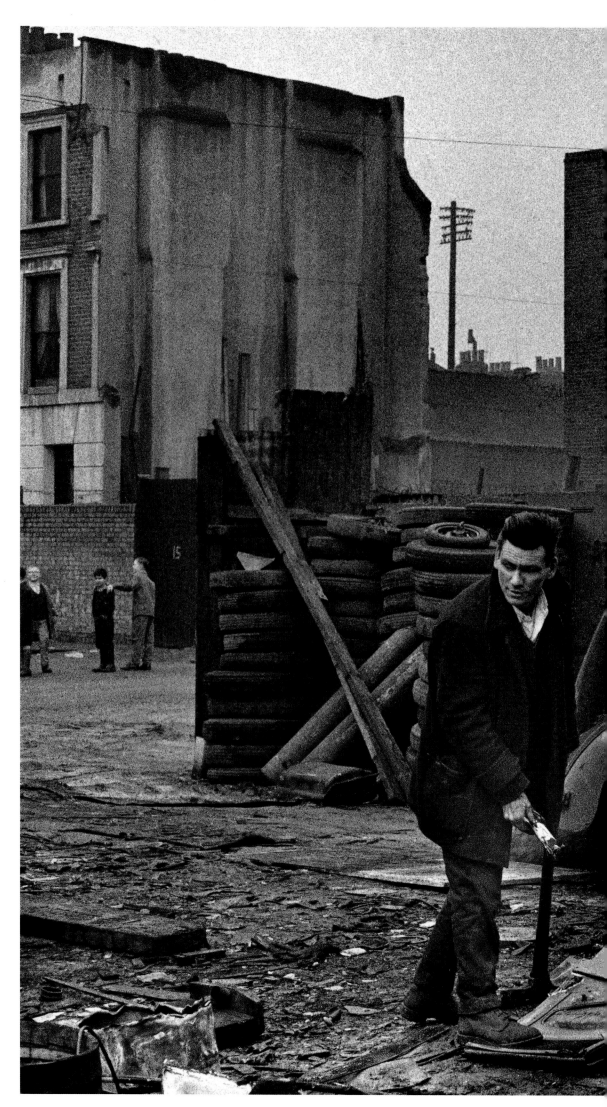

Finsbury Park, London, 1960

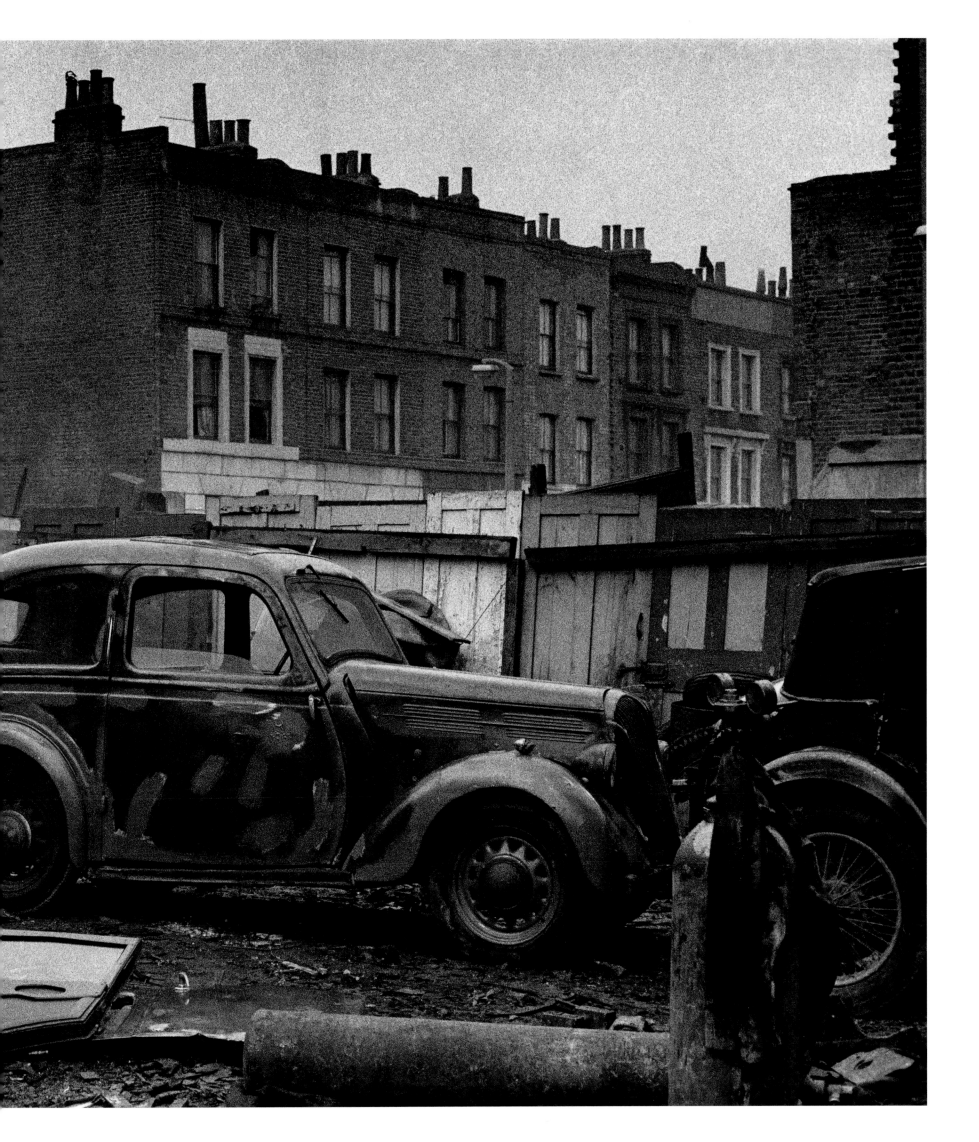

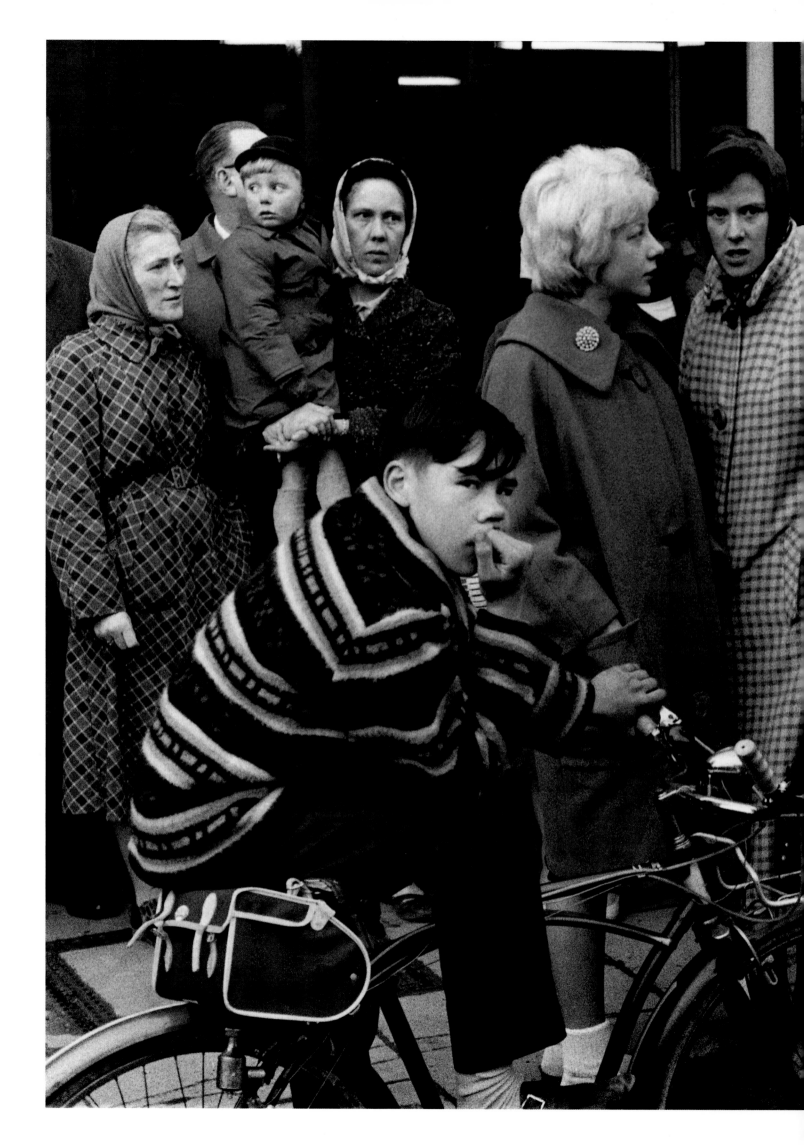

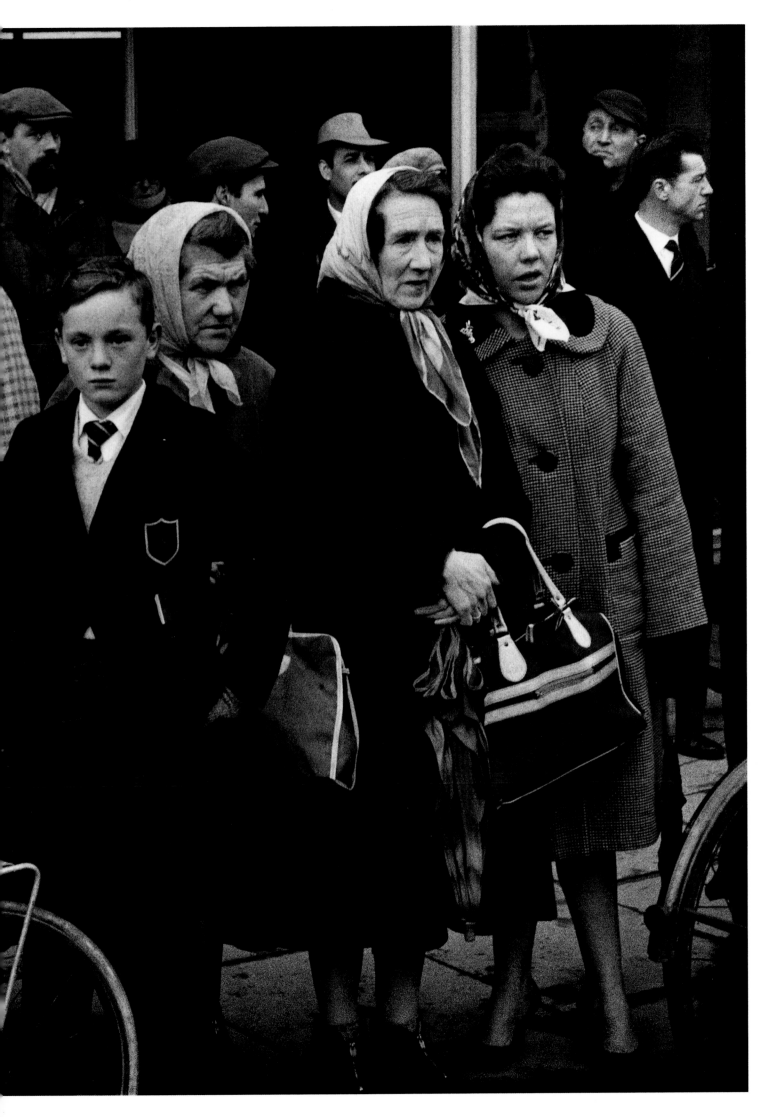

Outside Bedford Prison on the morning
of the execution of James Hanratty, 1962

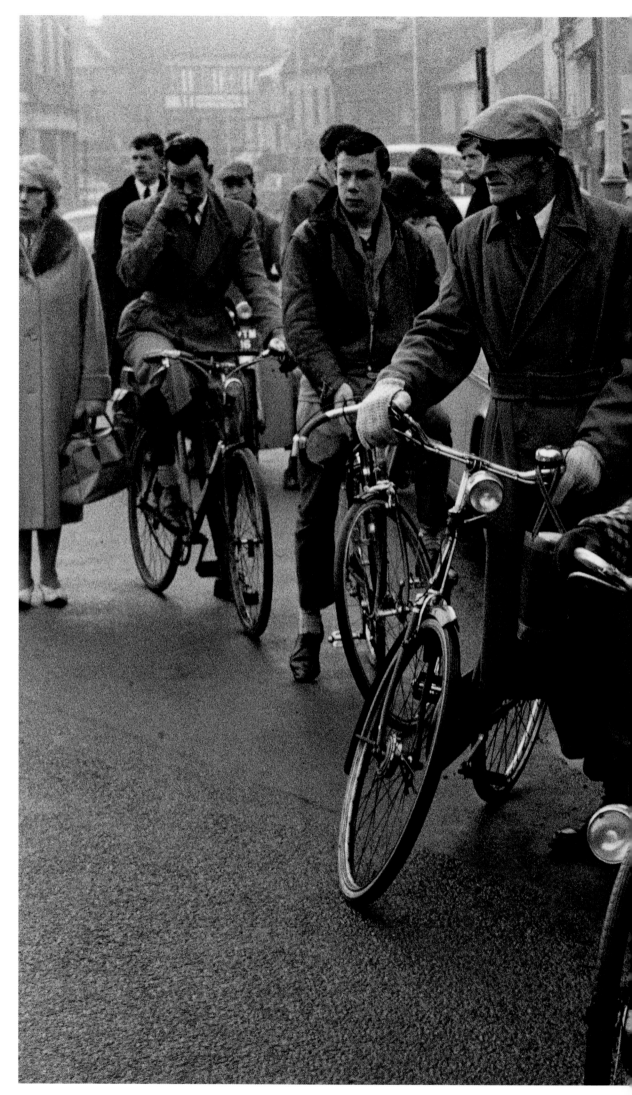

Outside Bedford Prison on the morning
of the execution of James Hanratty, 1962

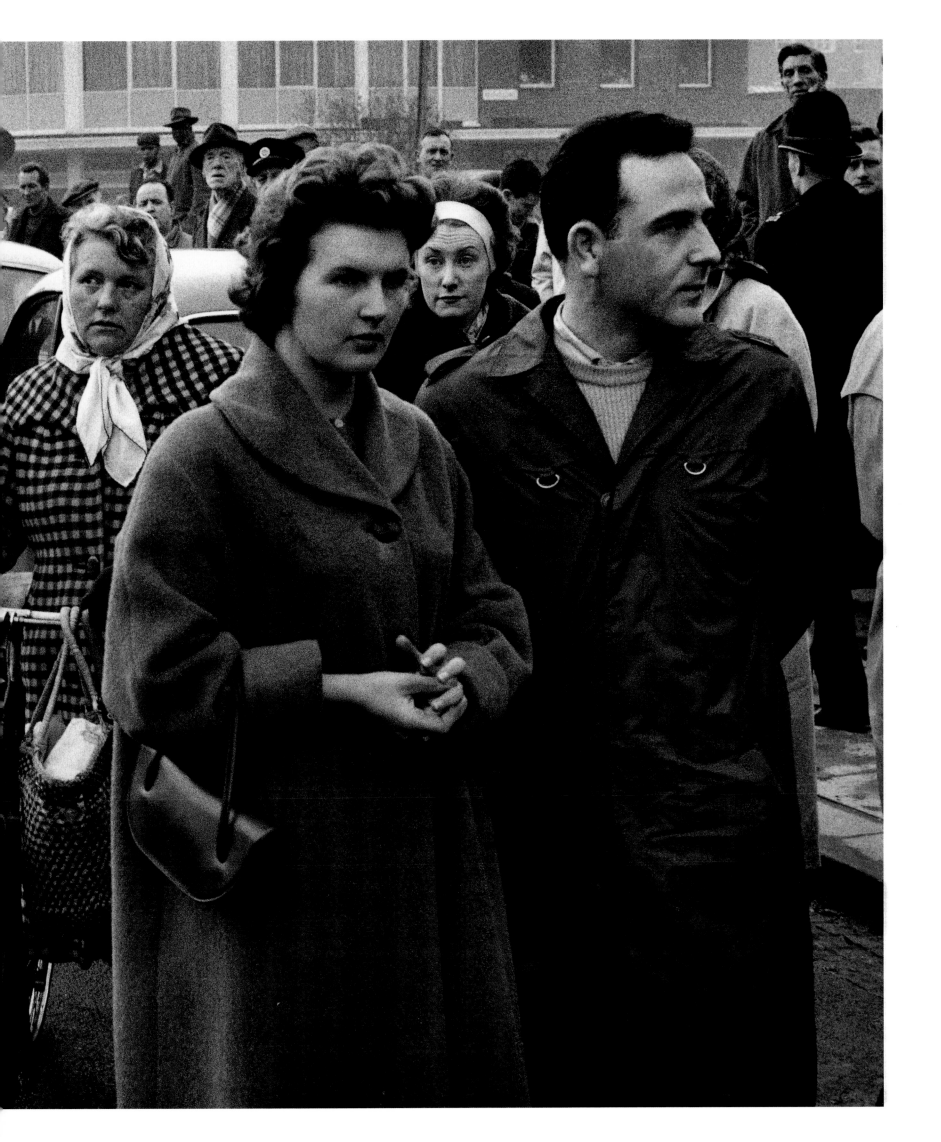

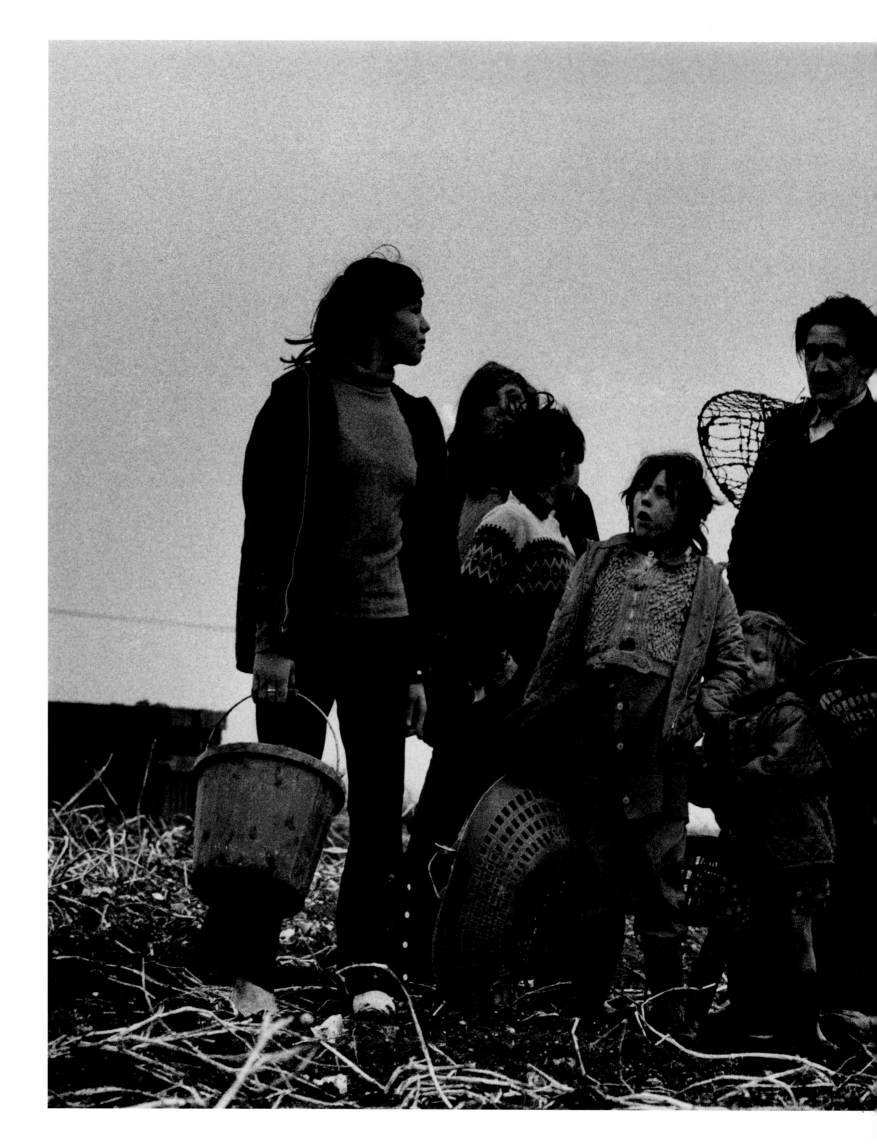

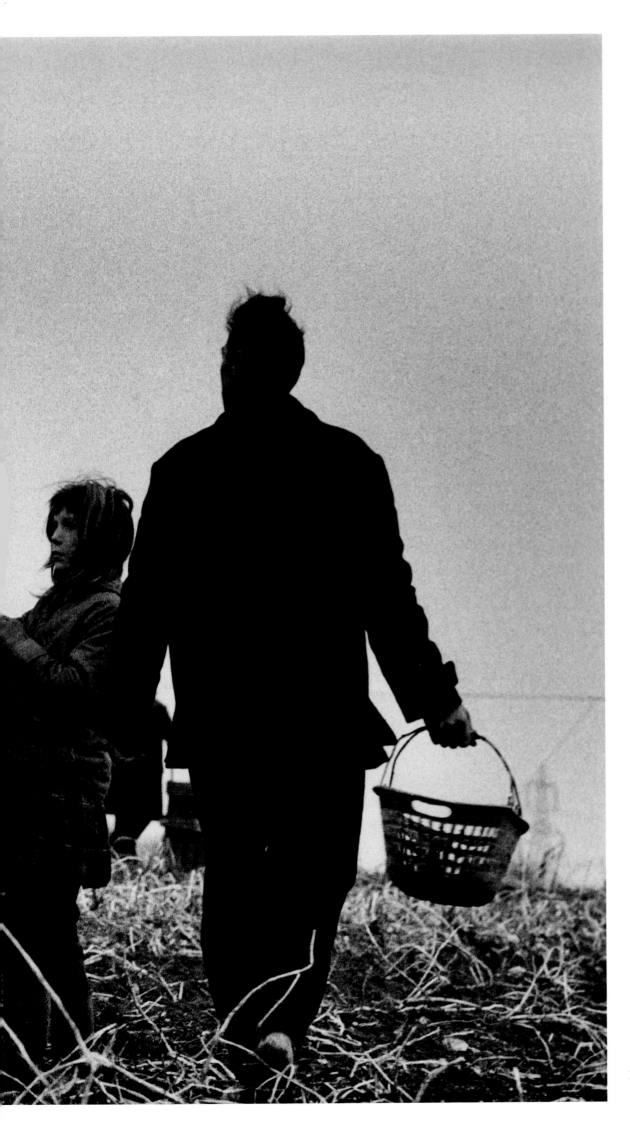

Itinerant potato pickers, Hertfordshire, 1961

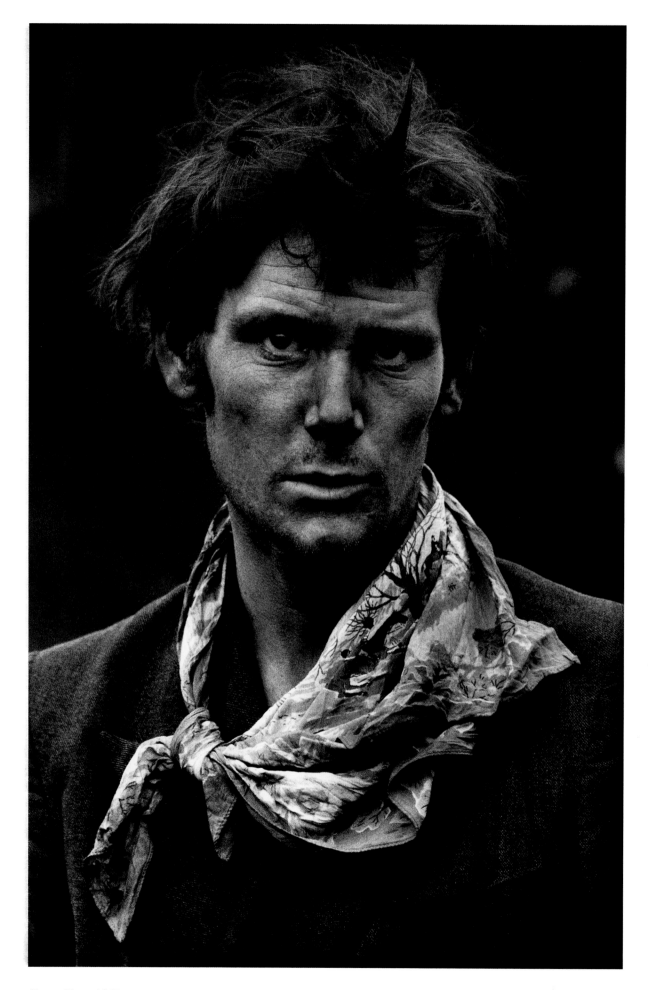

Gypsy, Kent, 1961

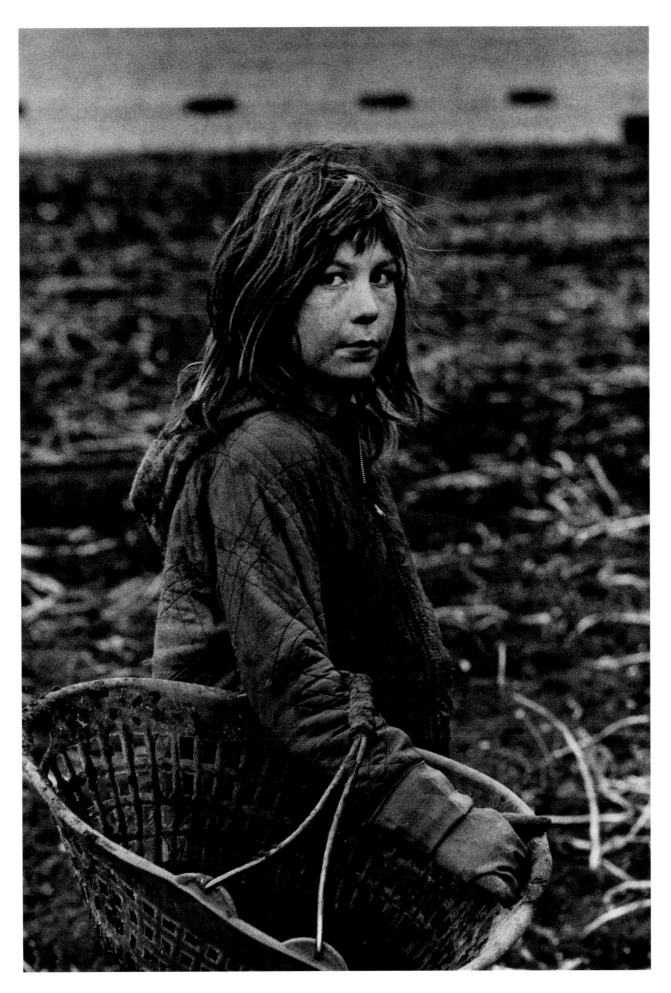

Potato picker, Hertfordshire, 1961

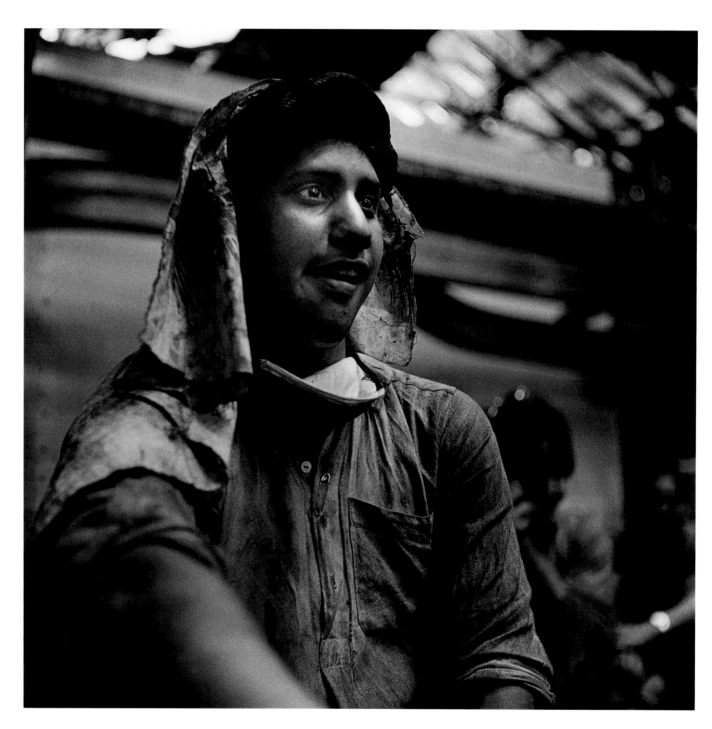

Birmingham, 1963

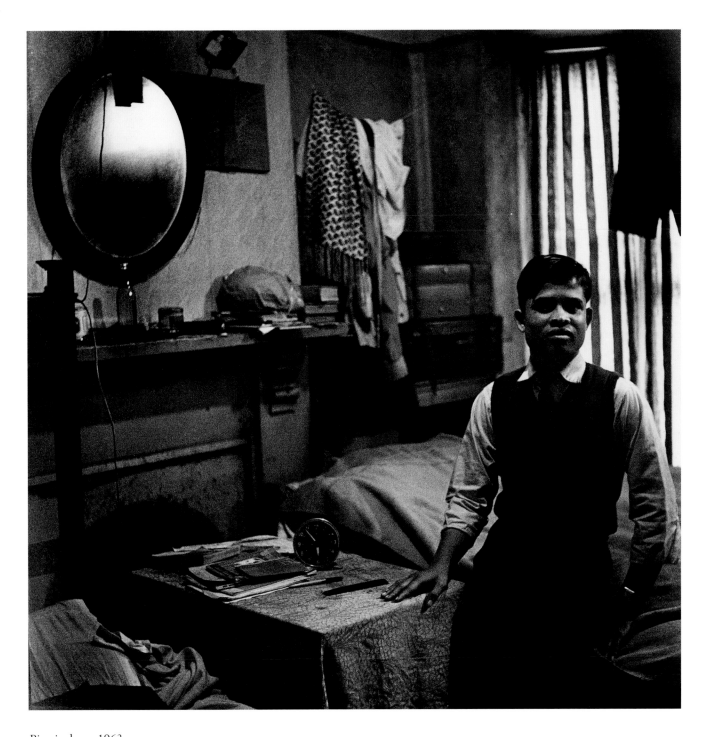

Birmingham, 1963

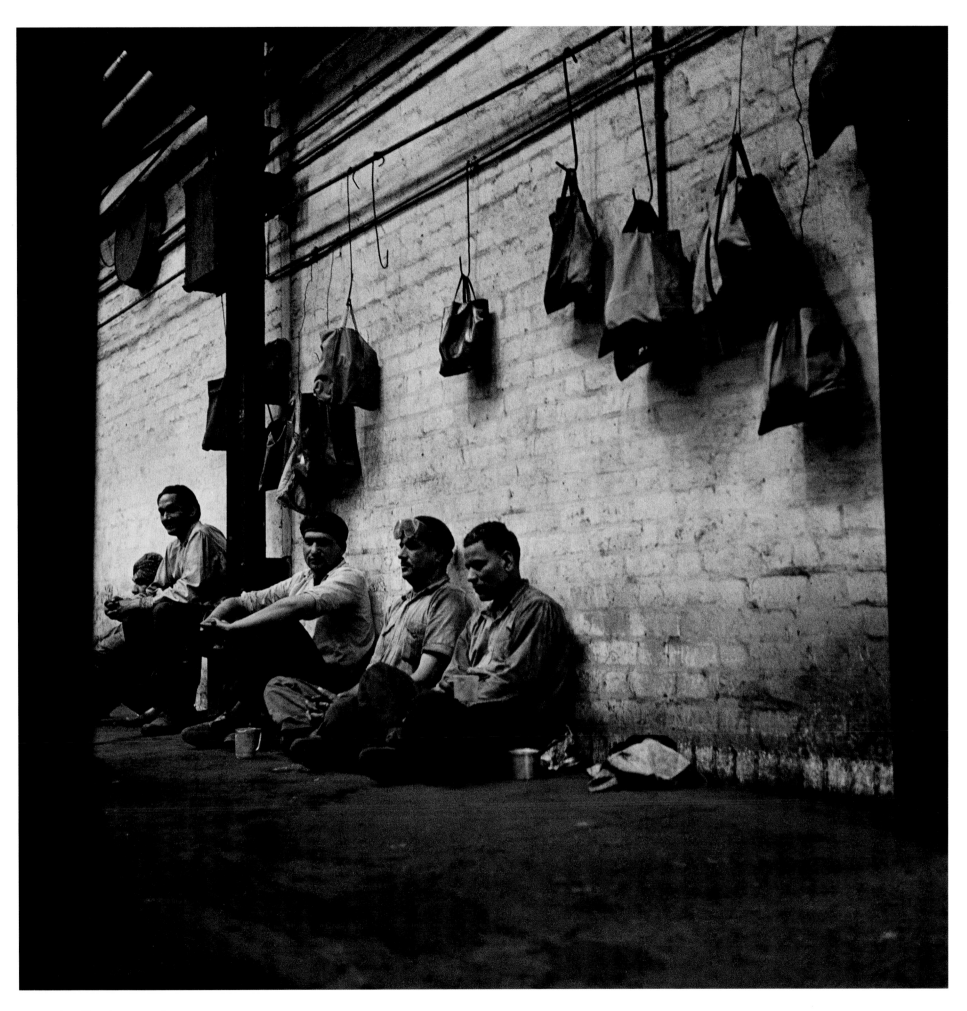

Factory lunchbreak, Birmingham, 1963

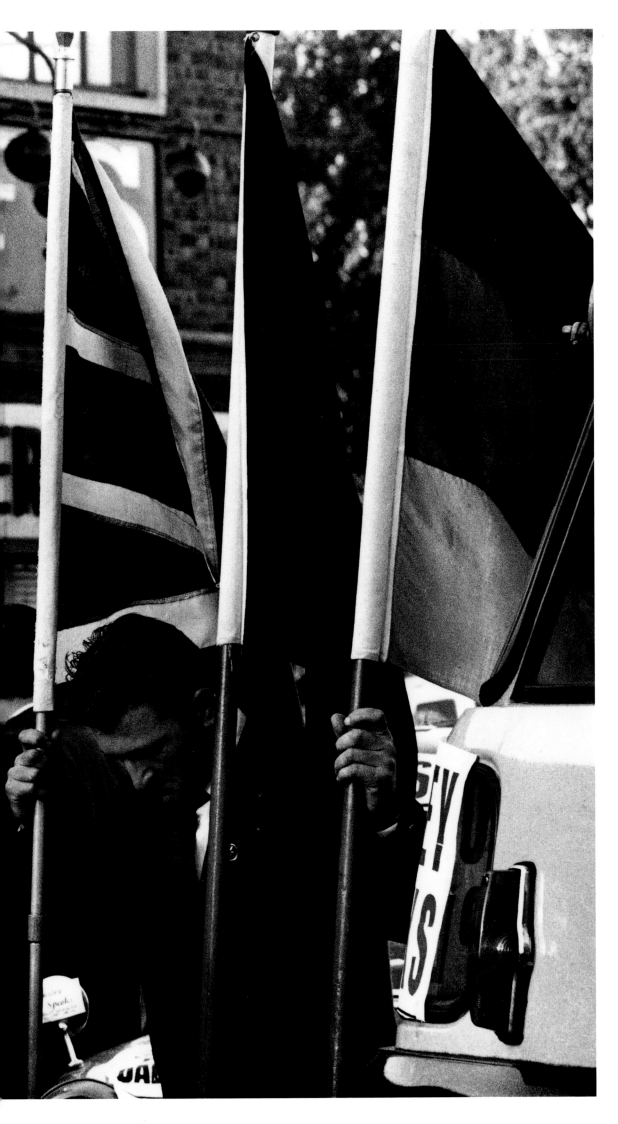

Mosley rally, Hackney, London, 1963

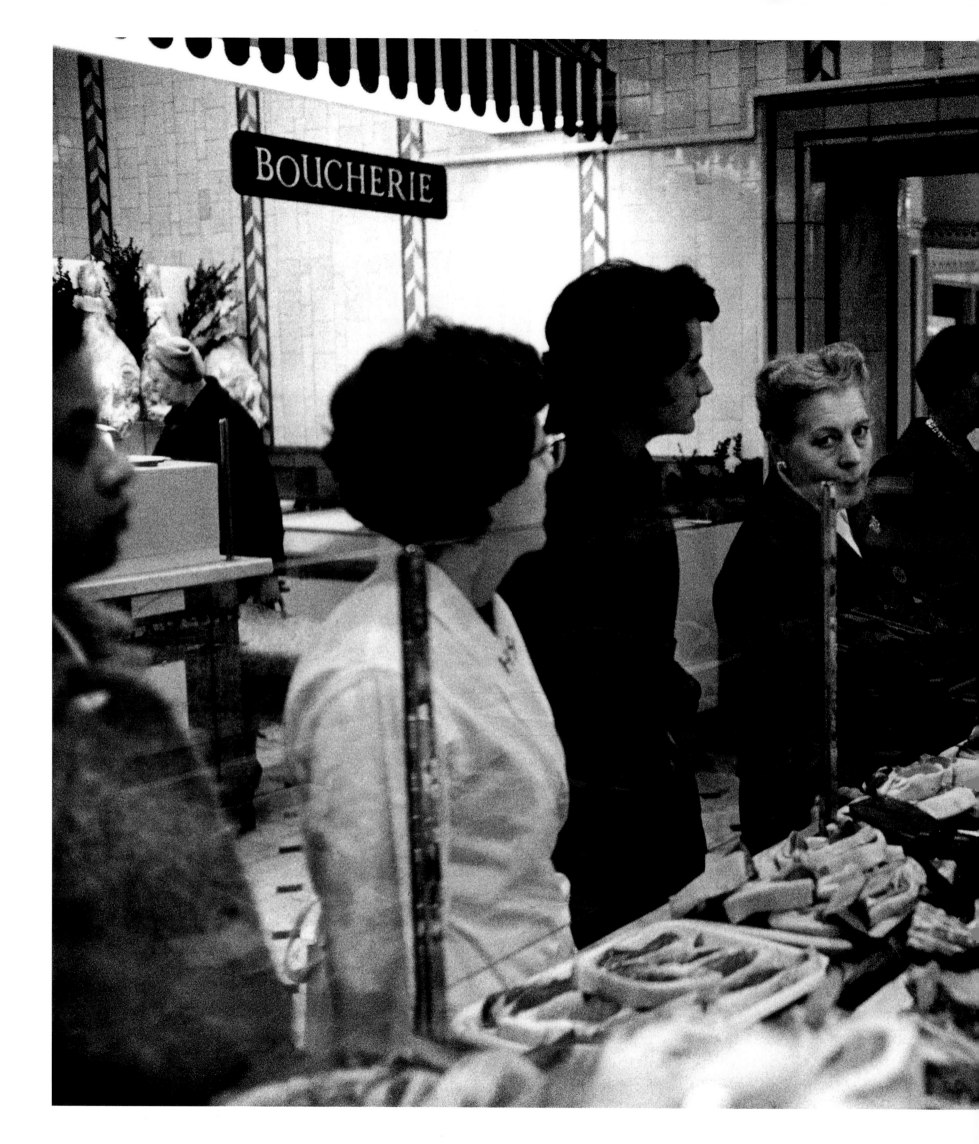

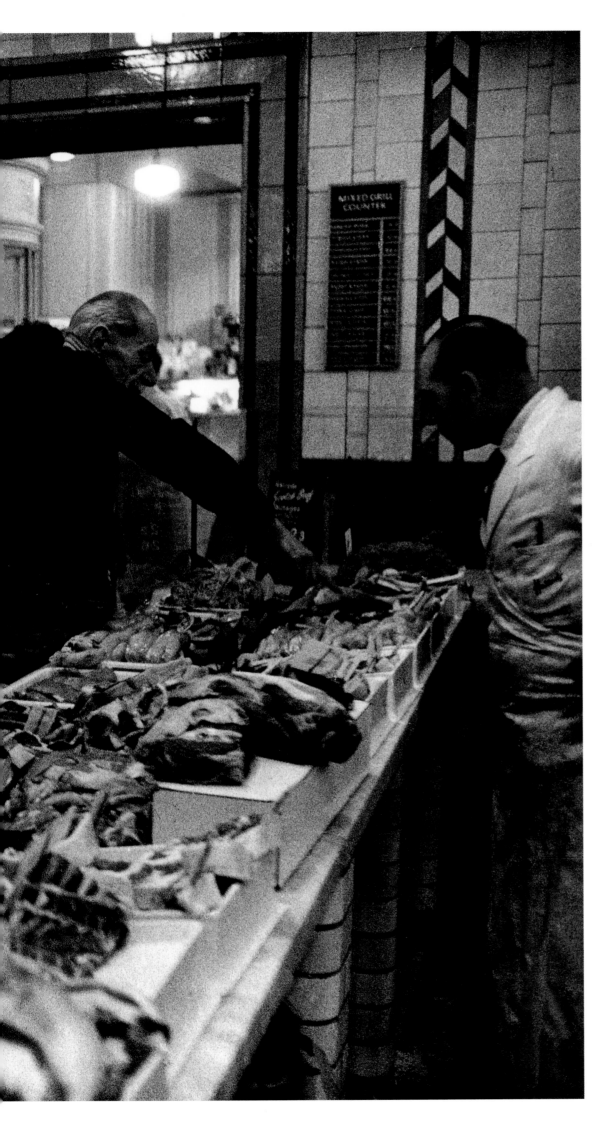

Harrod's Food Hall, 1965

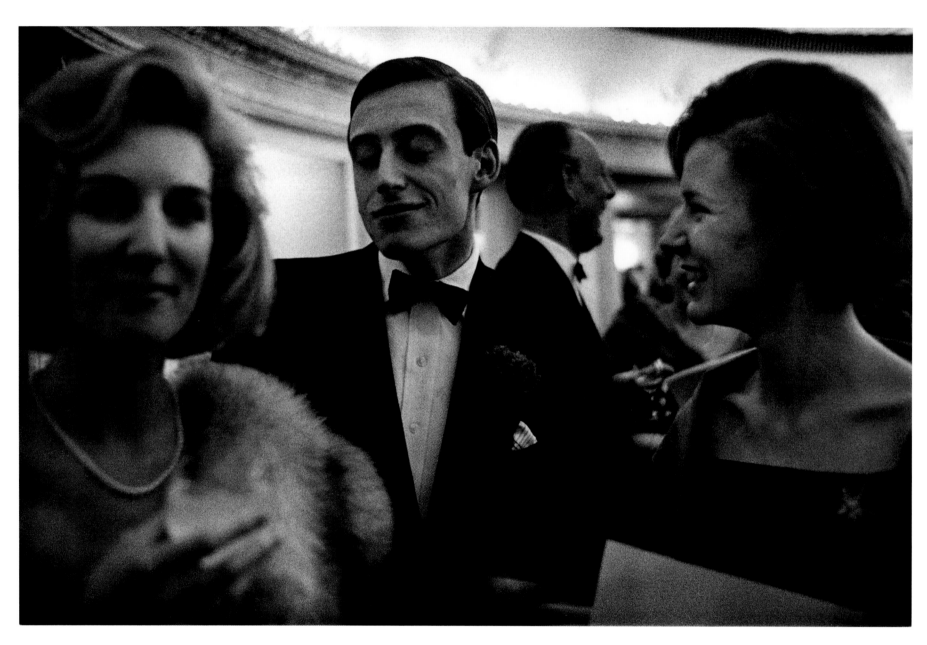

Mayfair, London, 1965

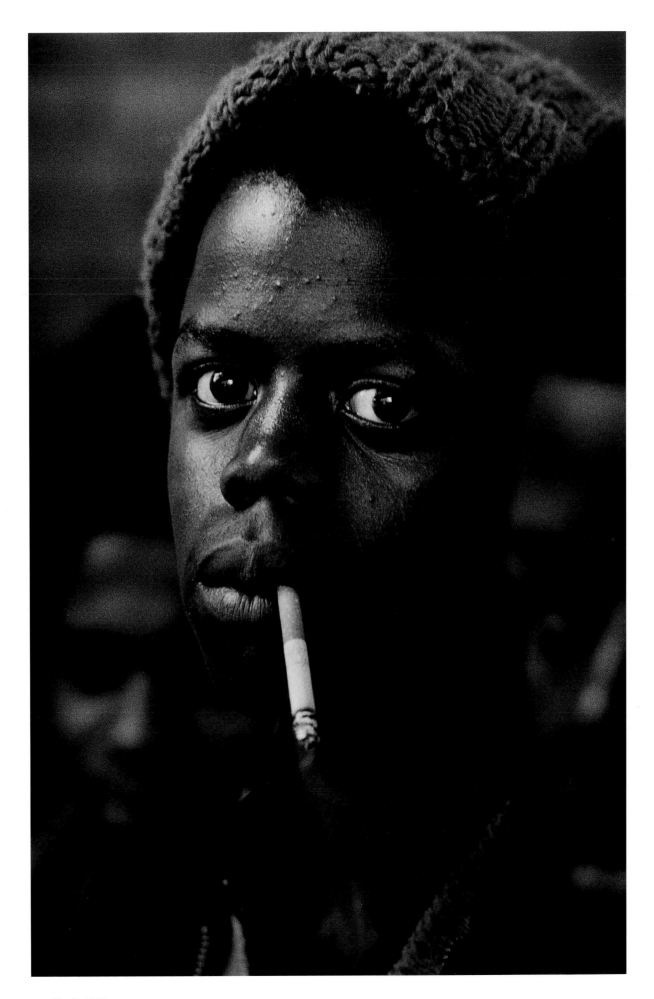

Bradford, 1973

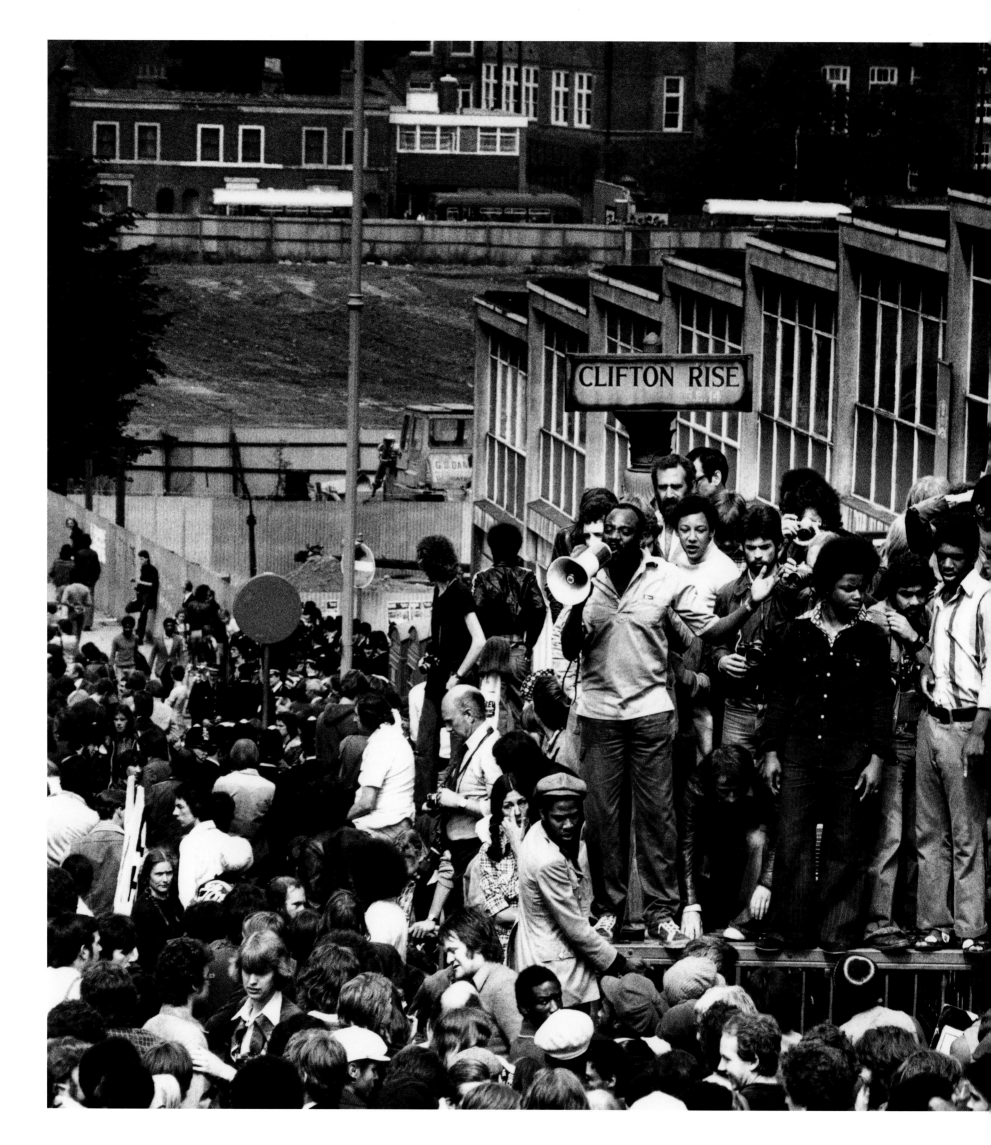

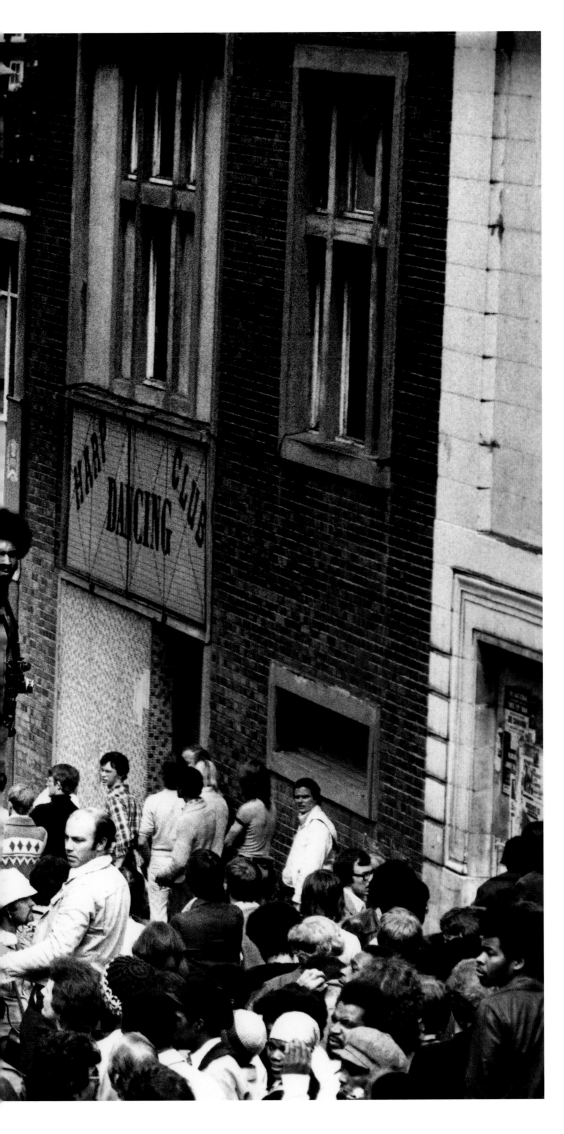

Lewisham, London, mid 1970s

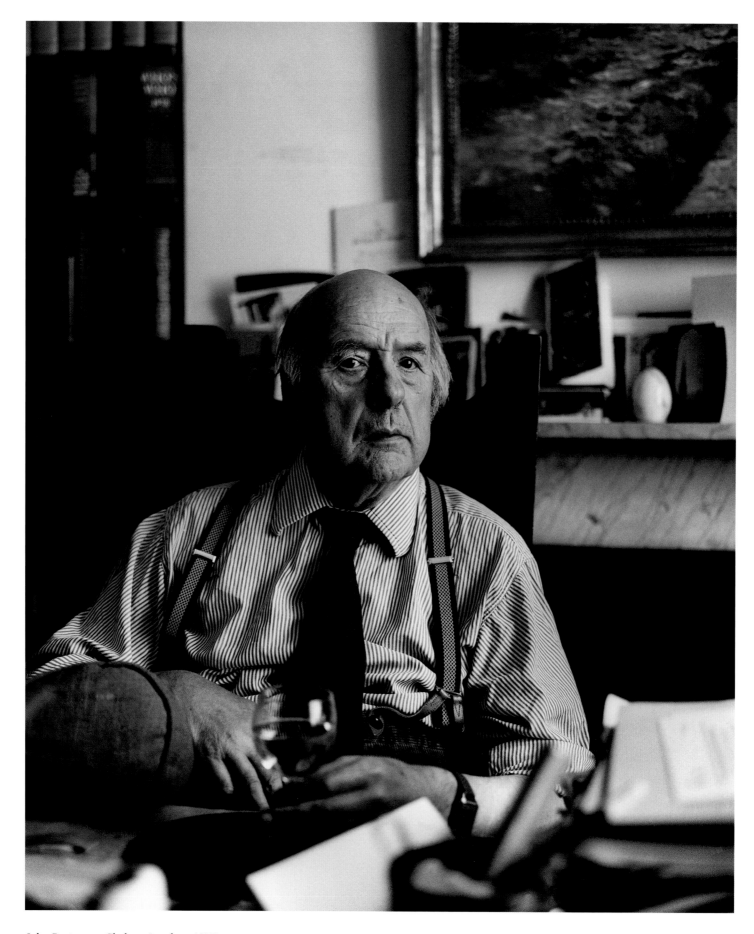

John Betjeman, Chelsea, London, 1974

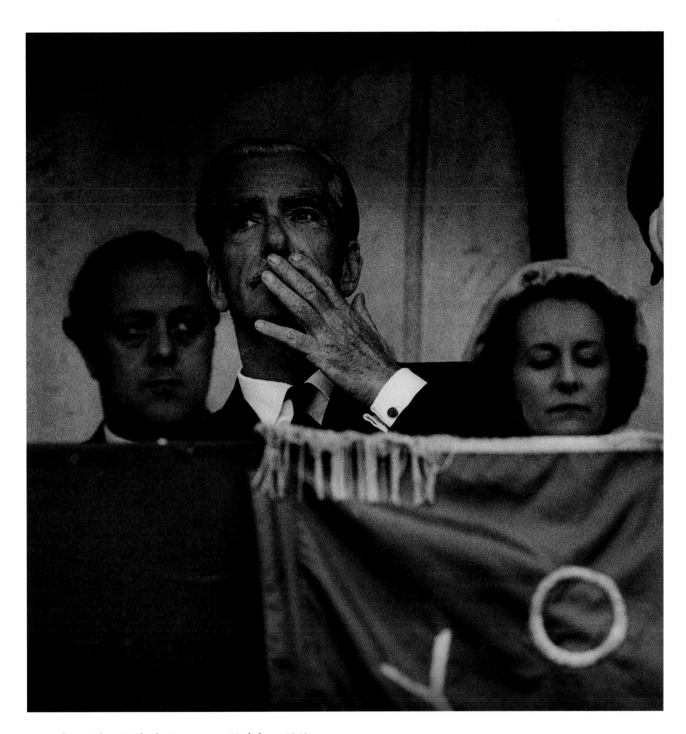

Sir Anthony Eden, Wetherby Racecourse, Yorkshire, 1963

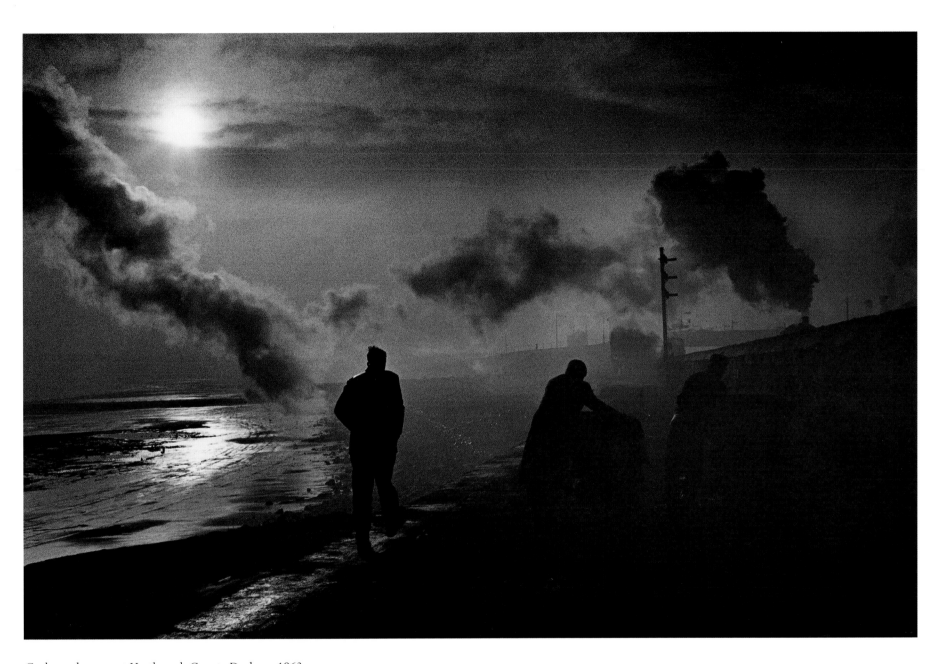

Coal searchers, west Hartlepool, County Durham, 1963

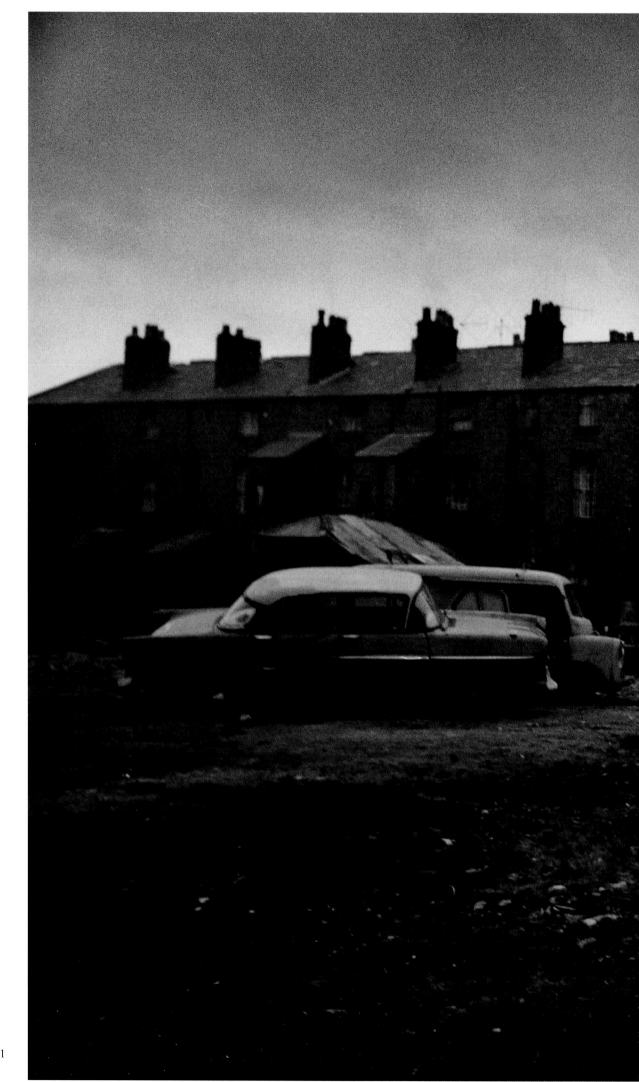

Liverpool 8, 1961

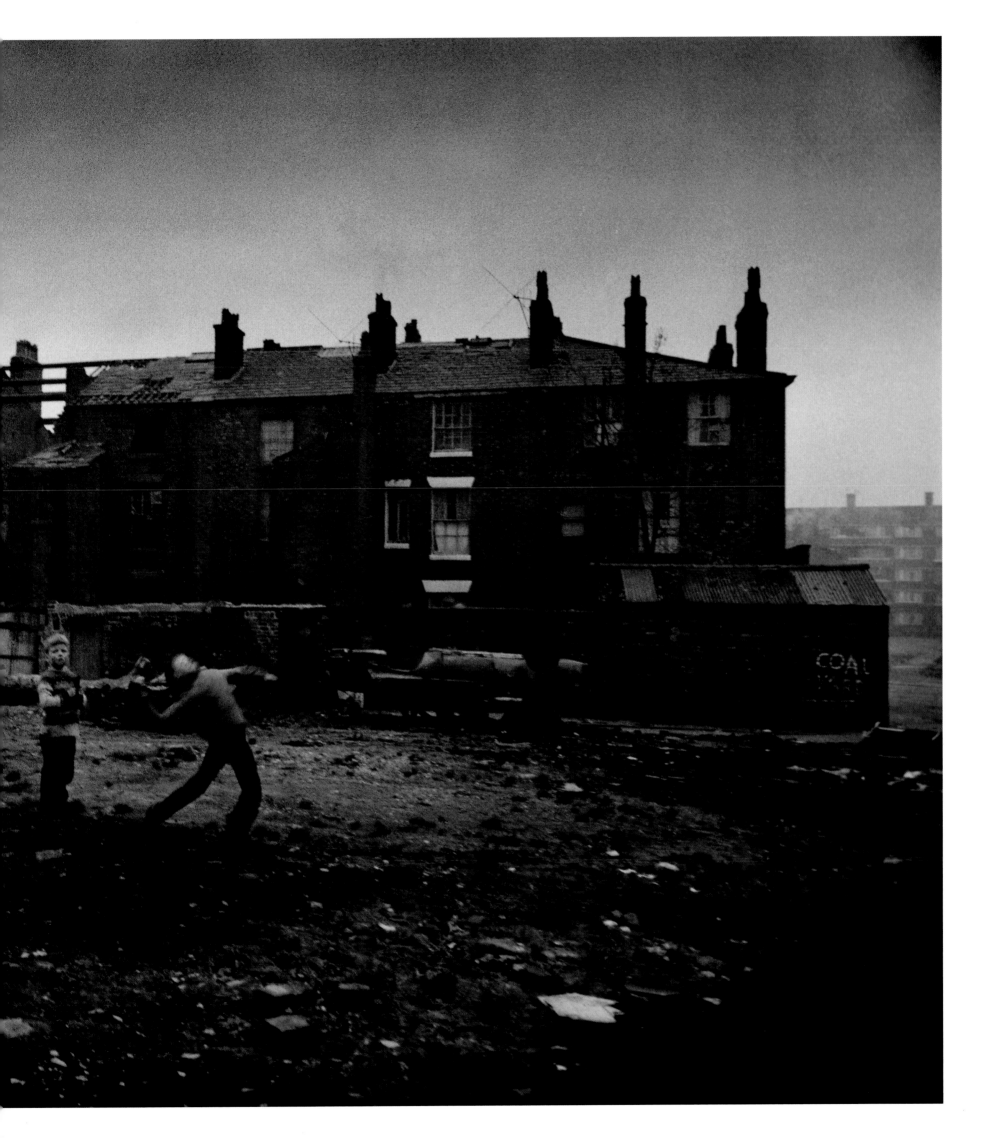

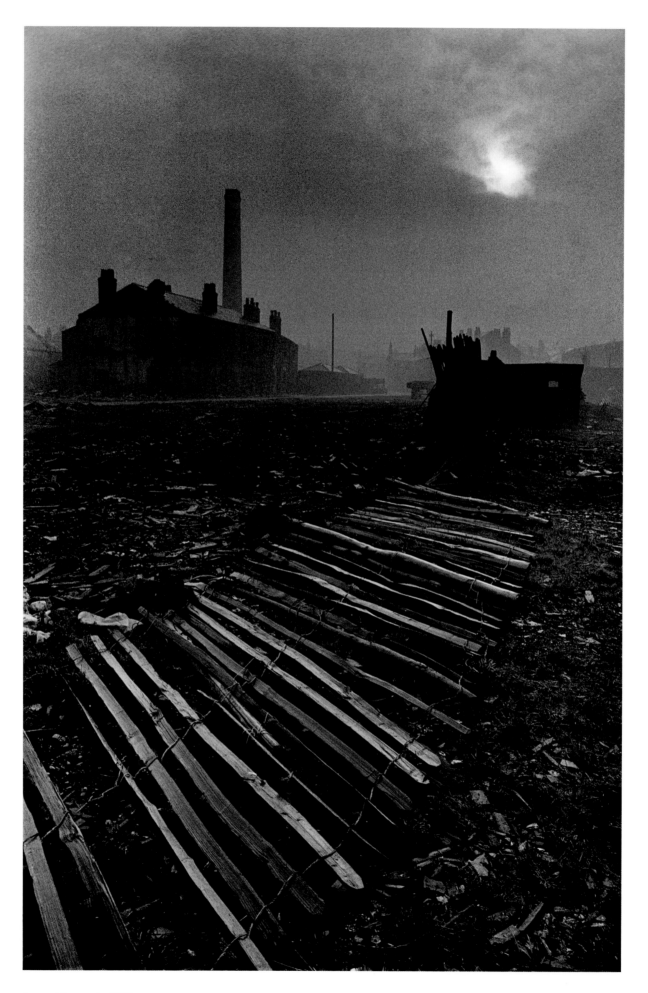

Lancashire, early 1960s

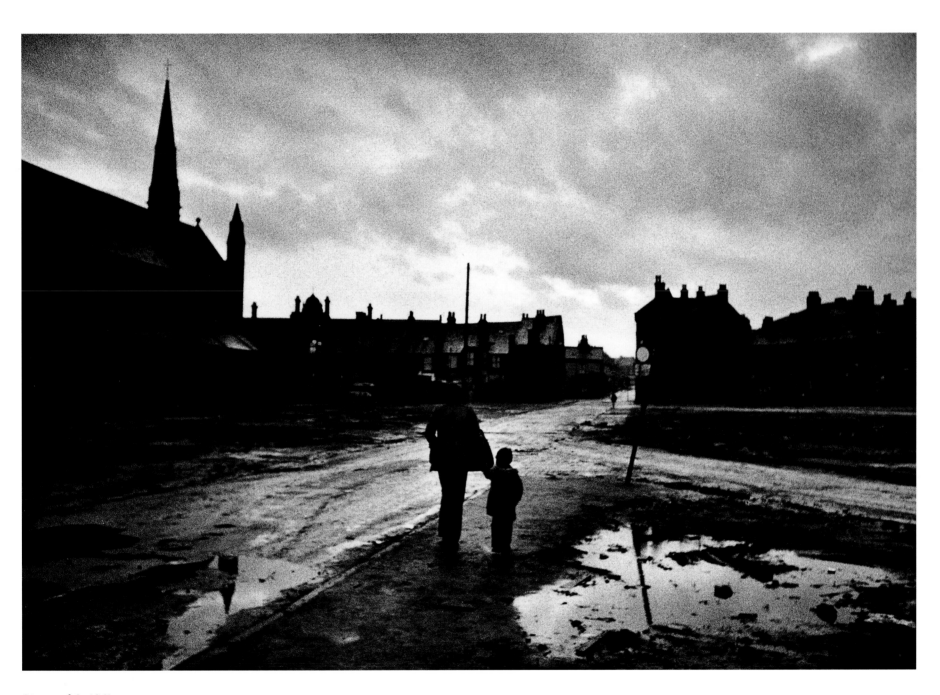

Liverpool 8, 1961

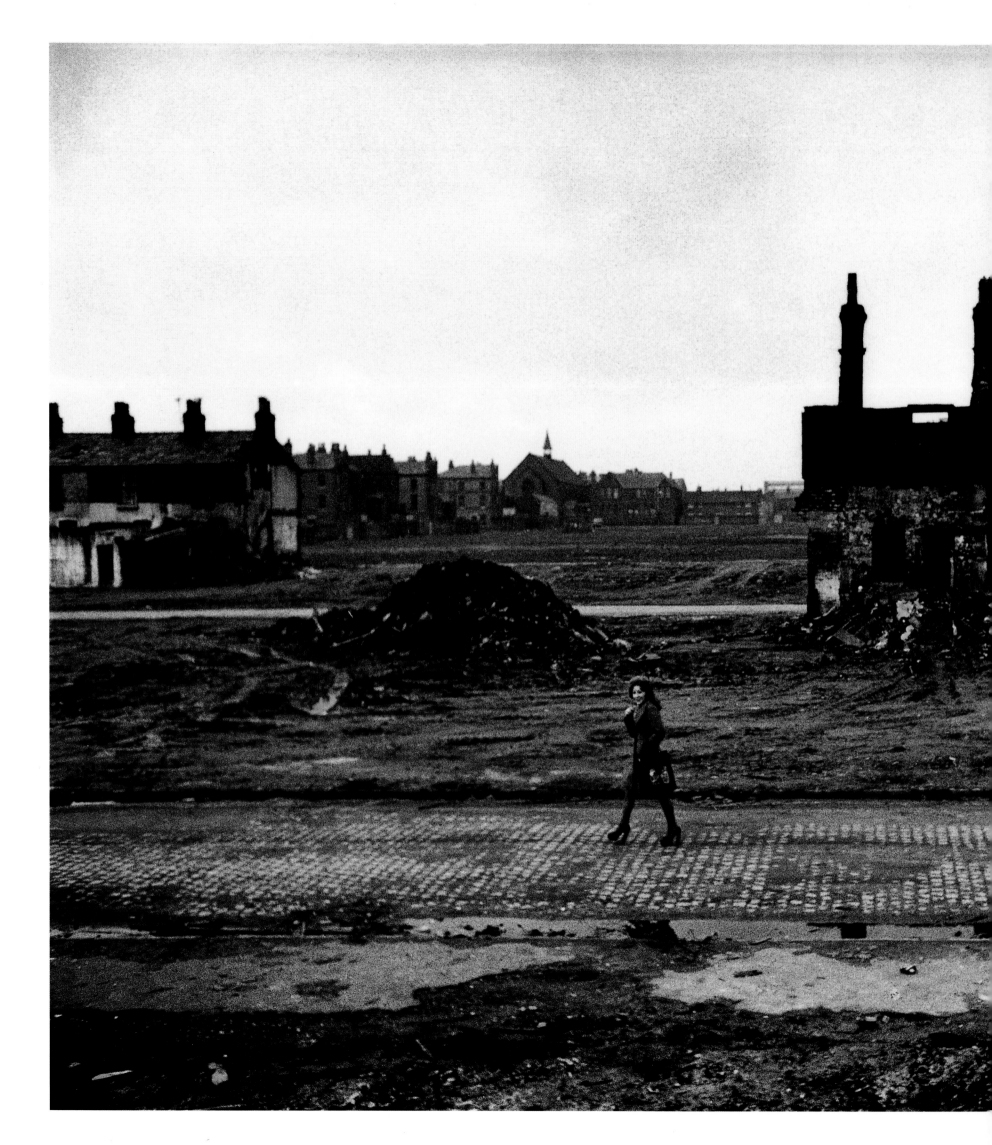

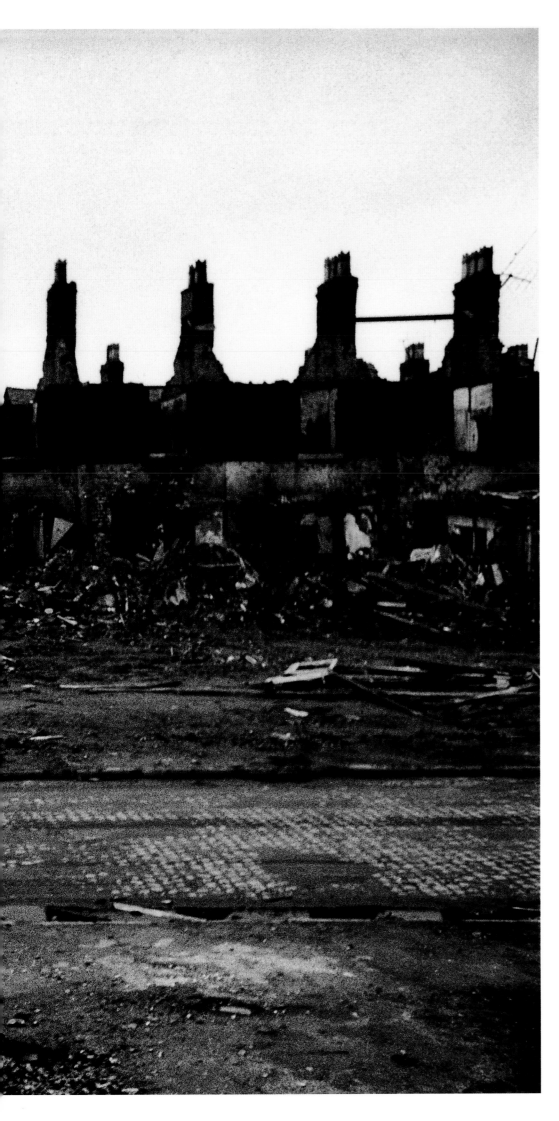

Slum clearance, Liverpool, late 1960s

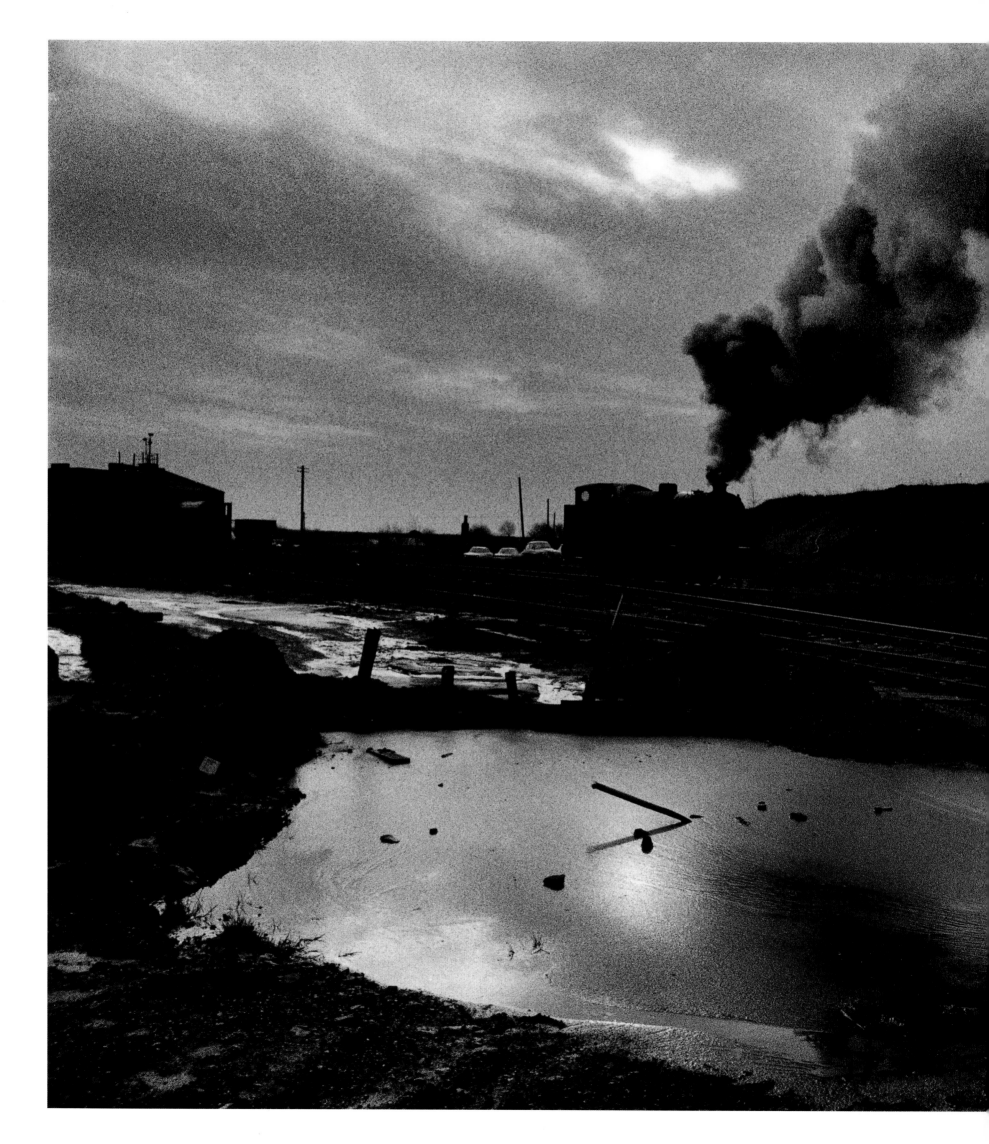

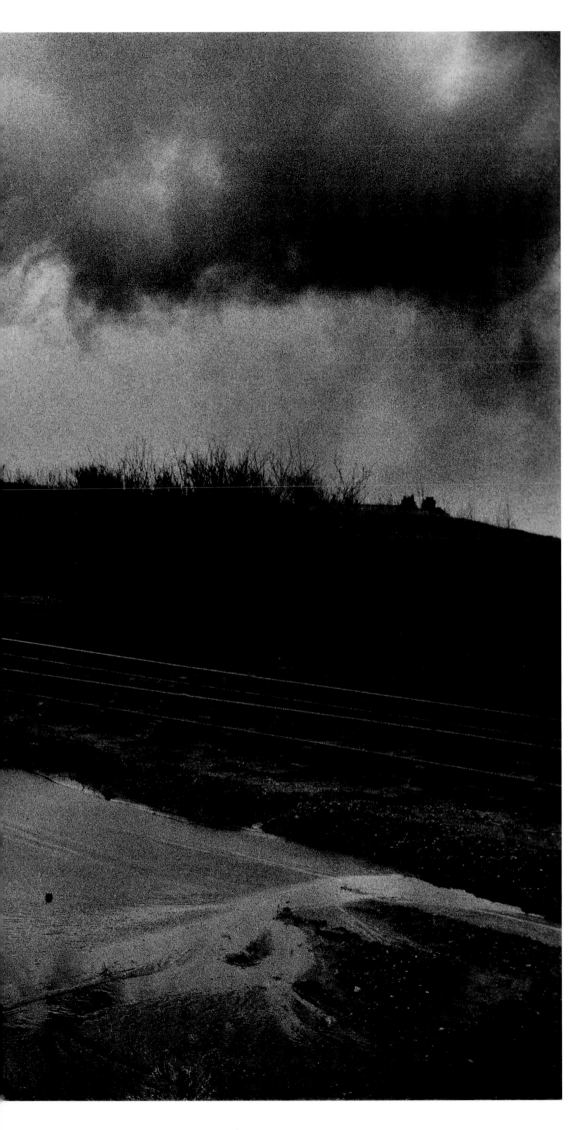

Doncaster, Yorkshire, 1967

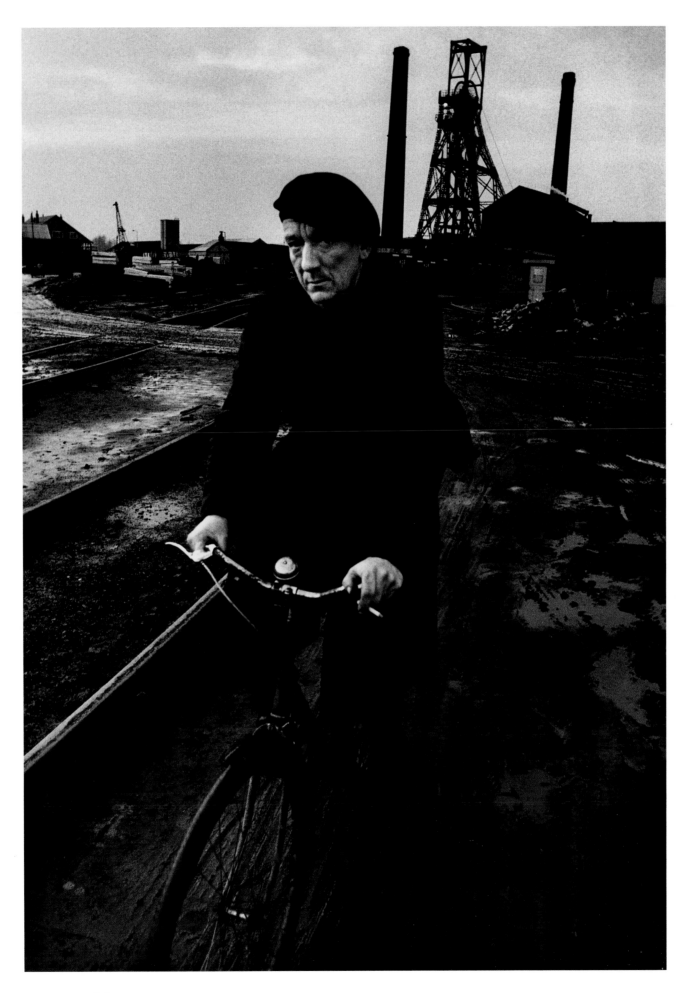

Doncaster, Yorkshire, 1967

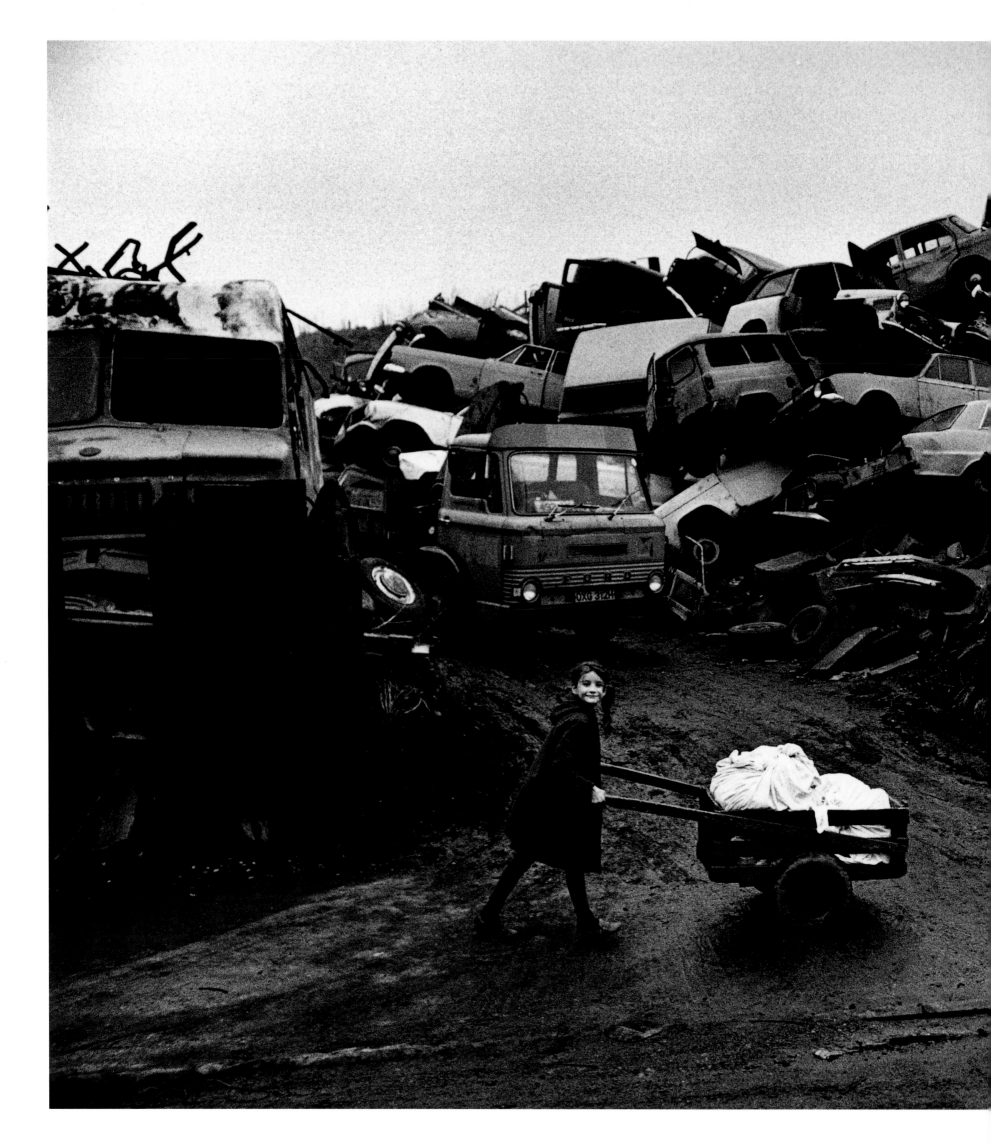

Girl and laundry, Bradford, early 1970s

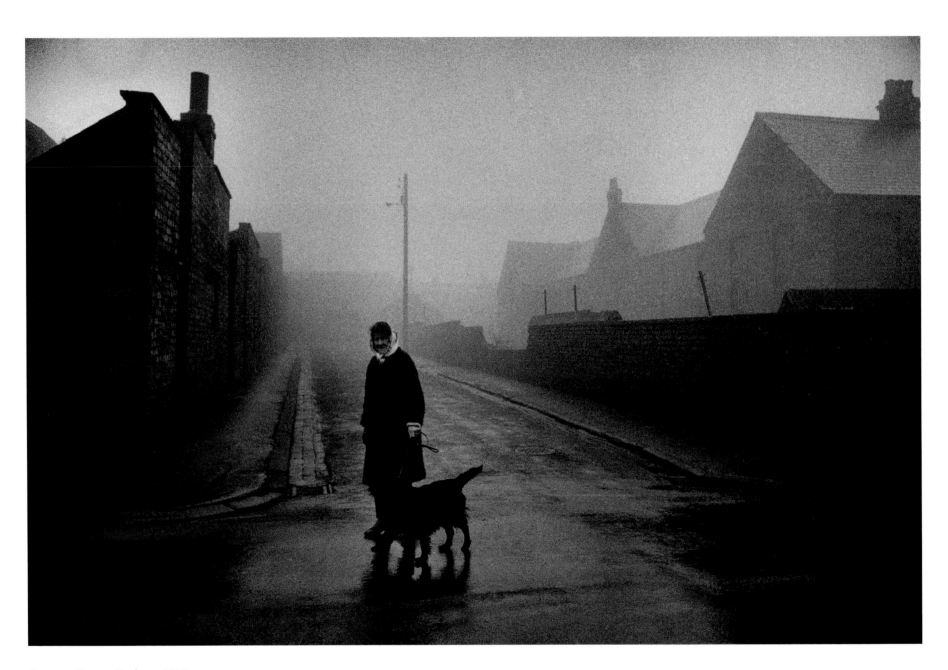

Consett, County Durham, 1970s

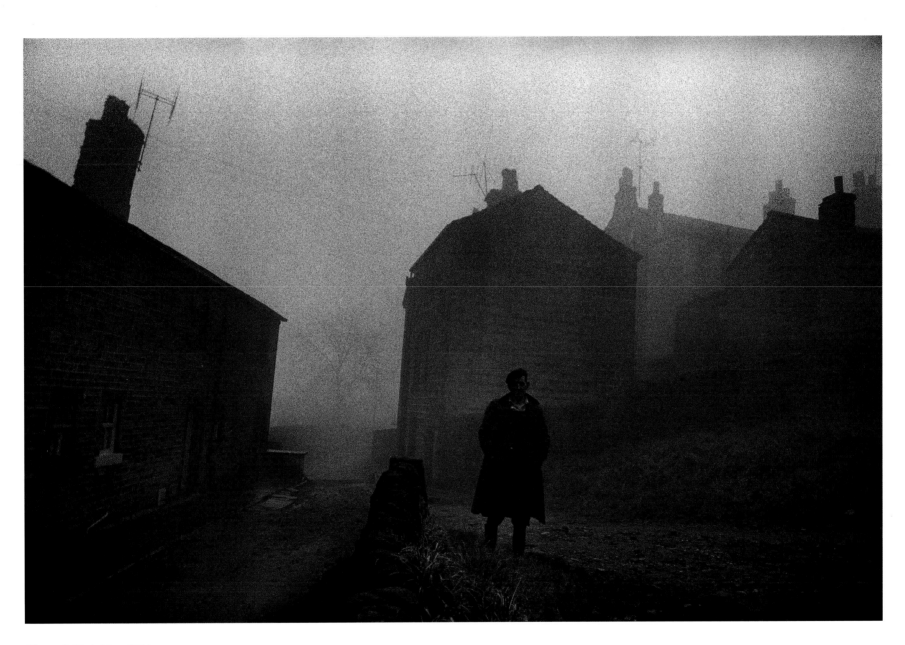

Haworth, Yorkshire, 1961

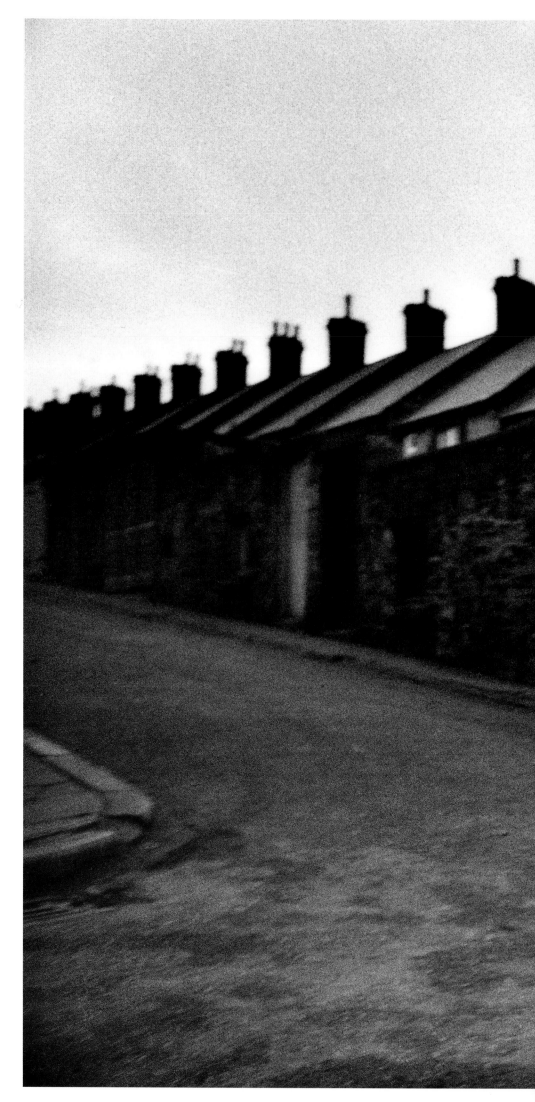

Consett, County Durham, 1970s

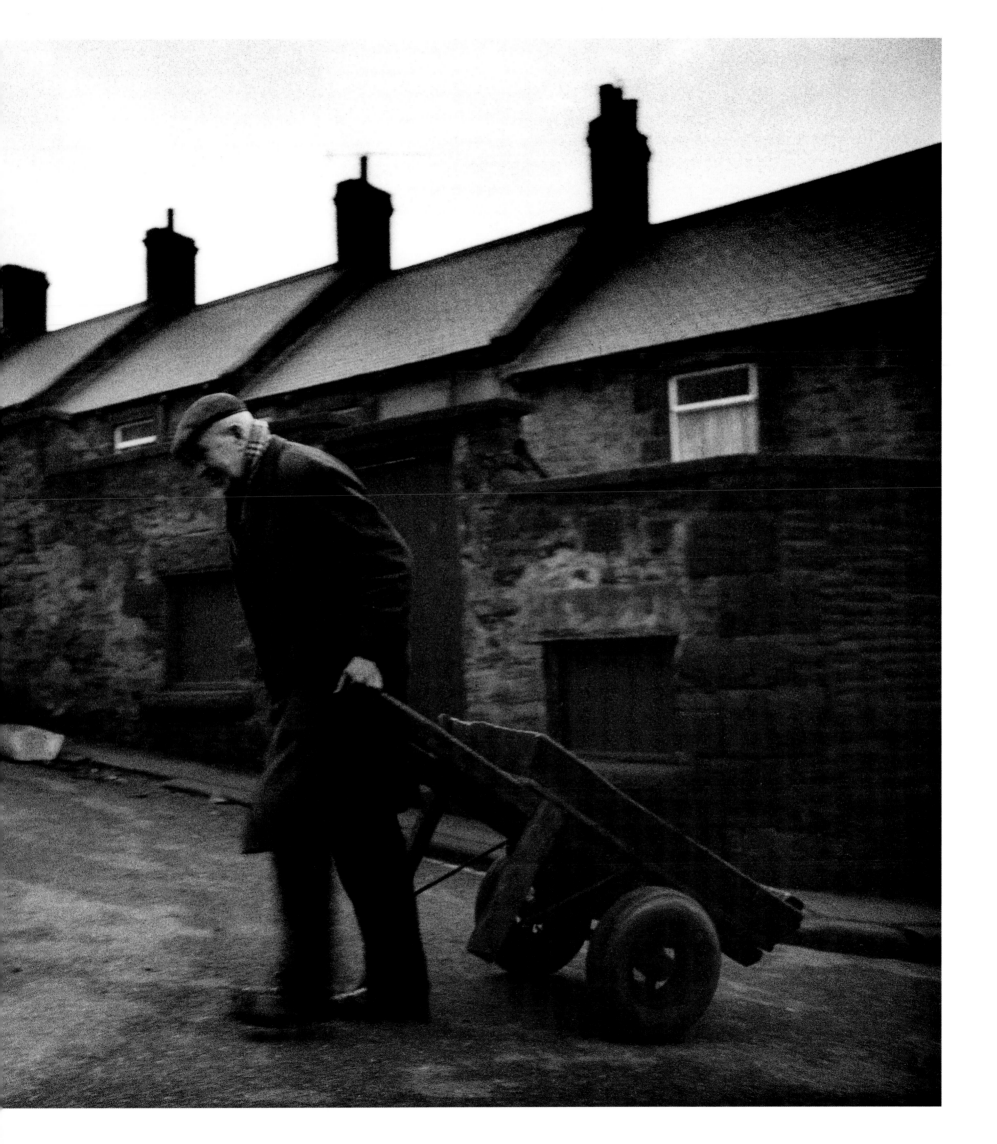

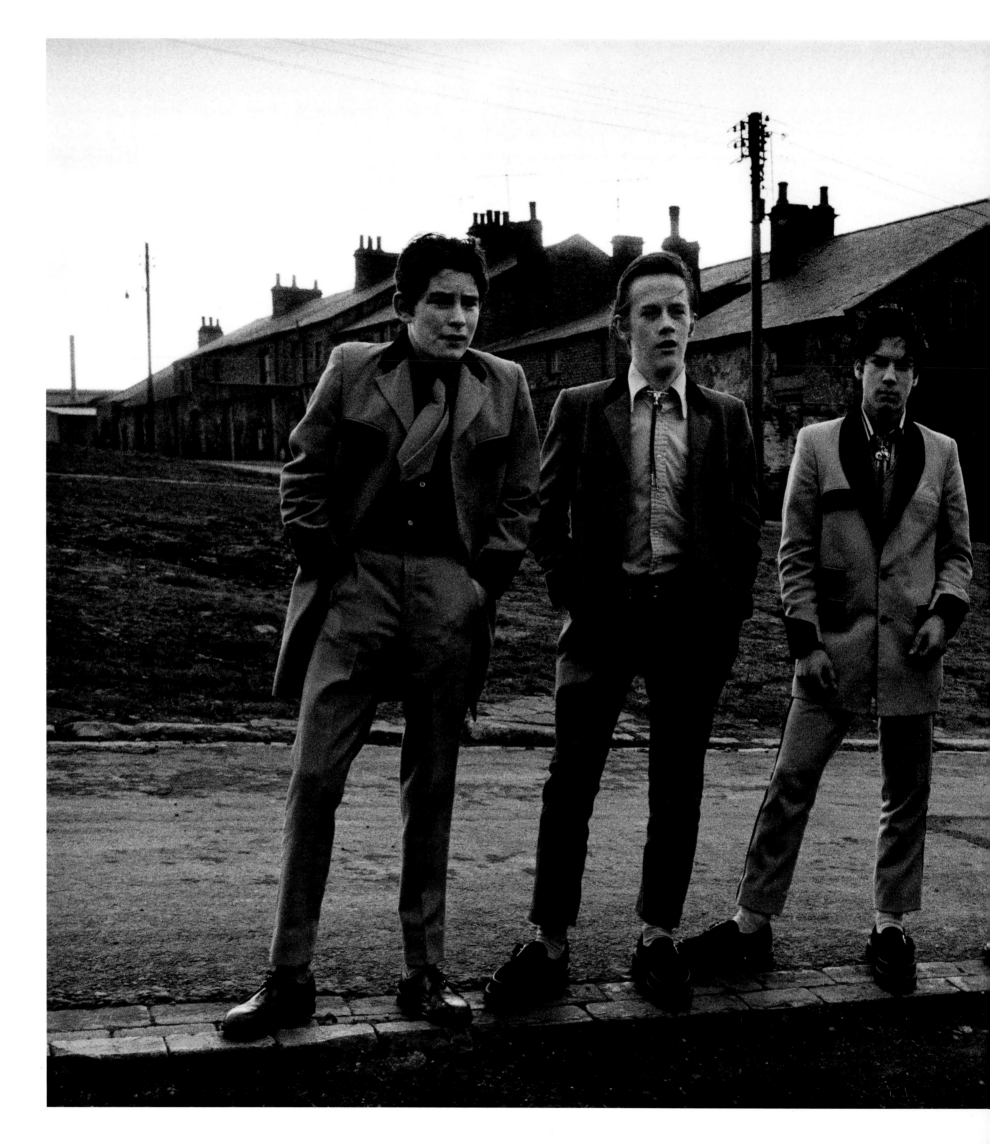

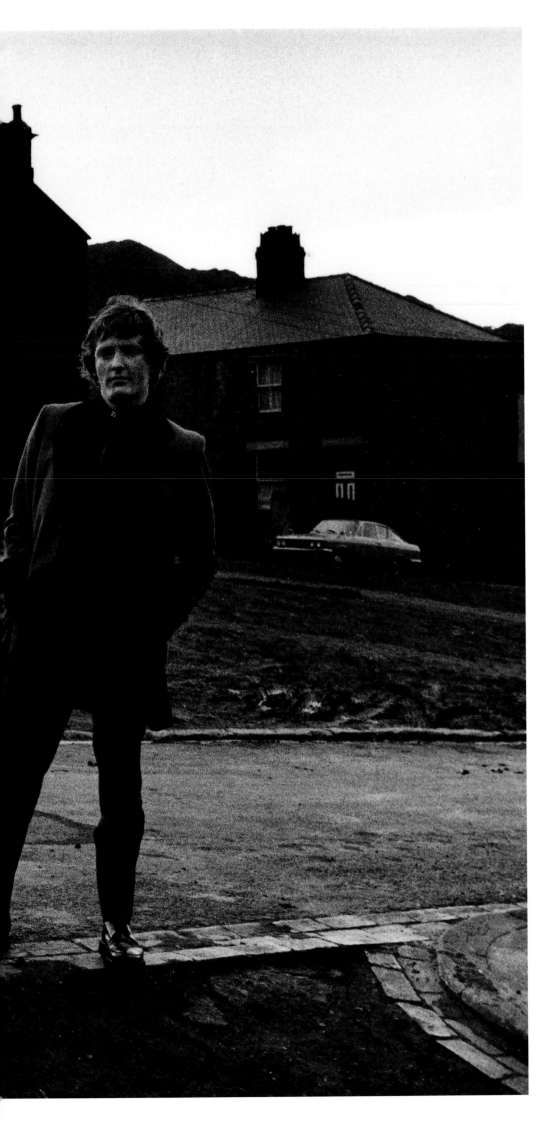

Consett, County Durham, 1970s

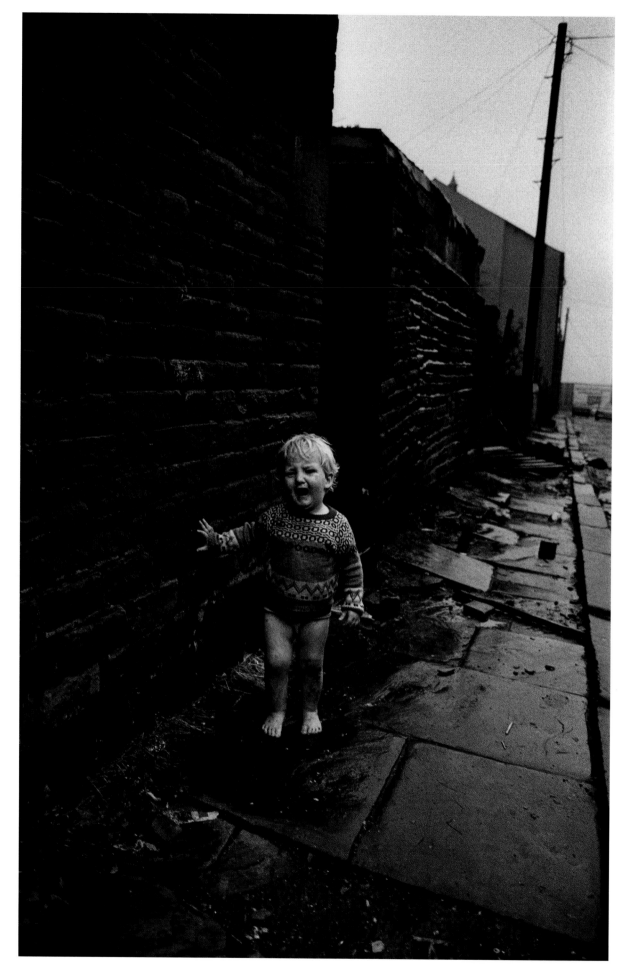

Bradford, 1970s

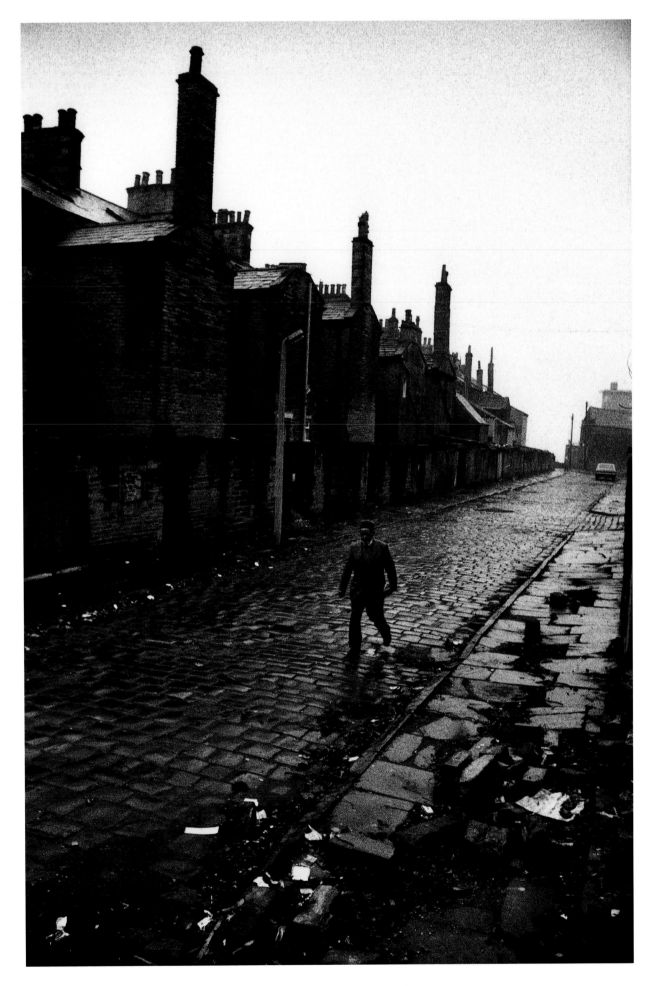

Bradford, 1970s

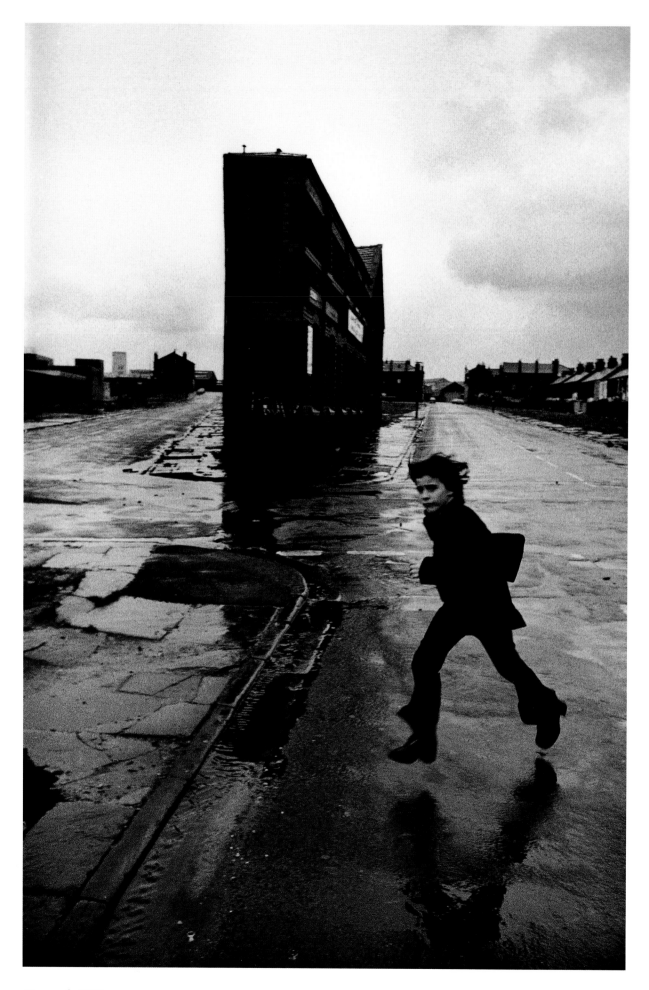

Liverpool, 1970s

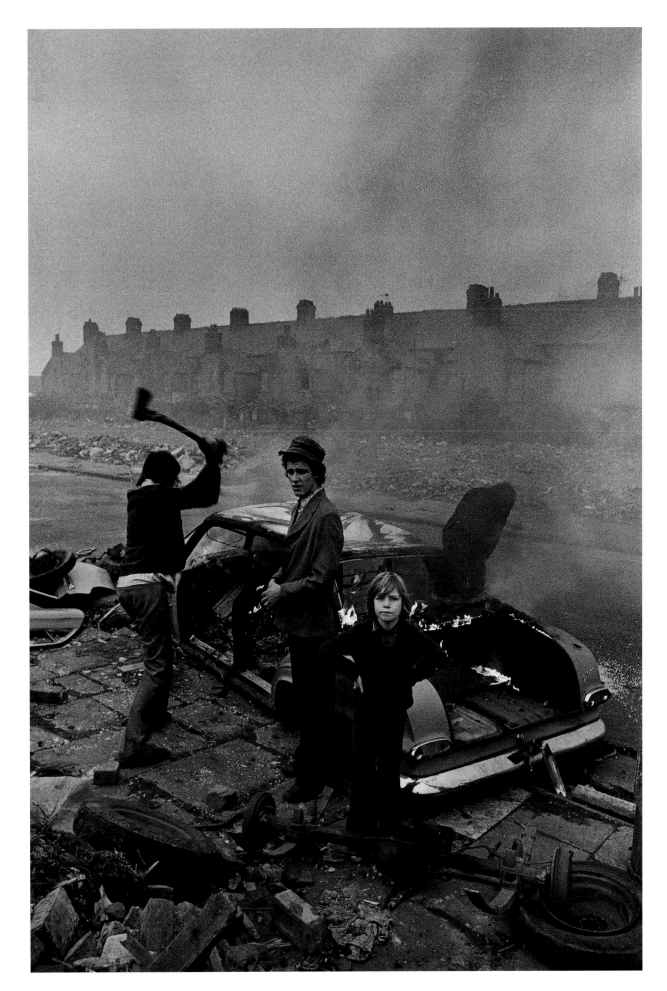

Birmingham, 1970s

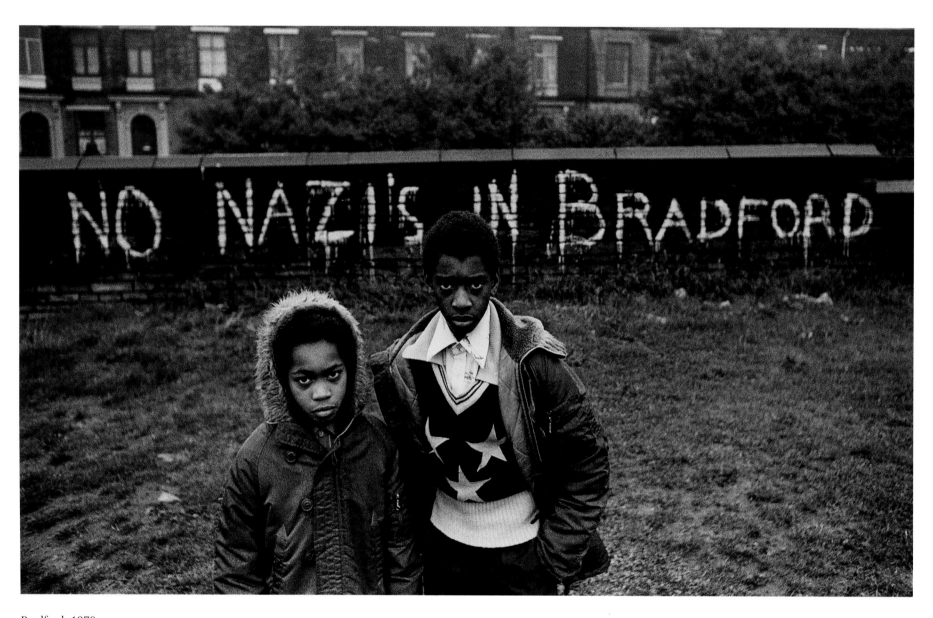

Bradford, 1970s

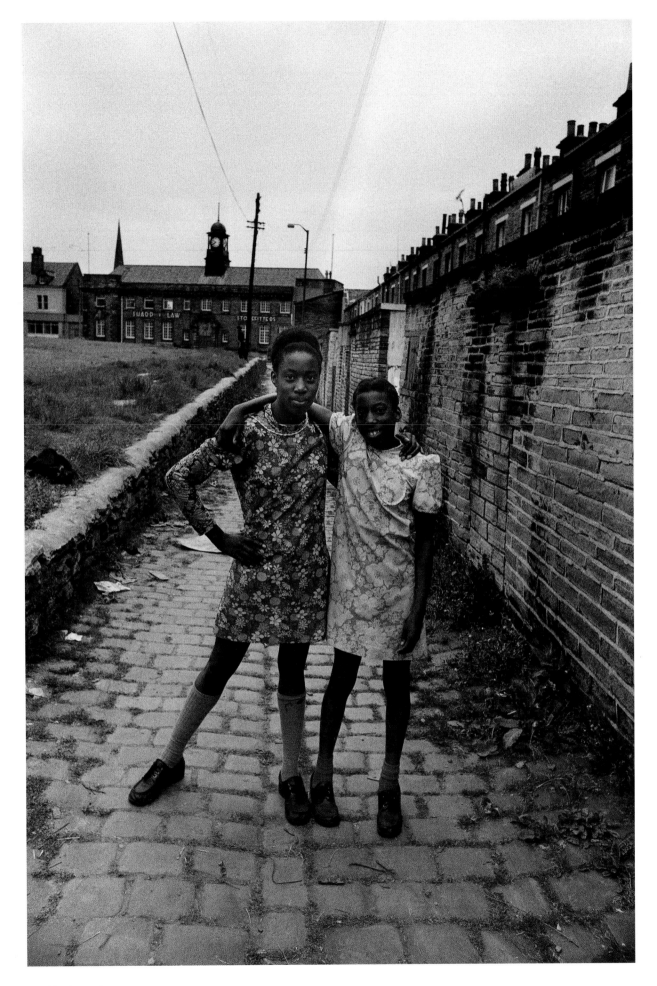

Bradford, 1970s

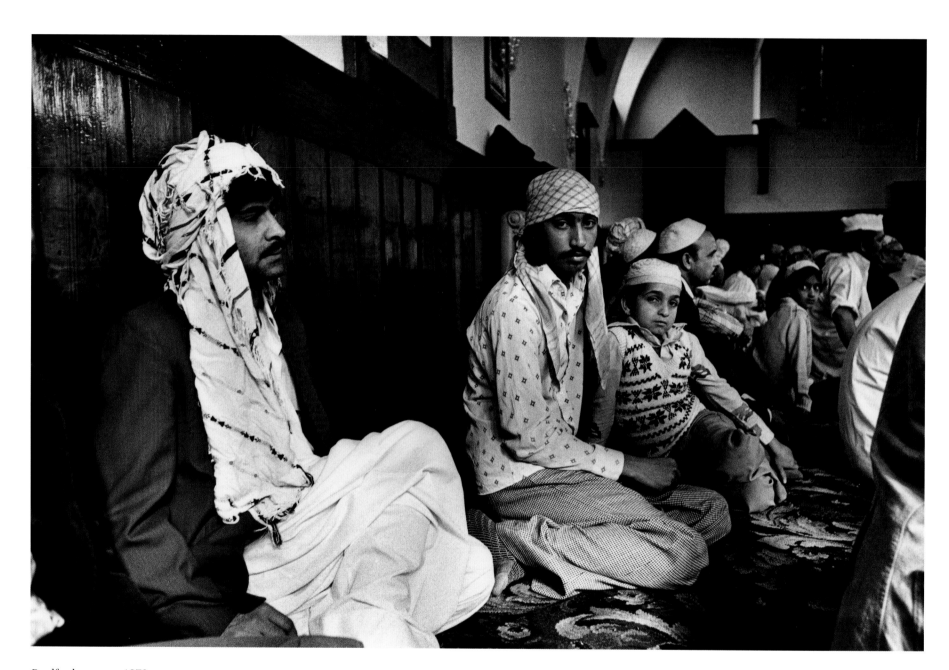

Bradford mosque, 1970s

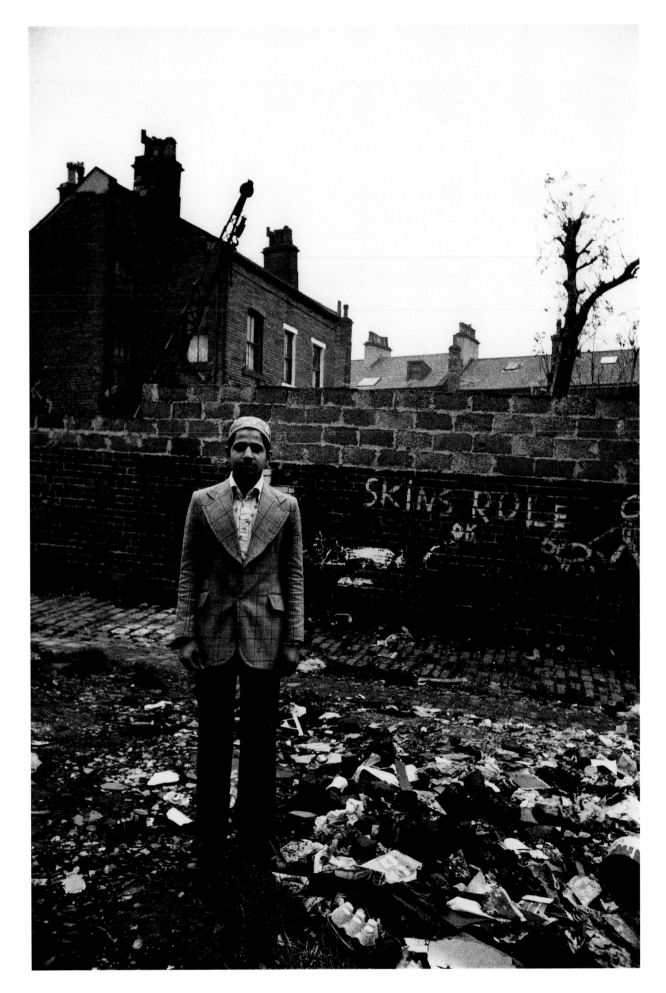

Bradford, 1970s

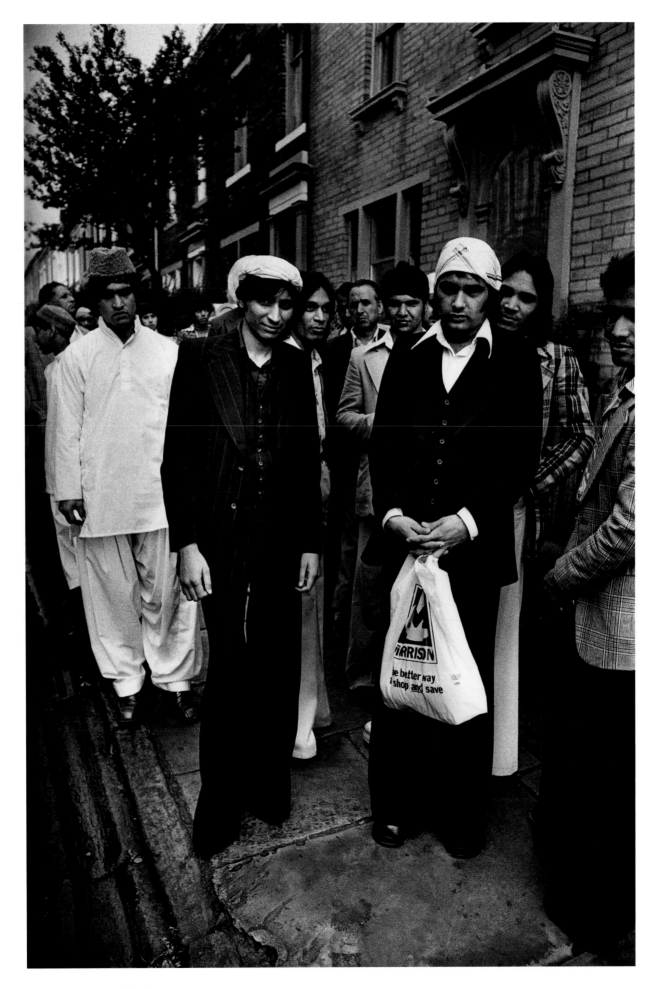

Festival of Eid, Bradford, 1970s

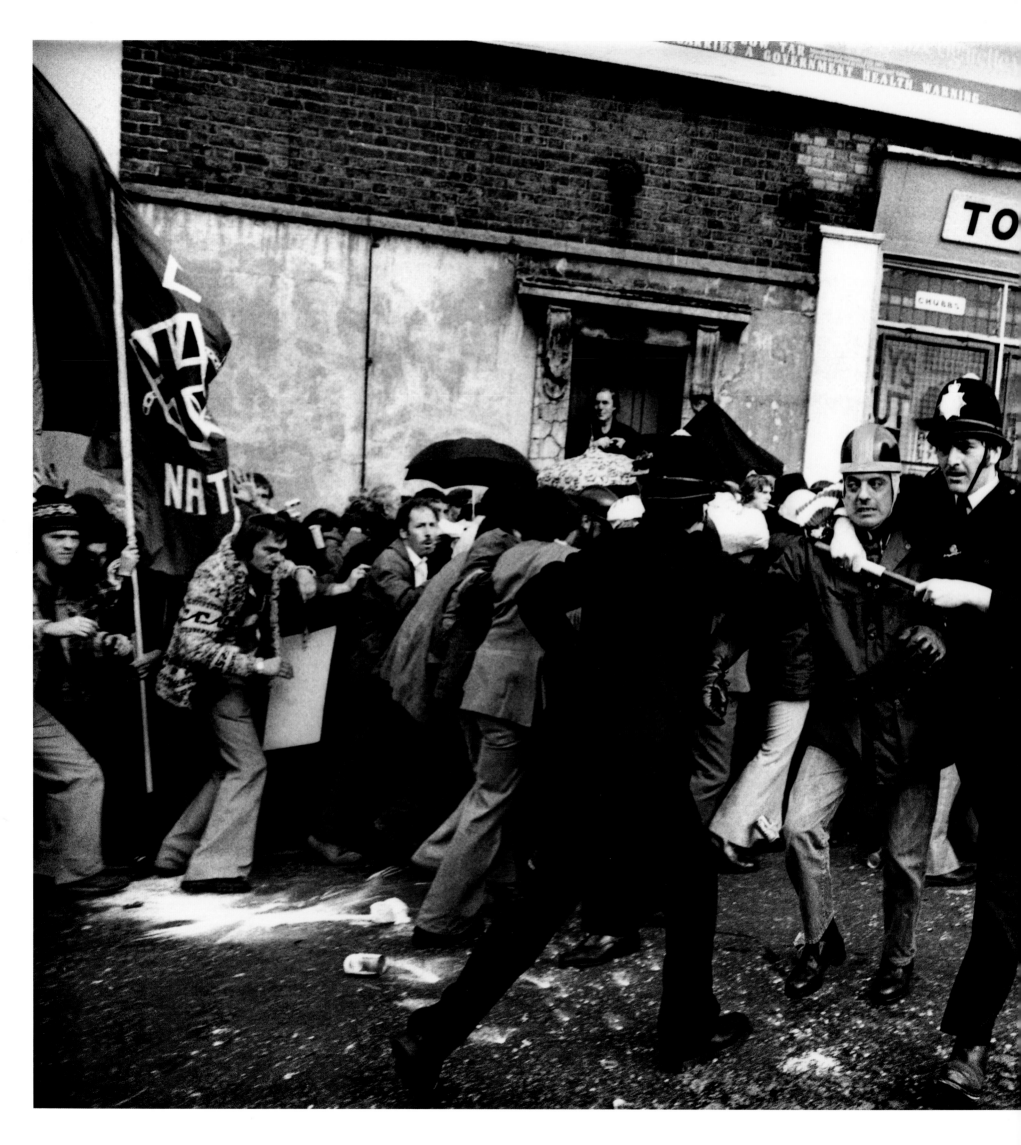

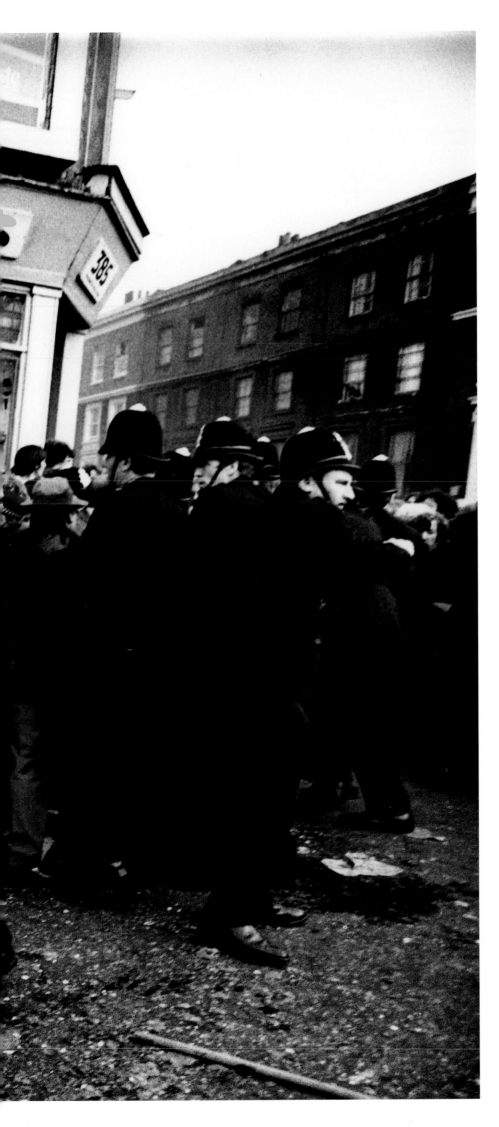

Lewisham, London, early 1970s

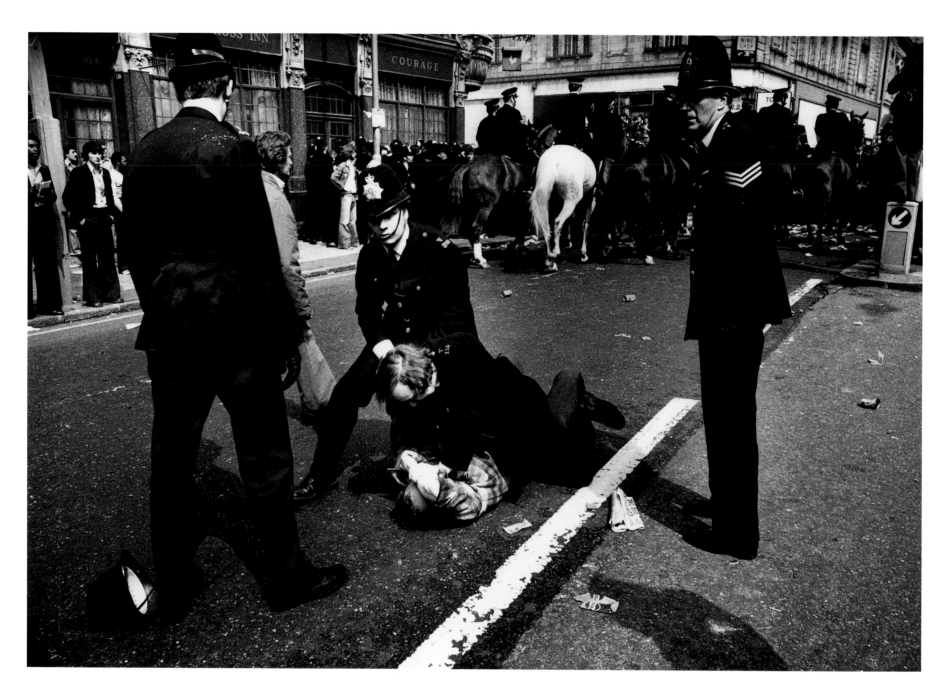

Lewisham, London, early 1970s

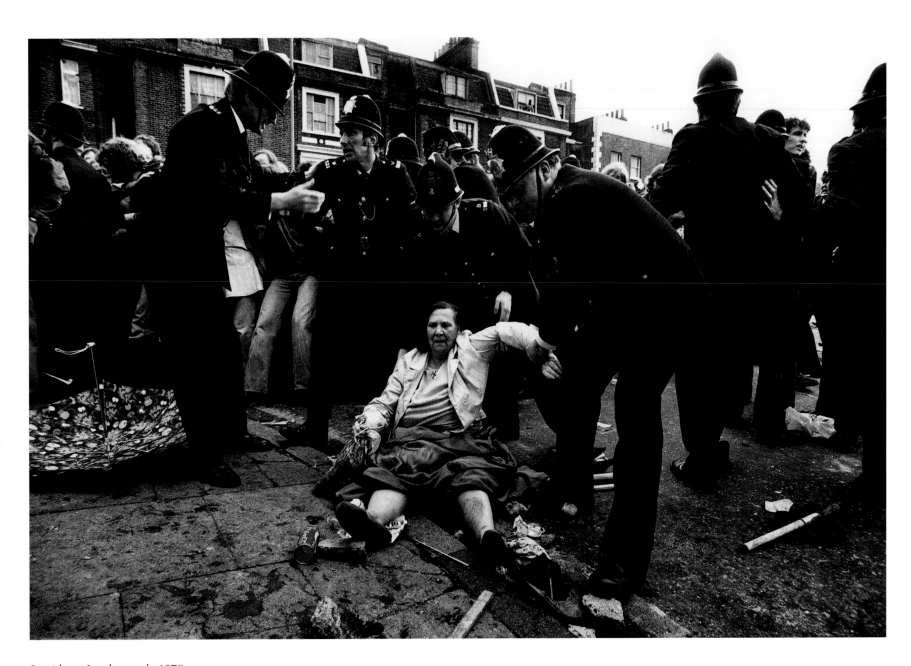

Lewisham, London, early 1970s

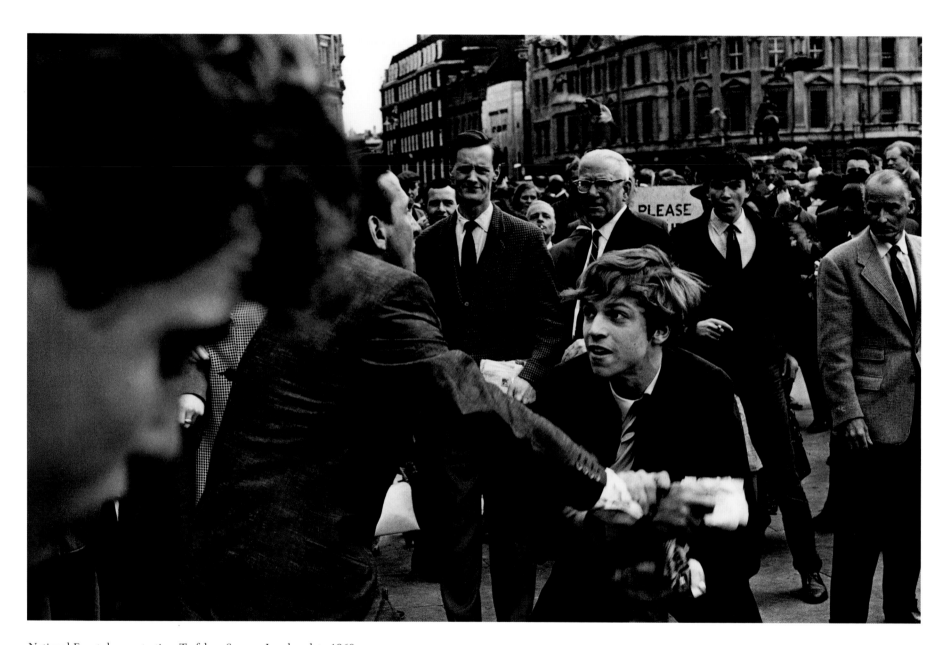

National Front demonstration, Trafalgar Square, London, late 1960s

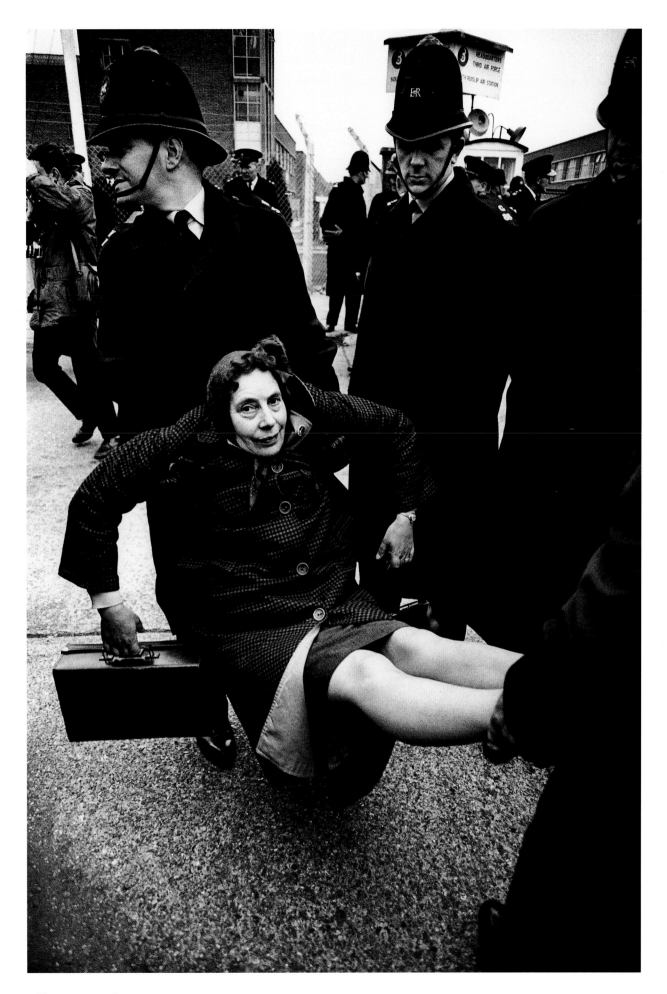

Aldermaston, early 1960s

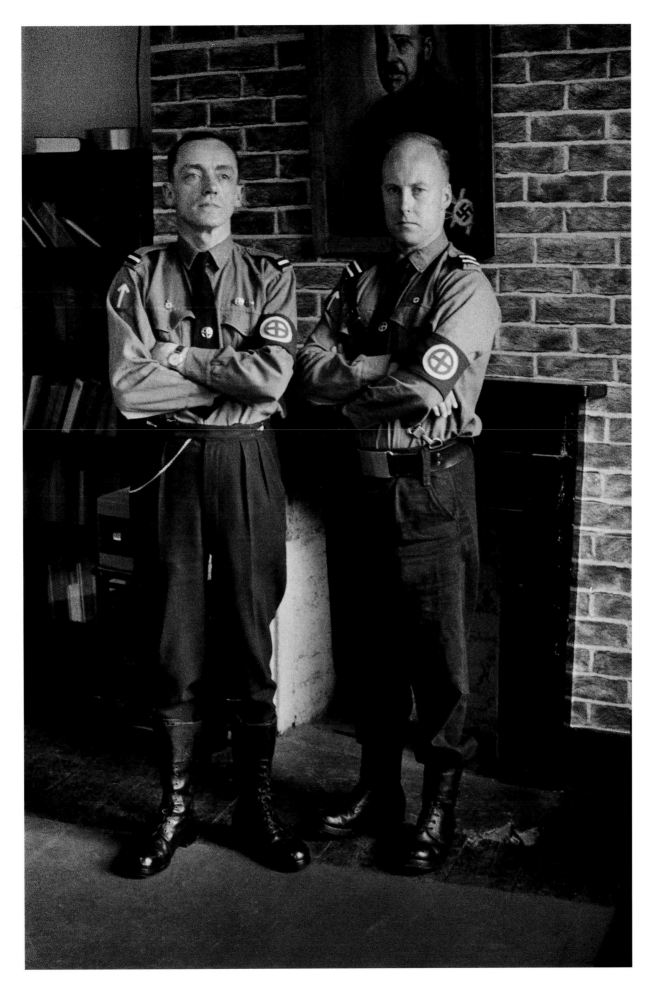

John Tyndall (right), Notting Hill, London, 1964

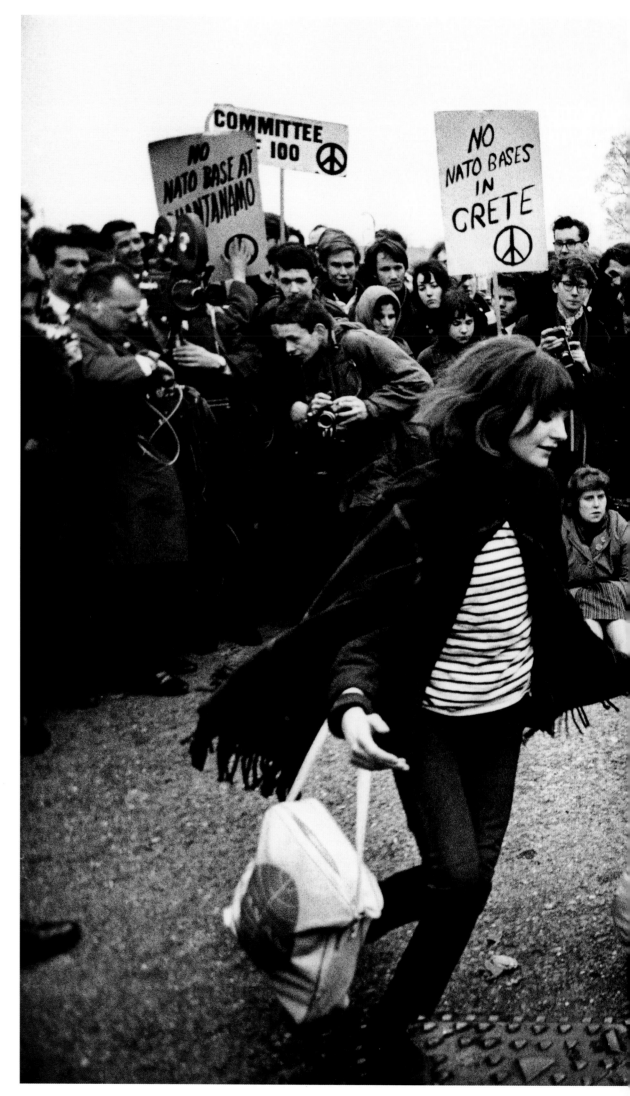

Ruislip, Middlesex, early 1960s

following pages:
The Cenotaph, London, early 1960s

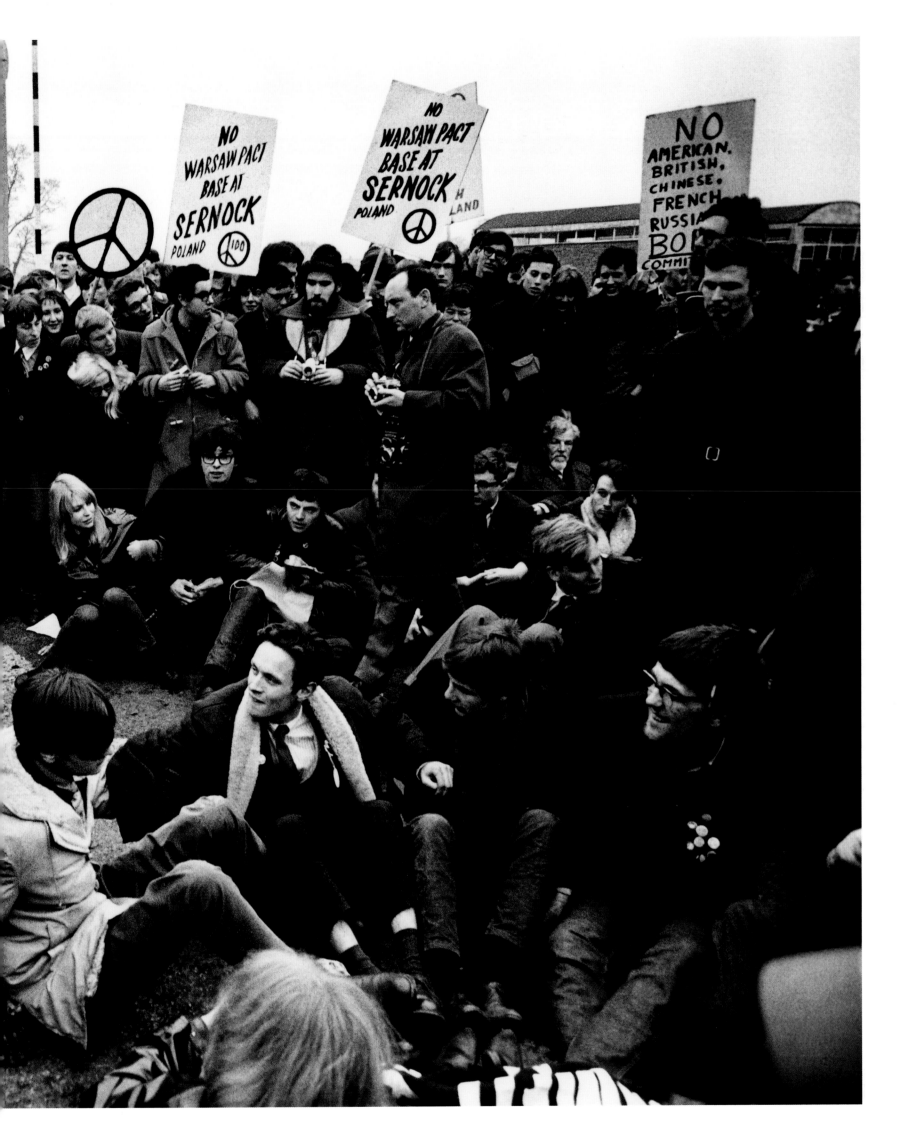

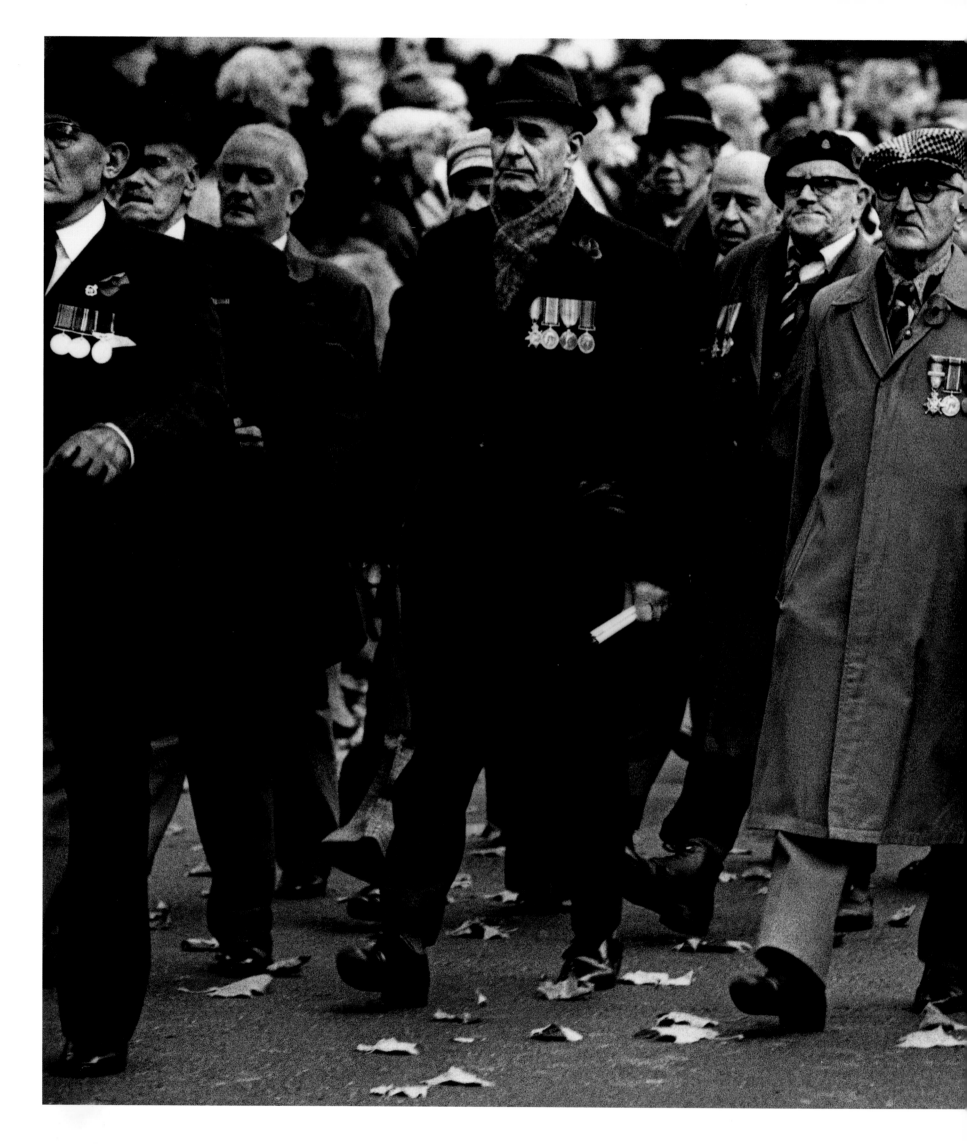

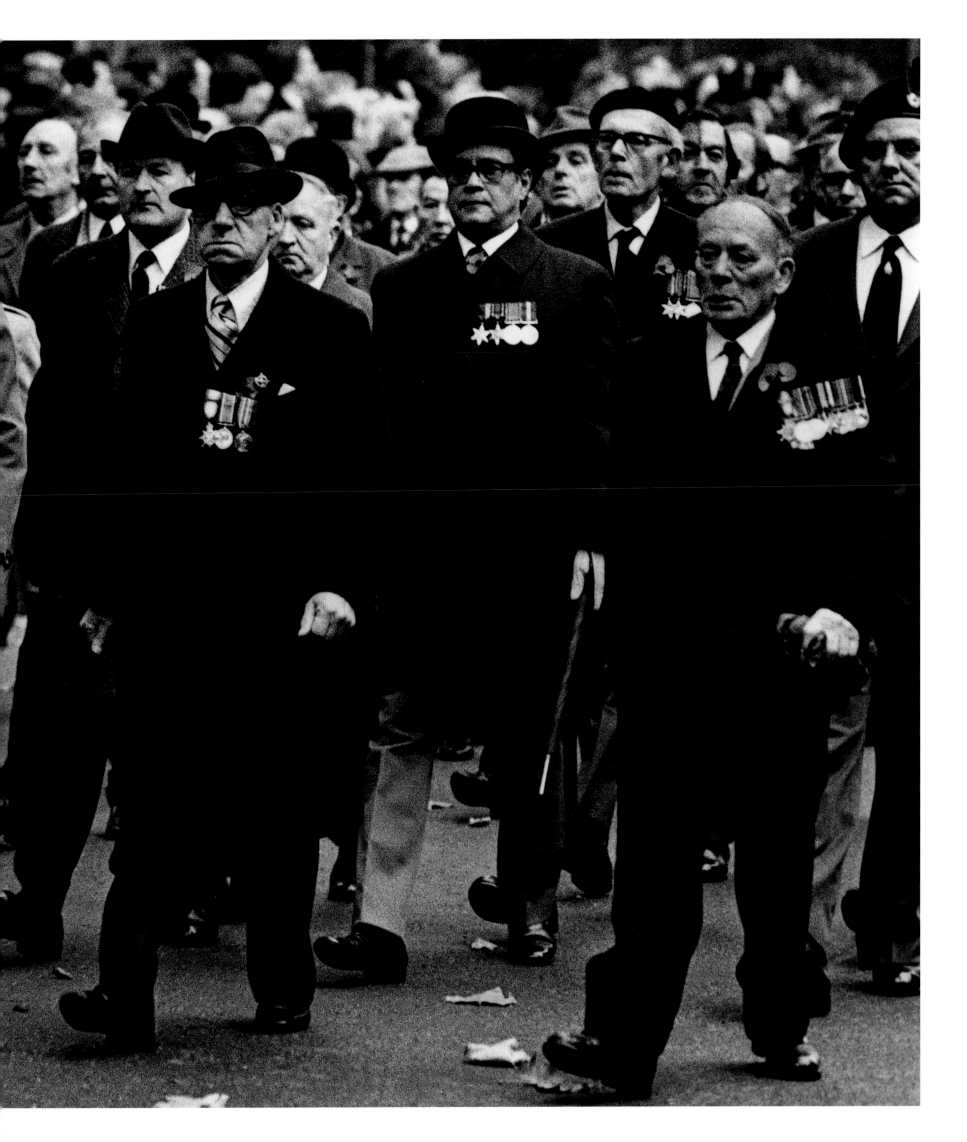

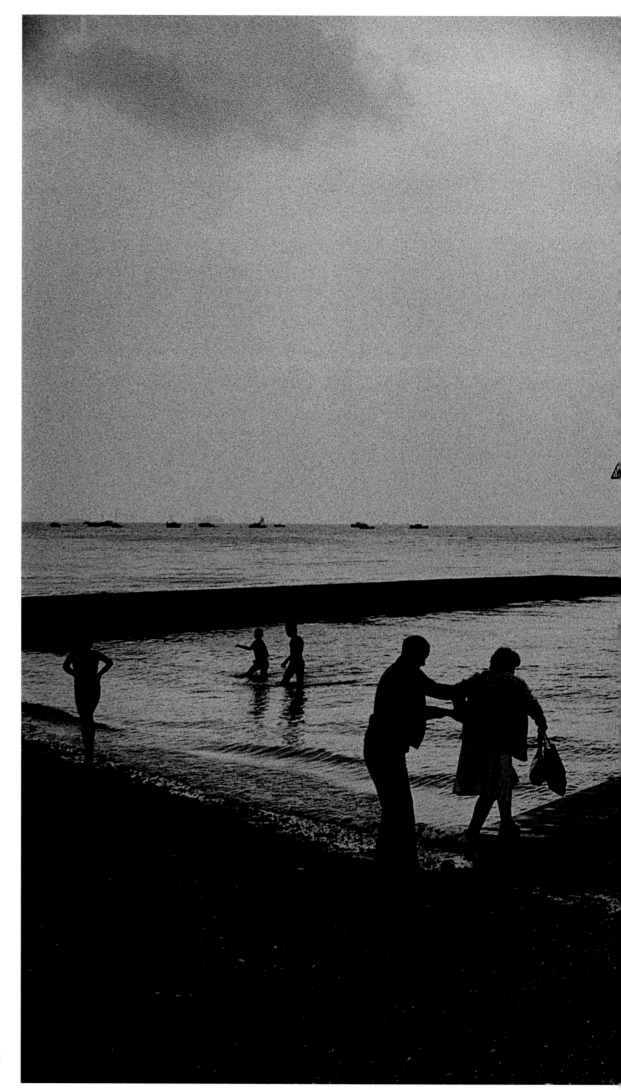

Southend, early 1960s

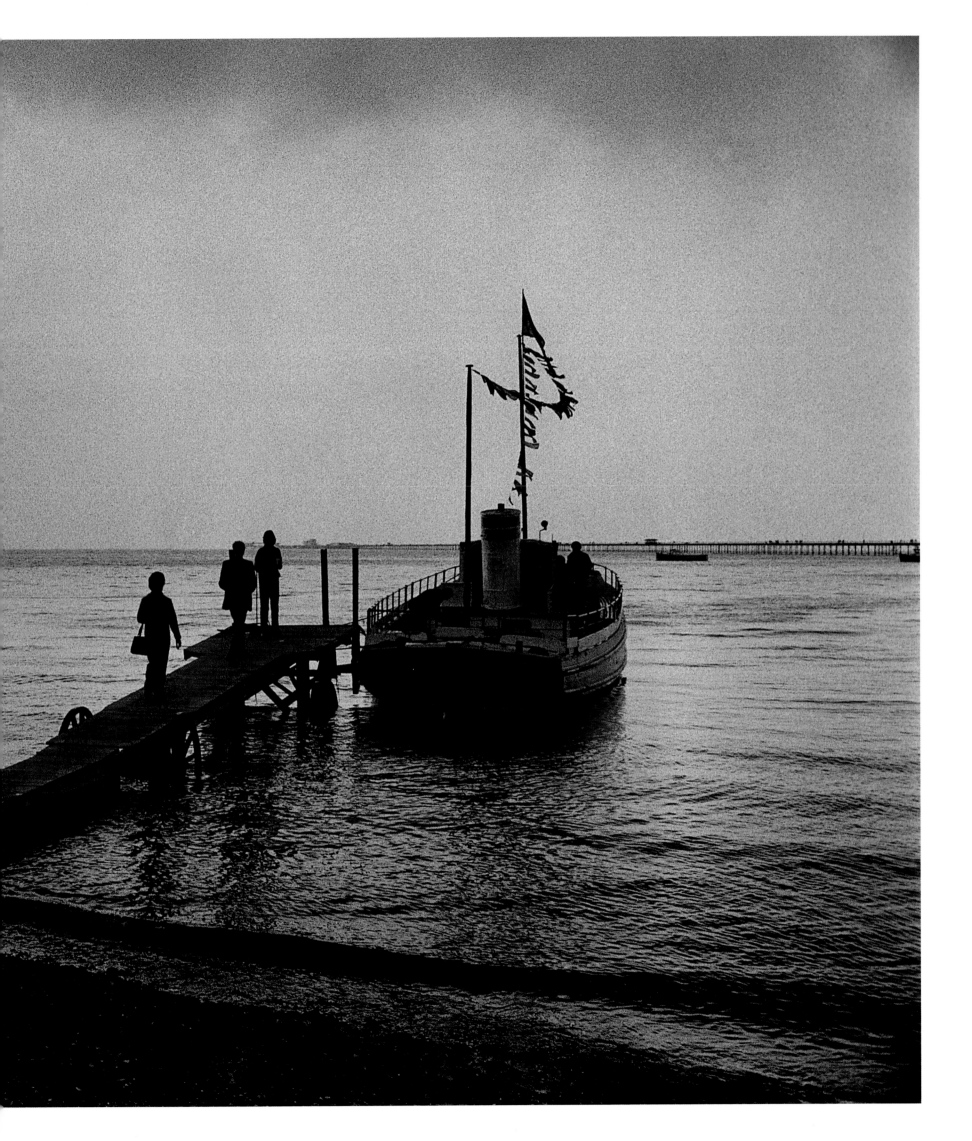

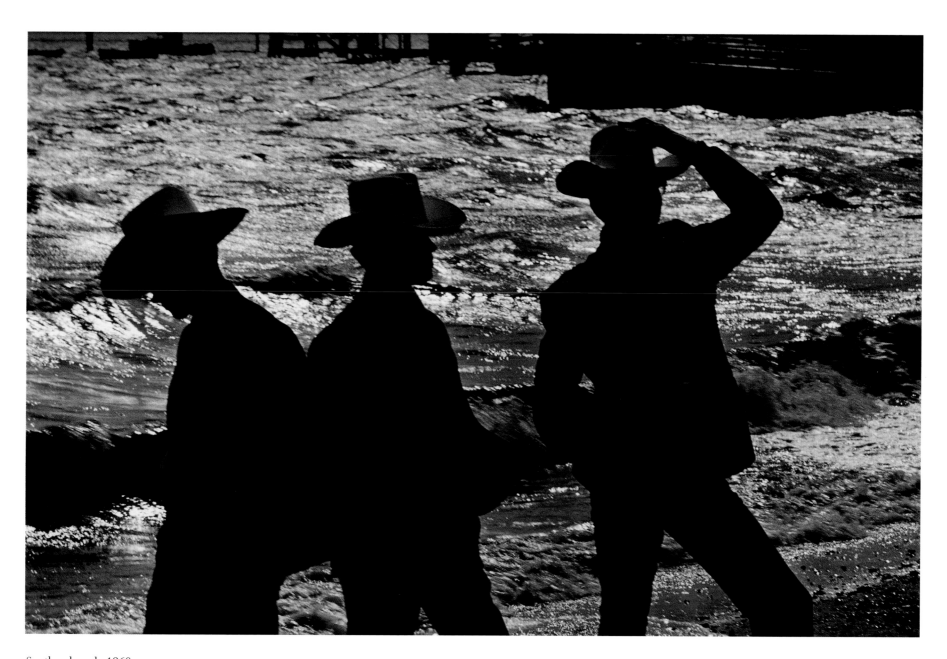

Southend, early 1960s

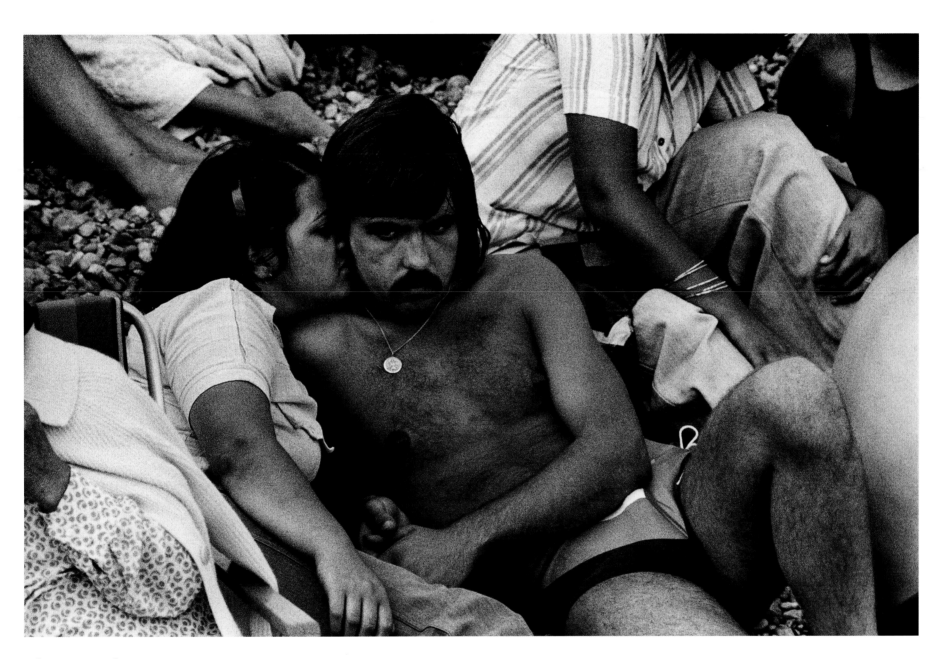

Selsey, Sussex, early 1970s

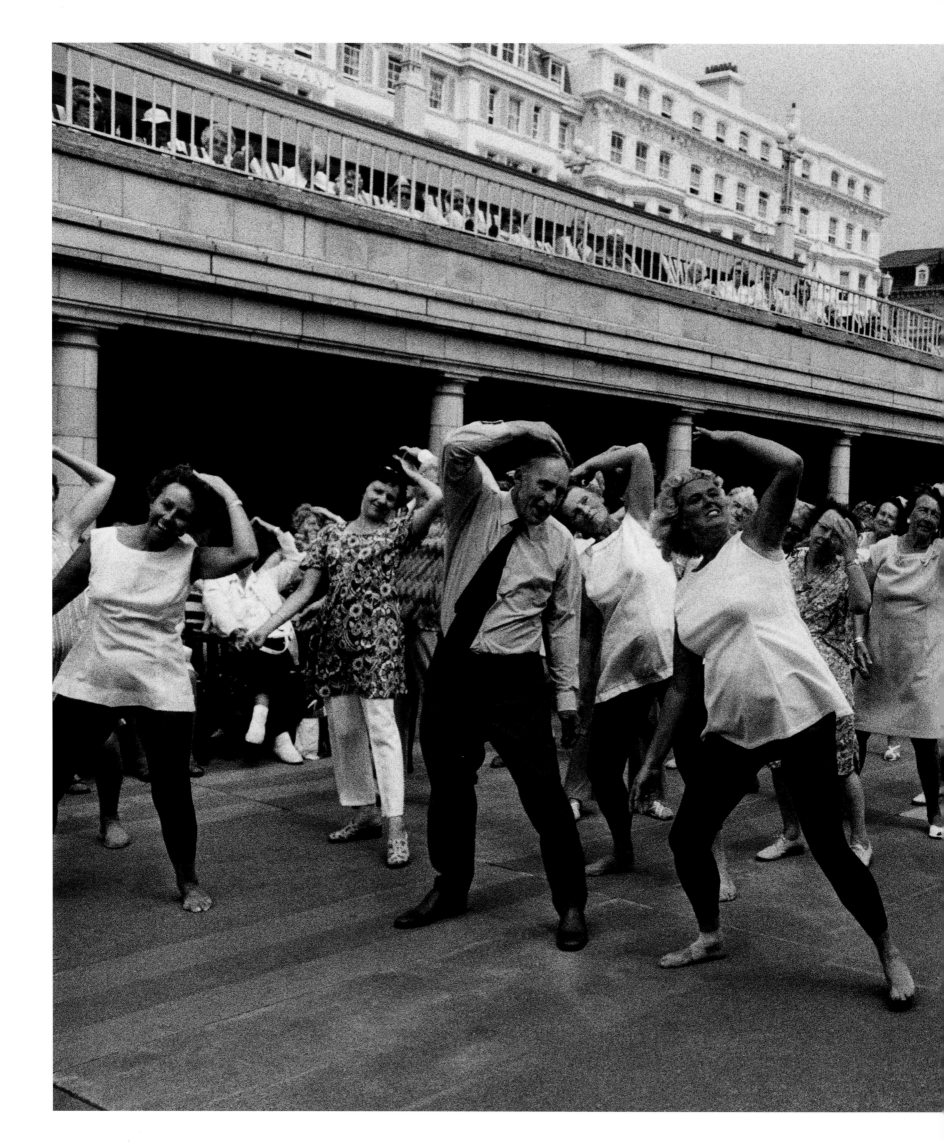

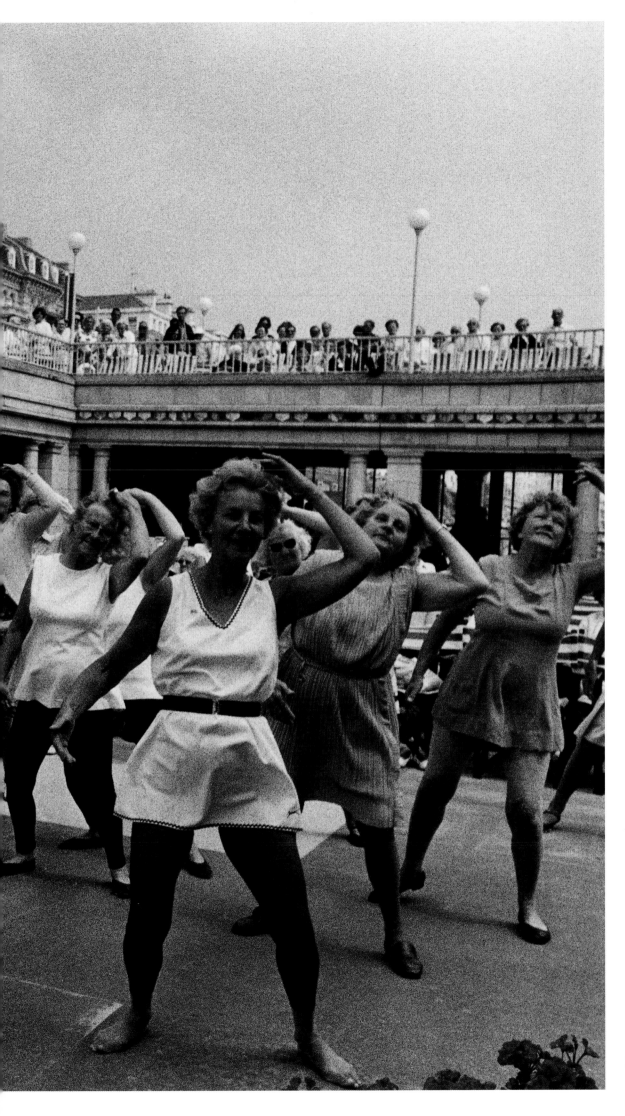

Eastbourne, Sussex, 1970s

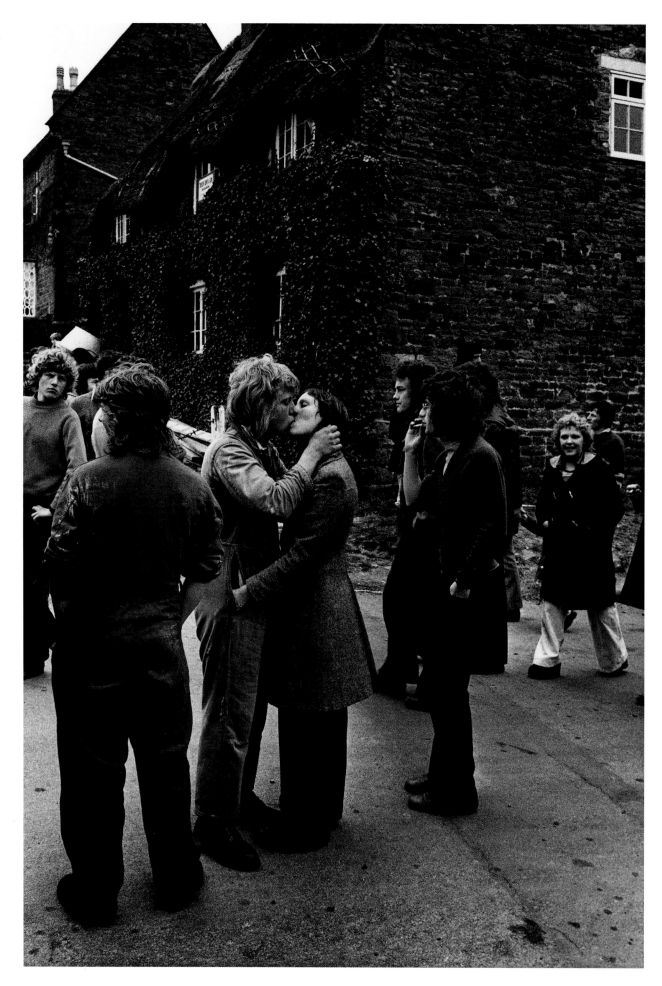

Hallaton, Leicestershire, 1970s

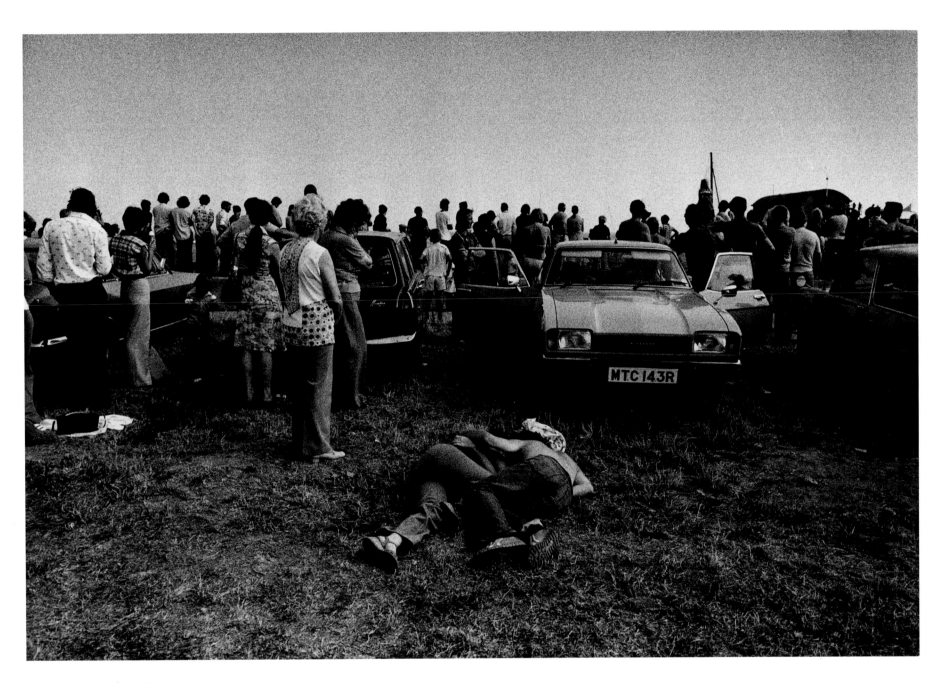

Selsey, Sussex, early 1970s

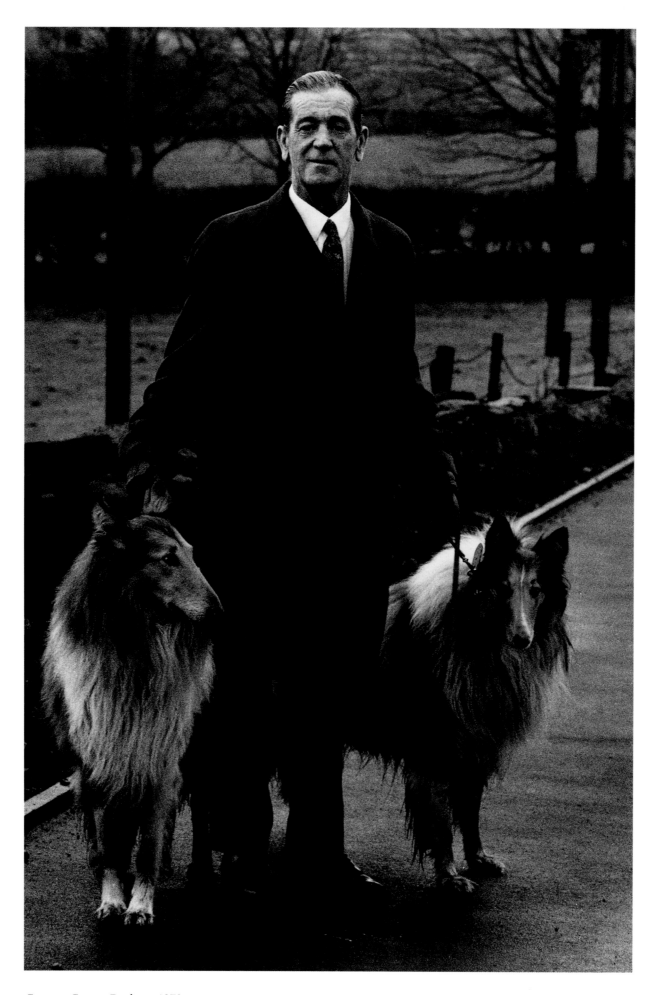

Consett, County Durham, 1970s

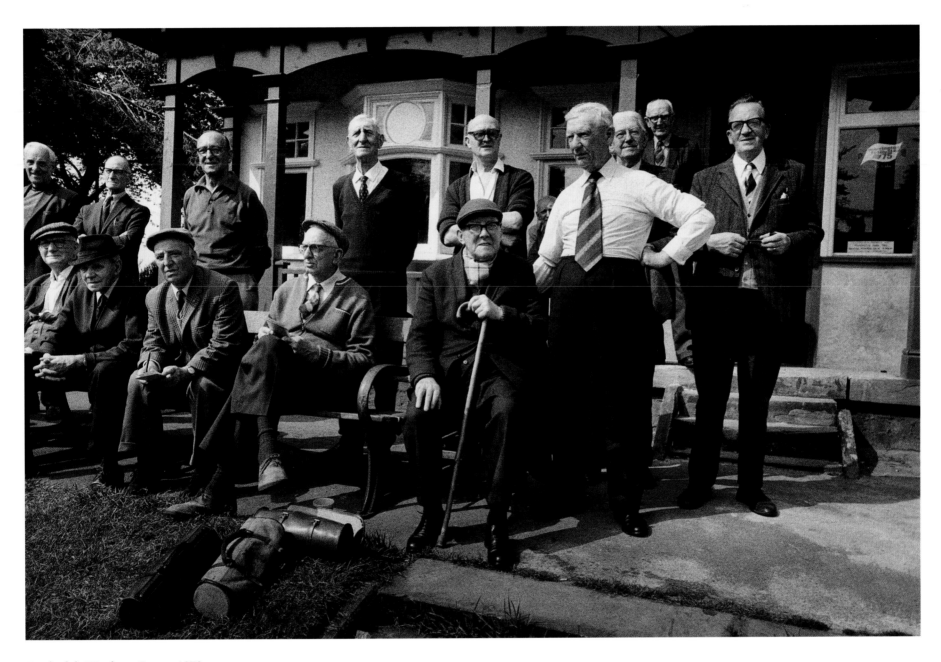

Bowls club, Worthing, Sussex, 1970s

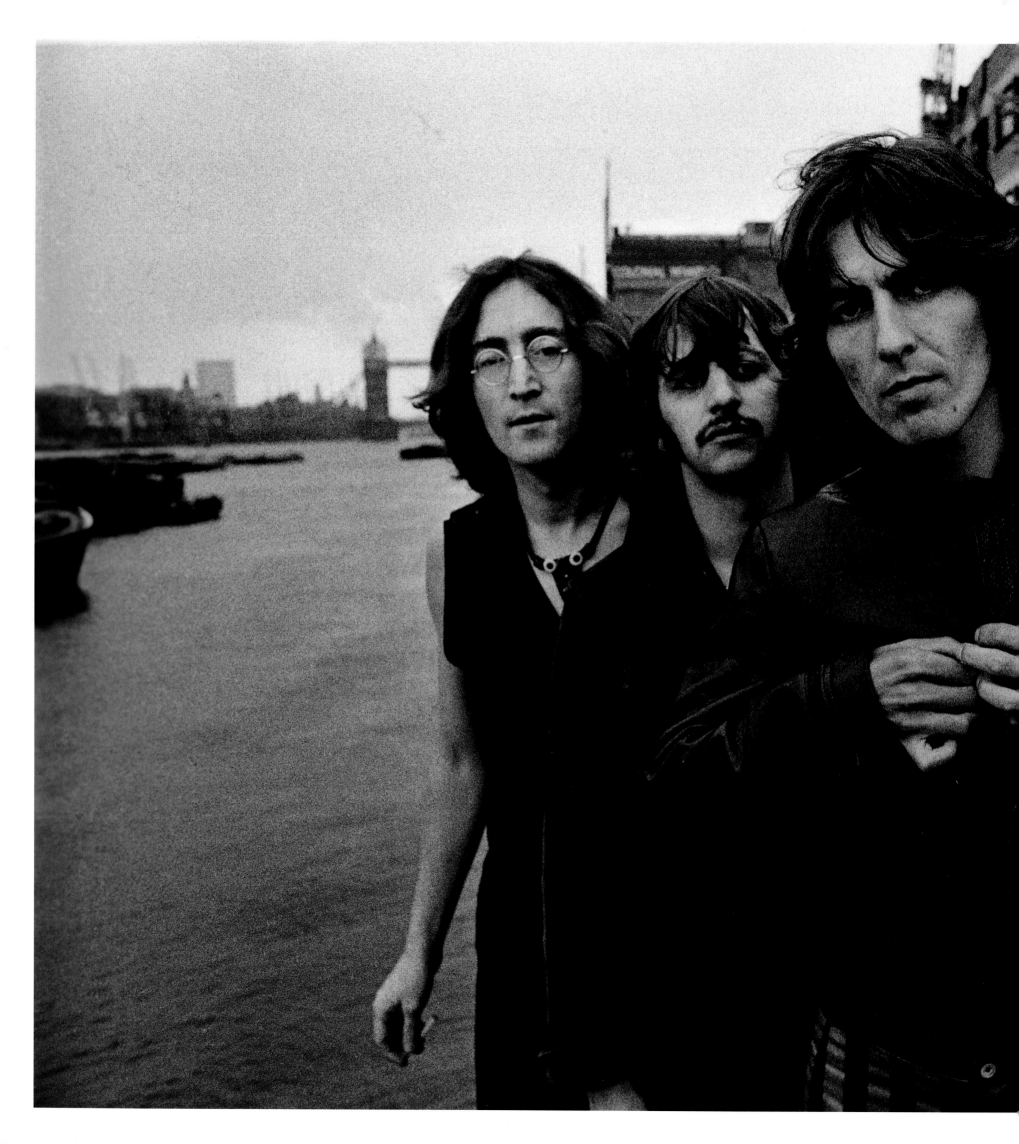

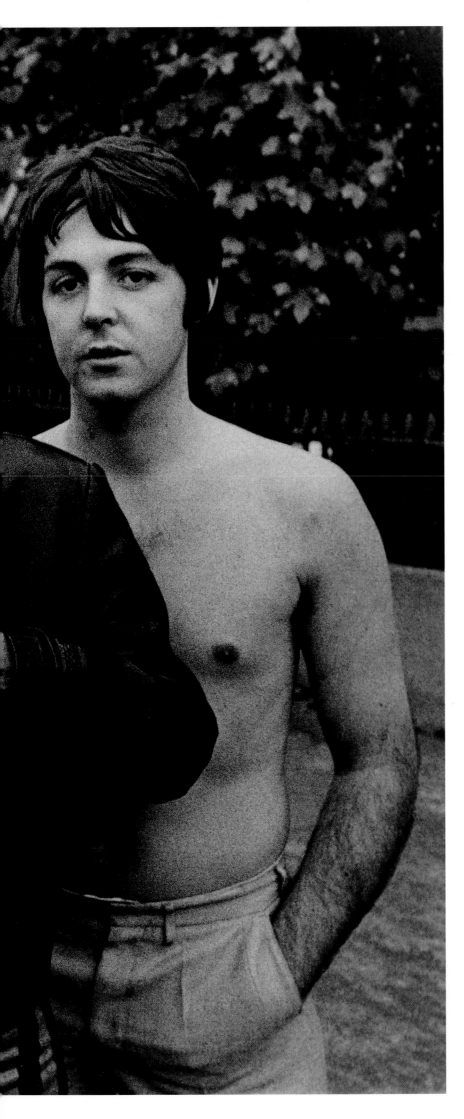

The Beatles, Limehouse, London, 1968

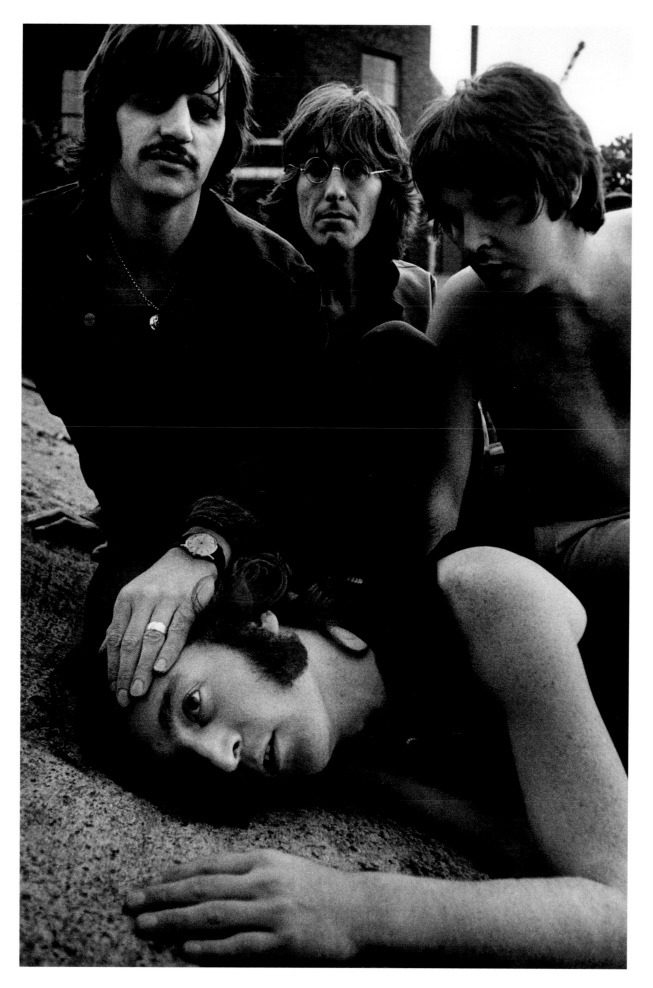

The Beatles, Limehouse, London, 1968

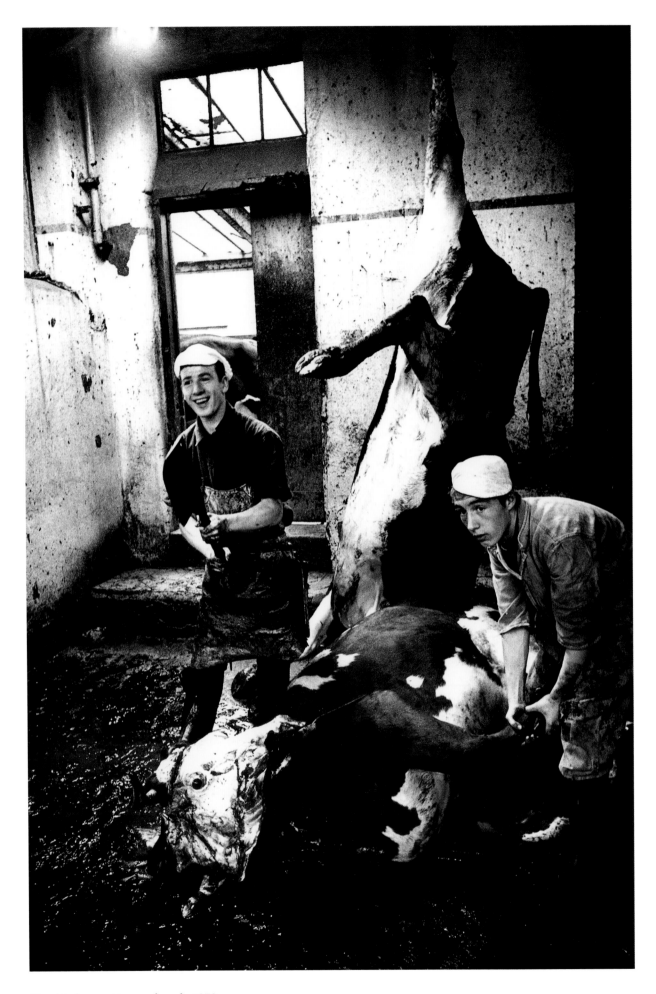

Slaughterhouse, Liverpool, early 1970s

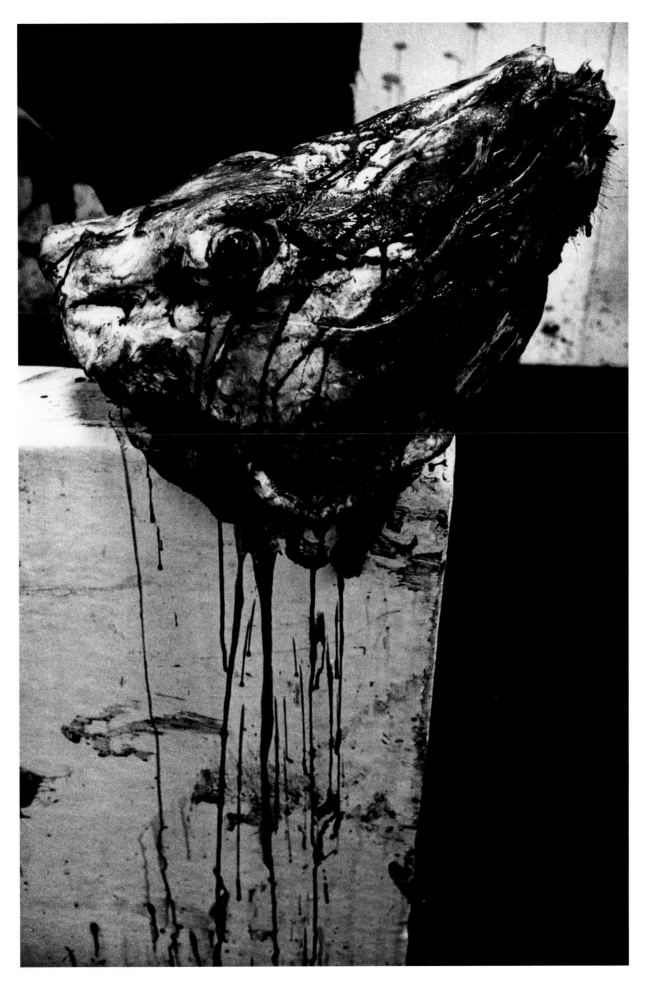

Slaughterhouse, Suffolk, late 1960s

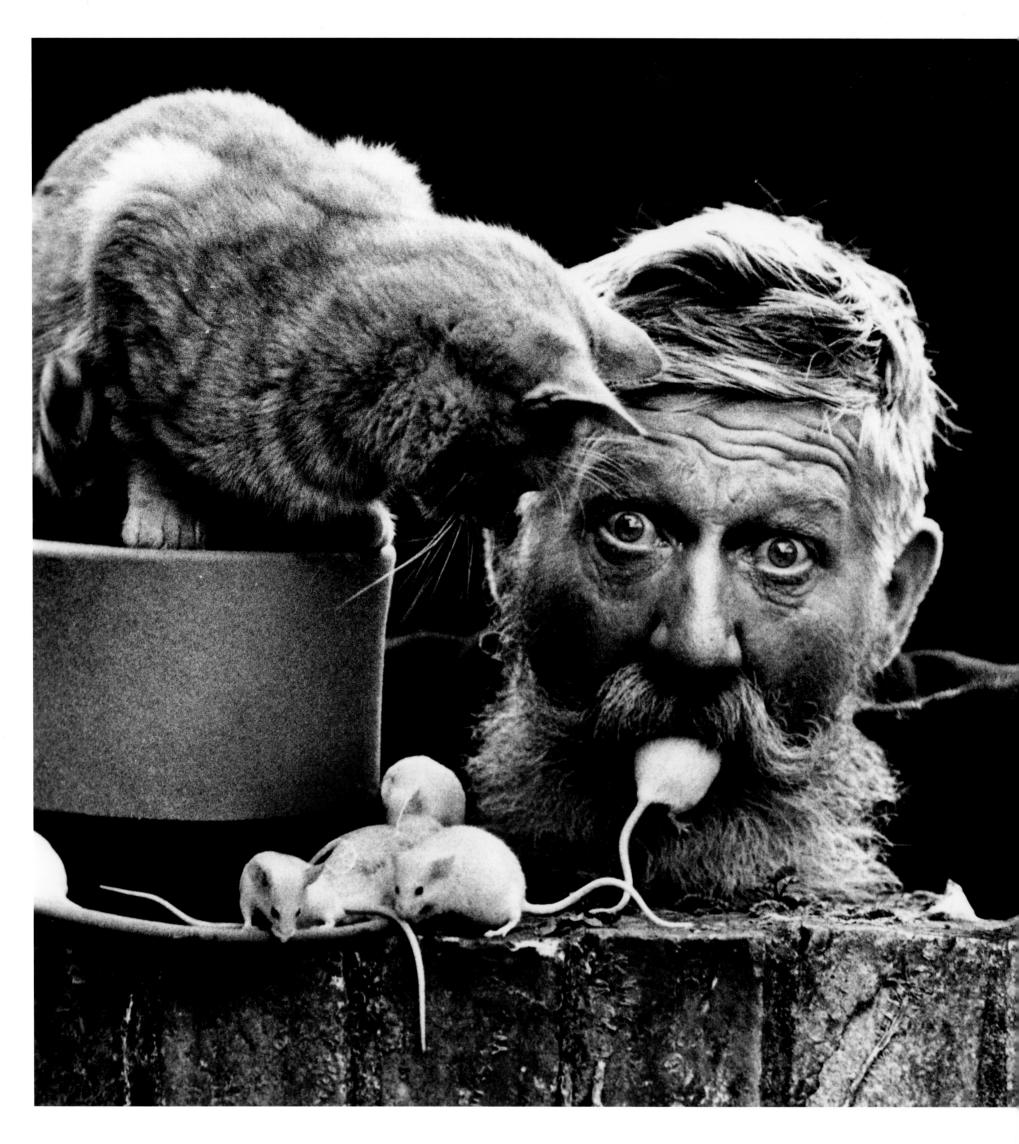

Snowy, Cambridge, early1970s

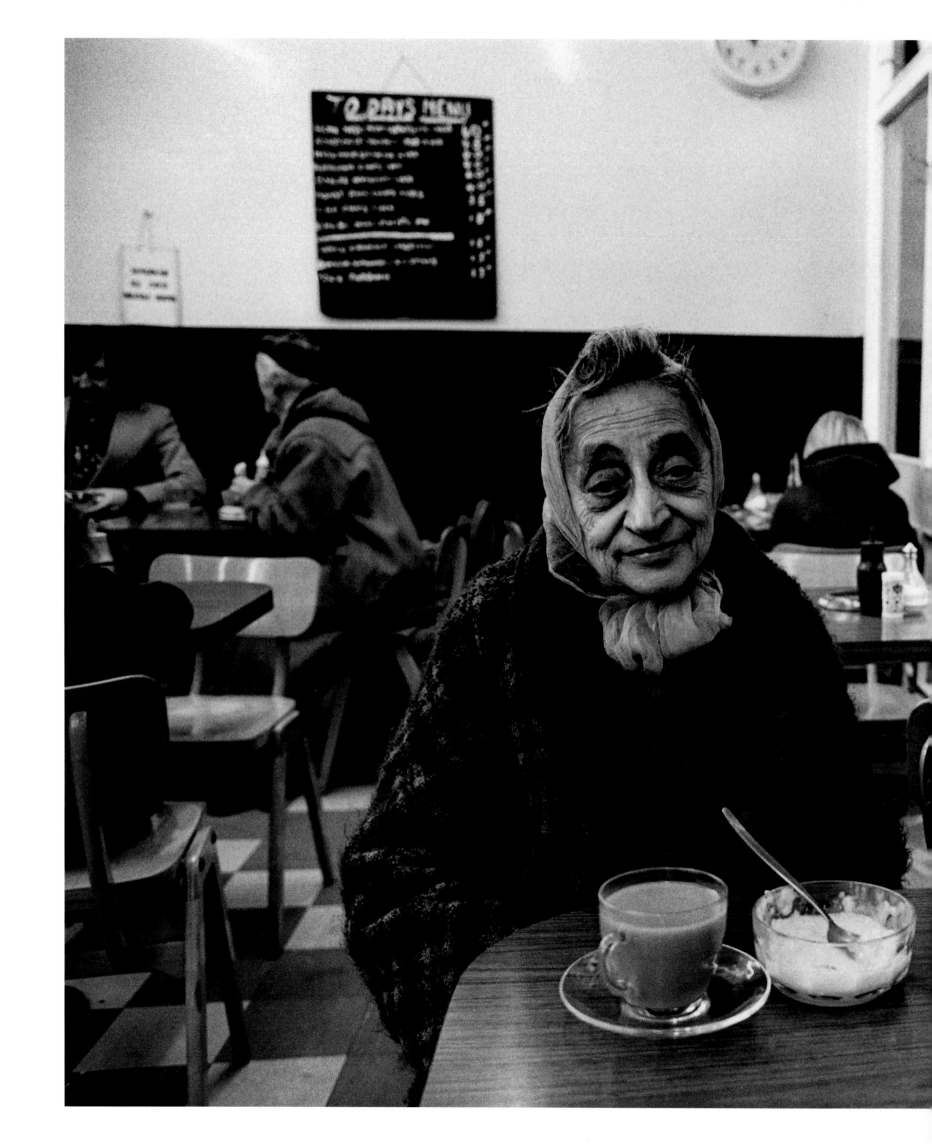

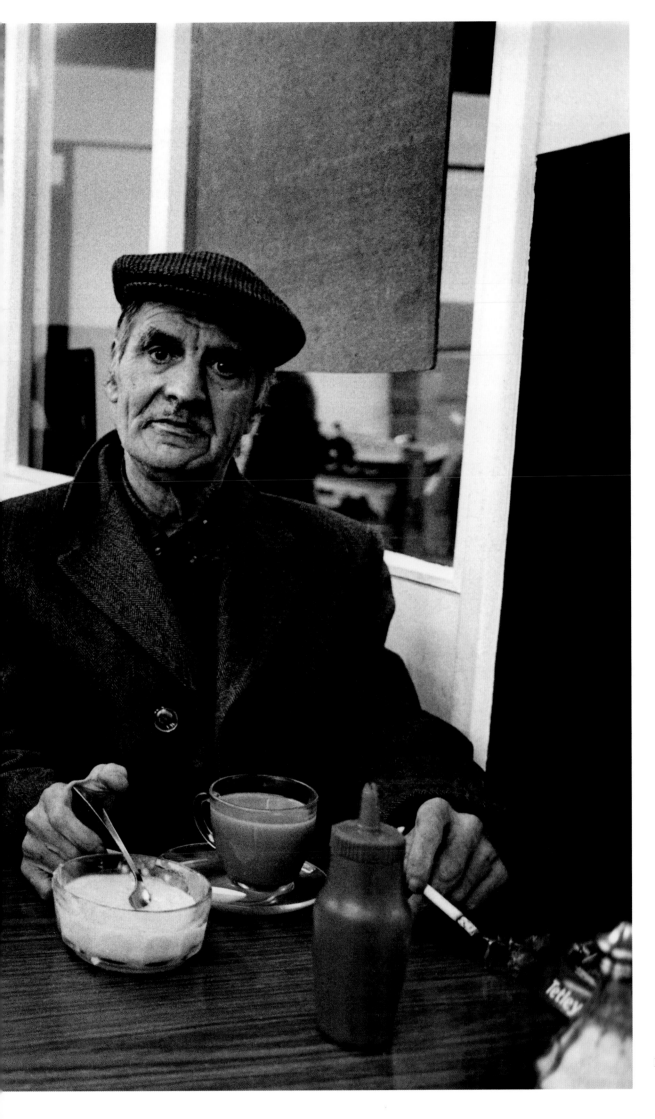

Bradford, early 1970s

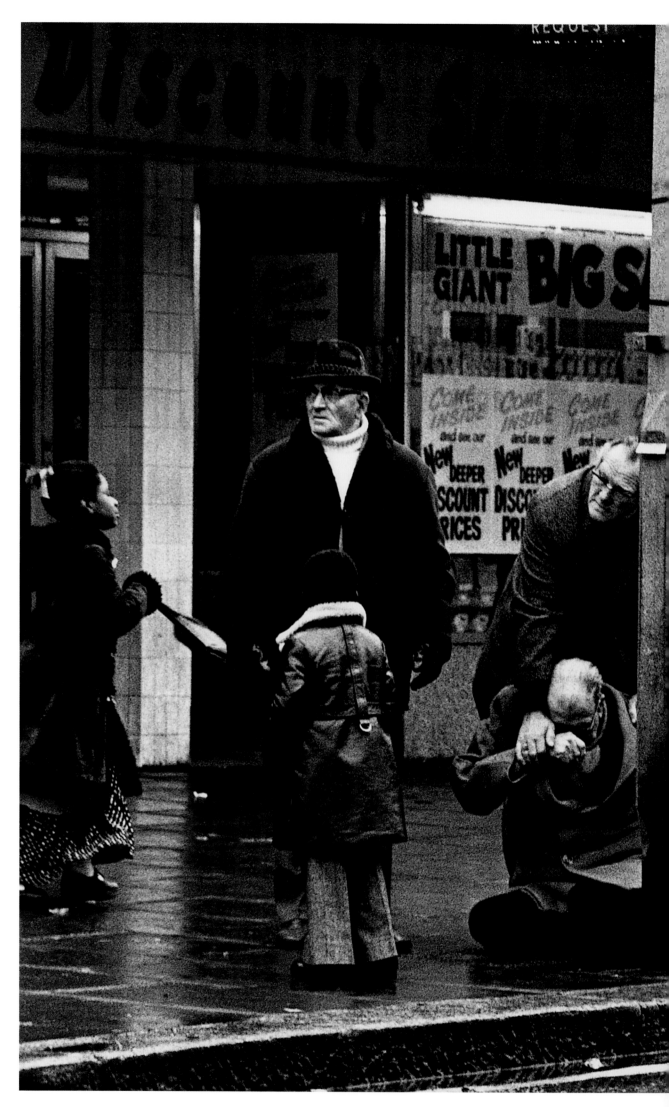

Tottenham High Street, London, early 1970s

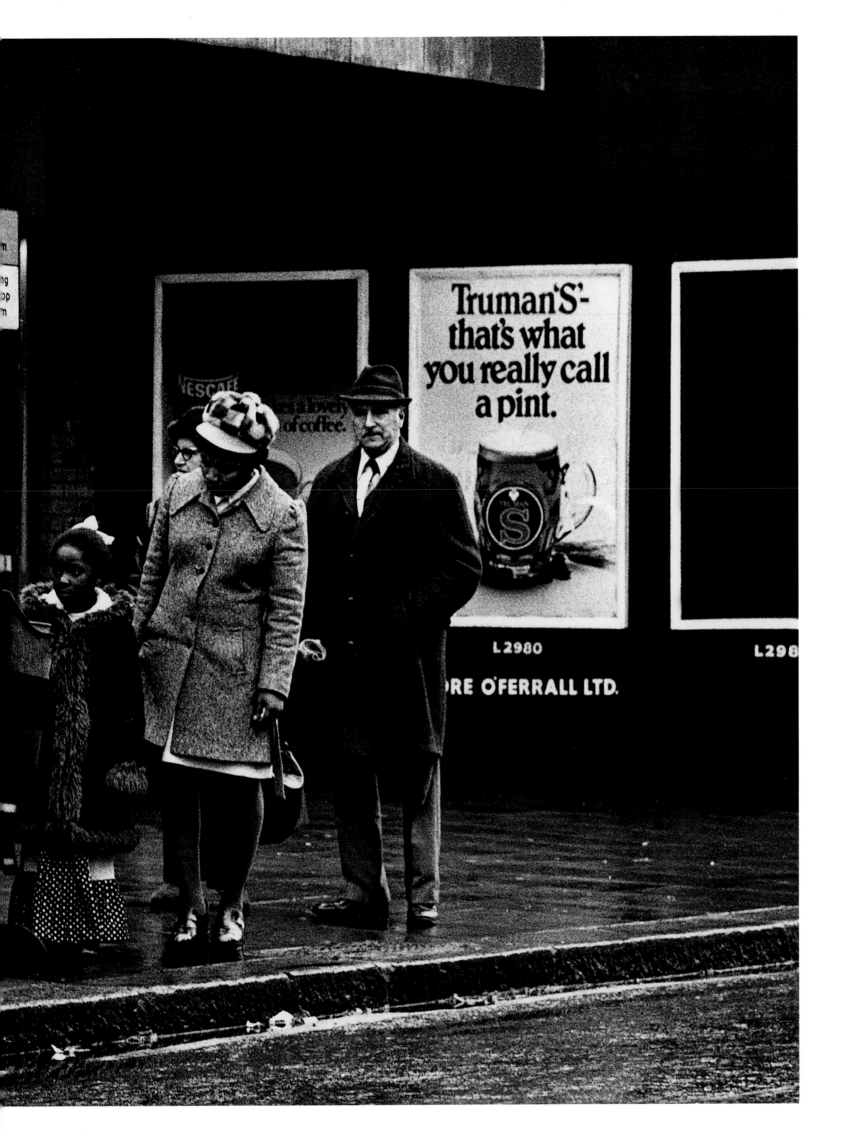

Early 1970s

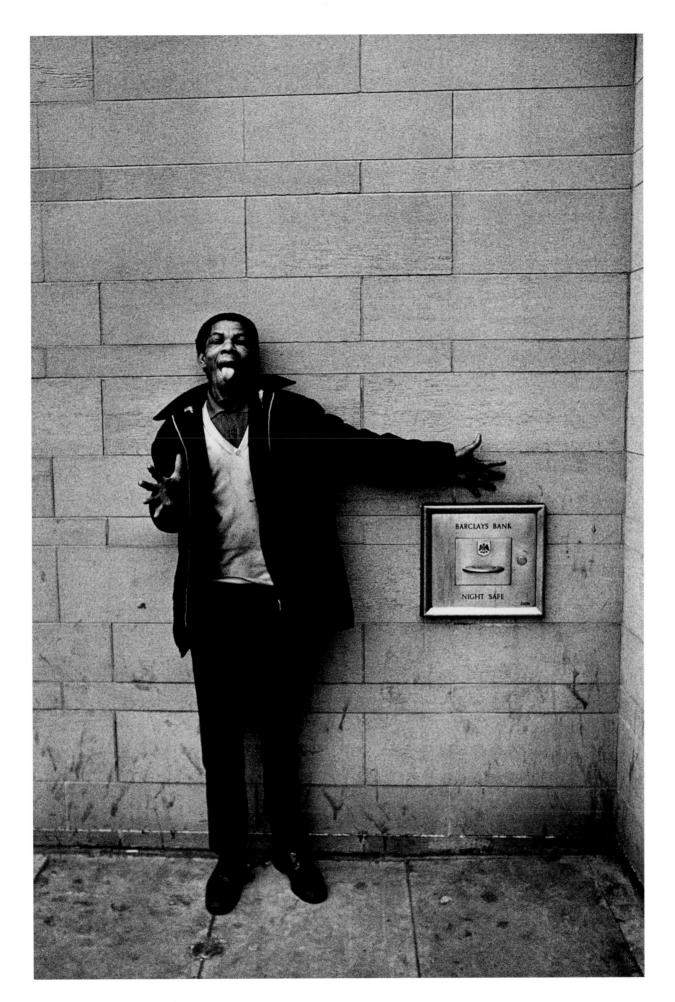

Bradford, early 1970s

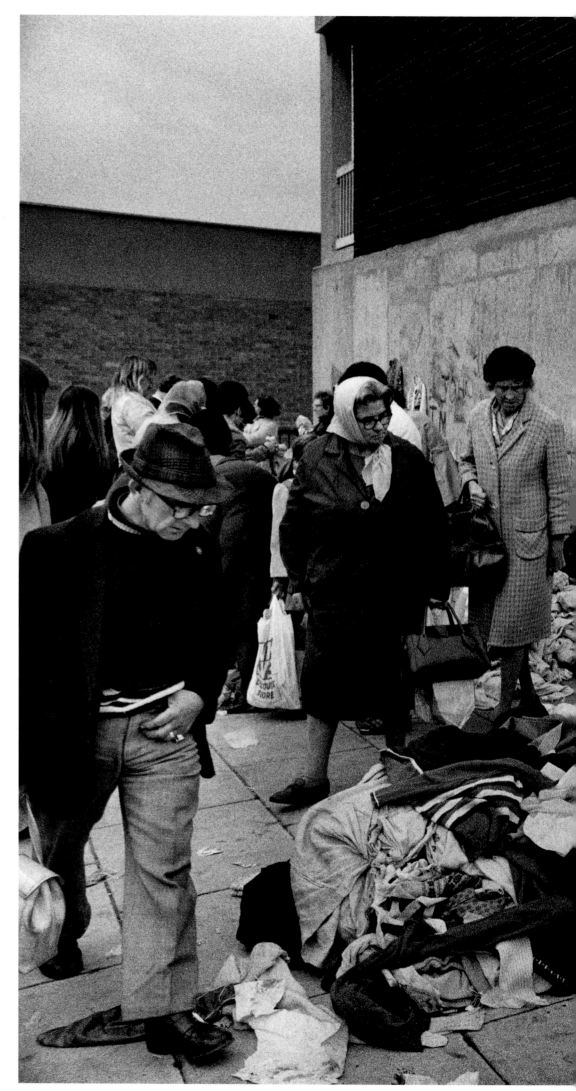

Paddy's Market, Liverpool, 1970s

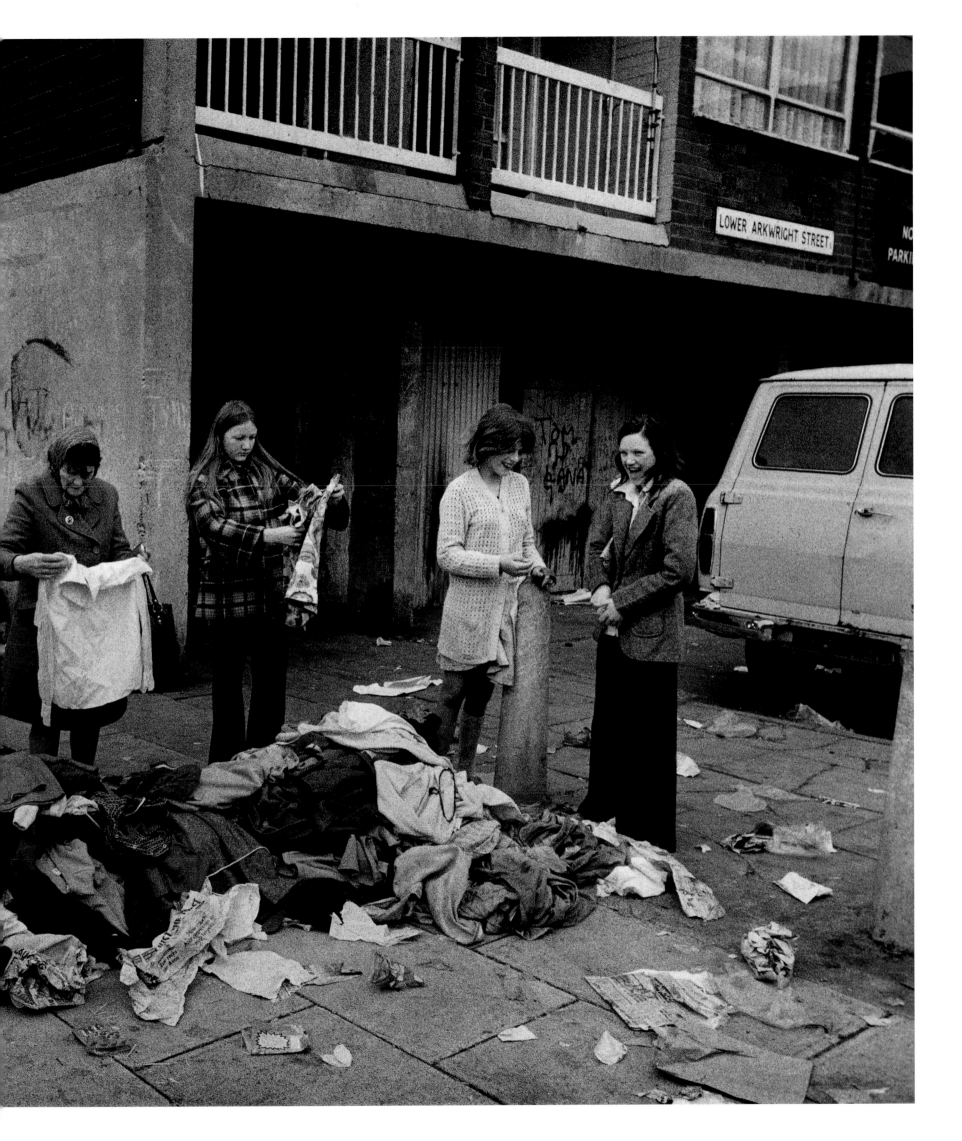

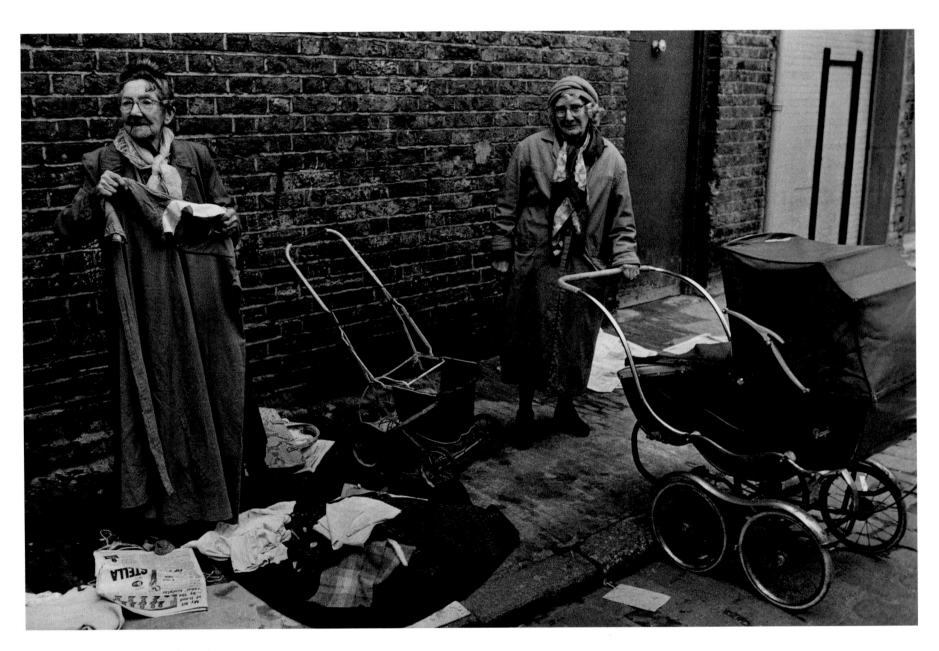

Chapel Market, Islington, London, 1961

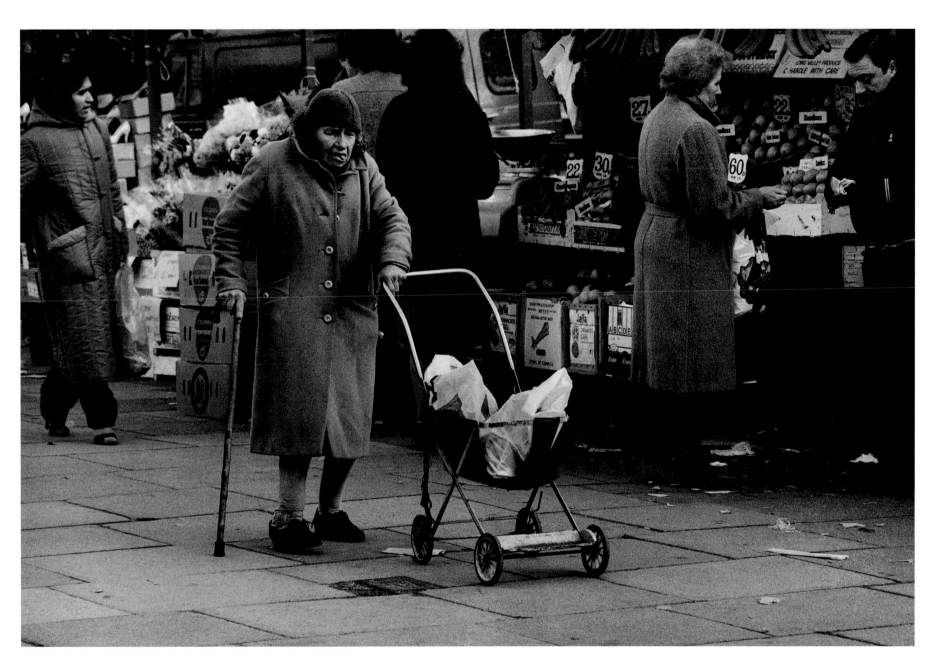

Whitechapel High Street, London, early 1970s

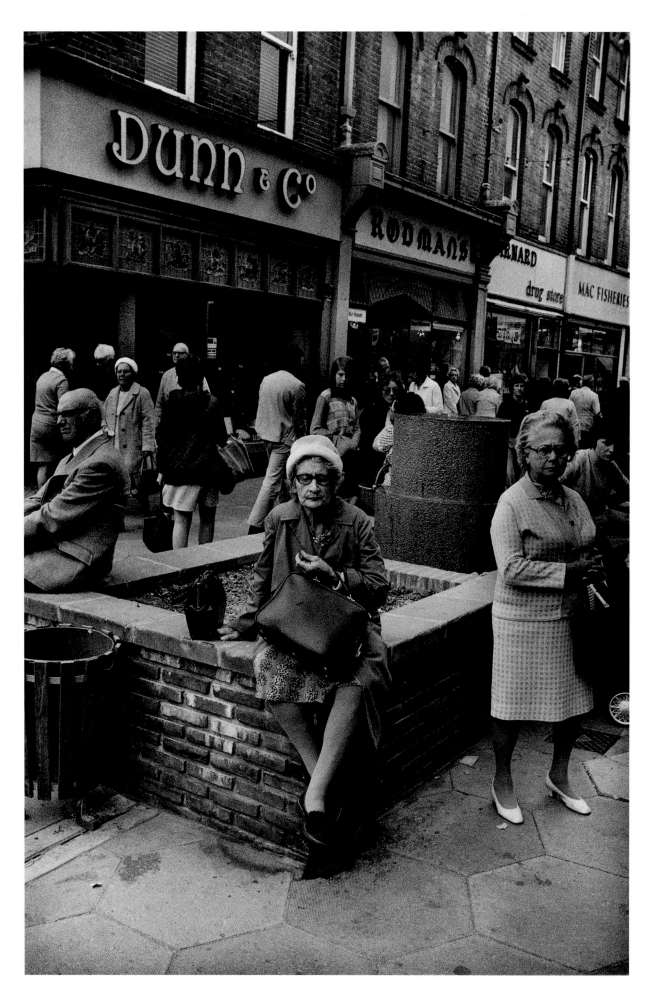

Worthing, Sussex, 1970s

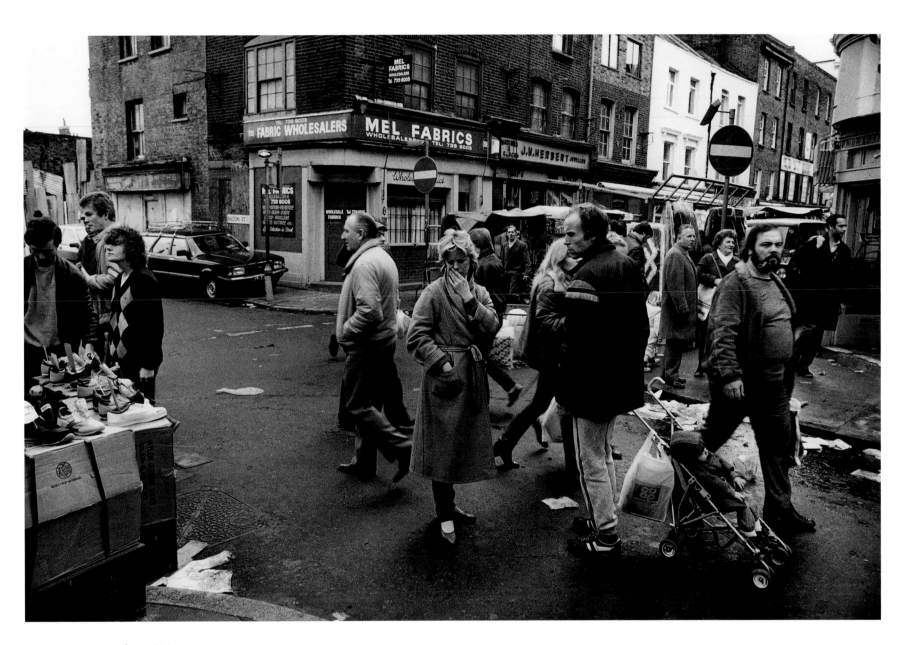

Petticoat Lane, London, 1970s

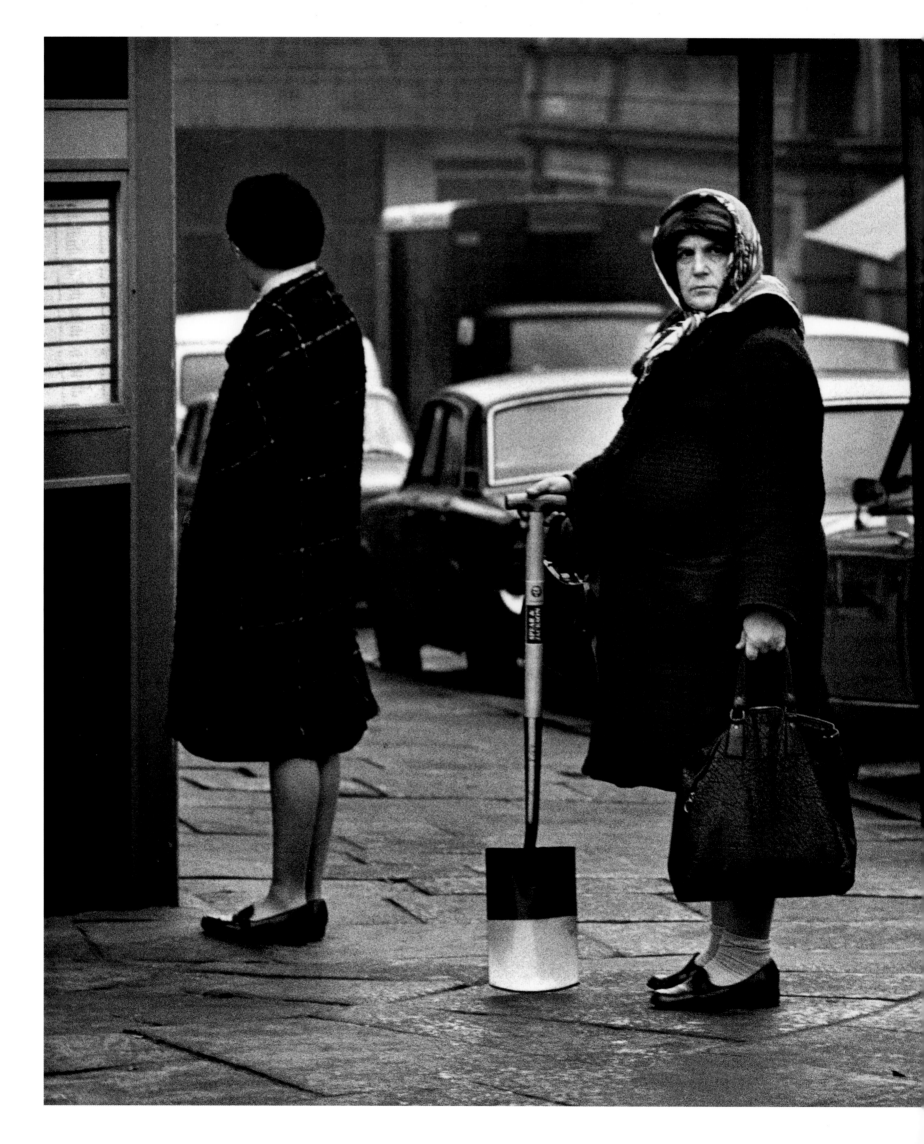

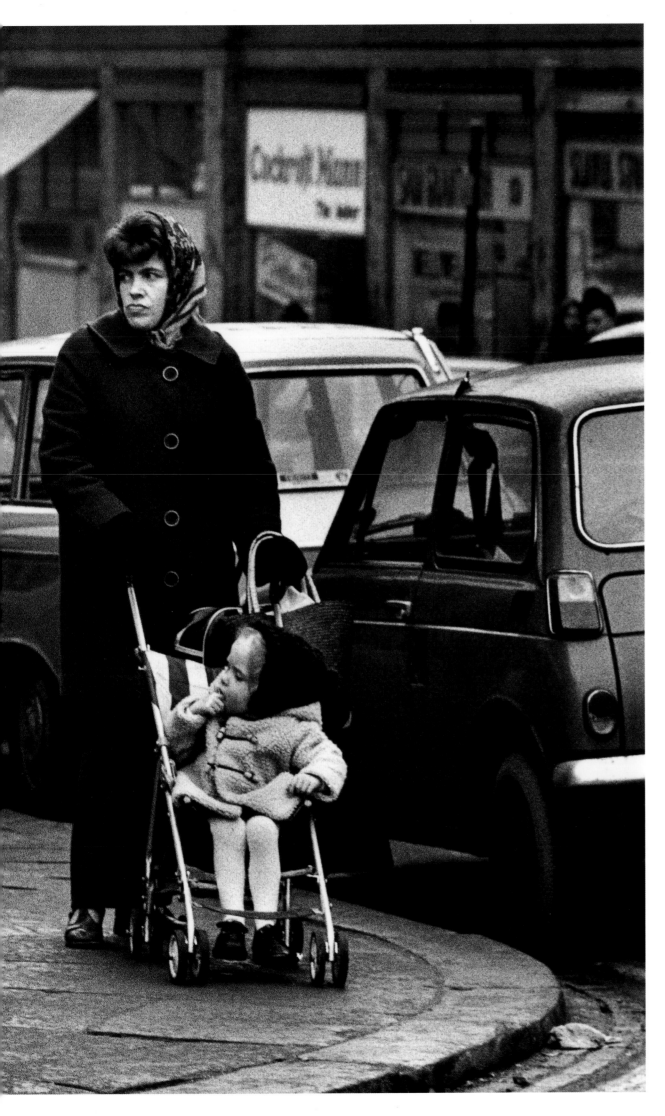

Bradford, 1970s

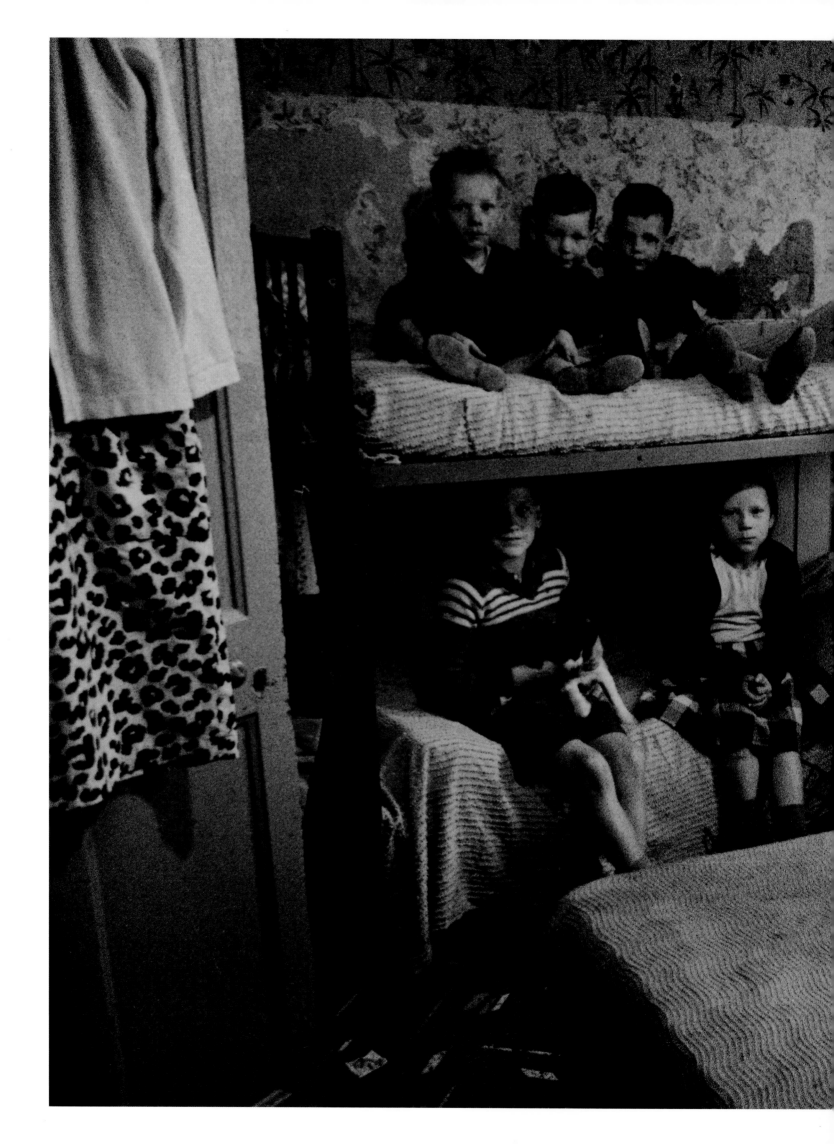

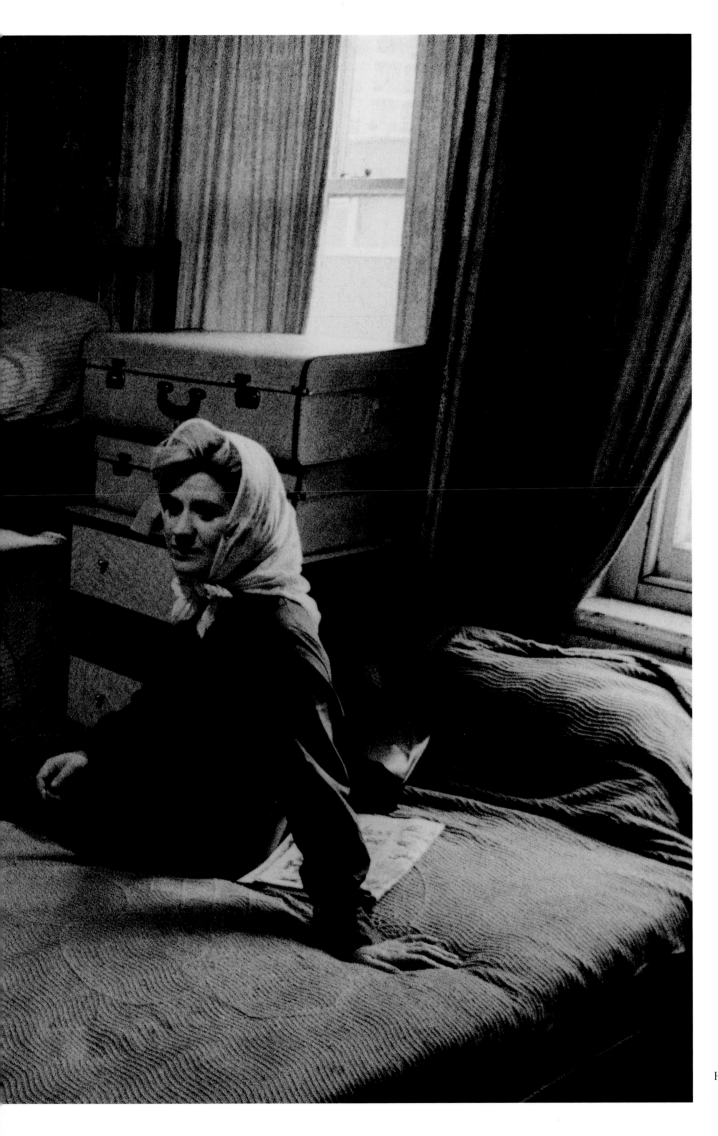

Homeless family, Whitechapel, 1961

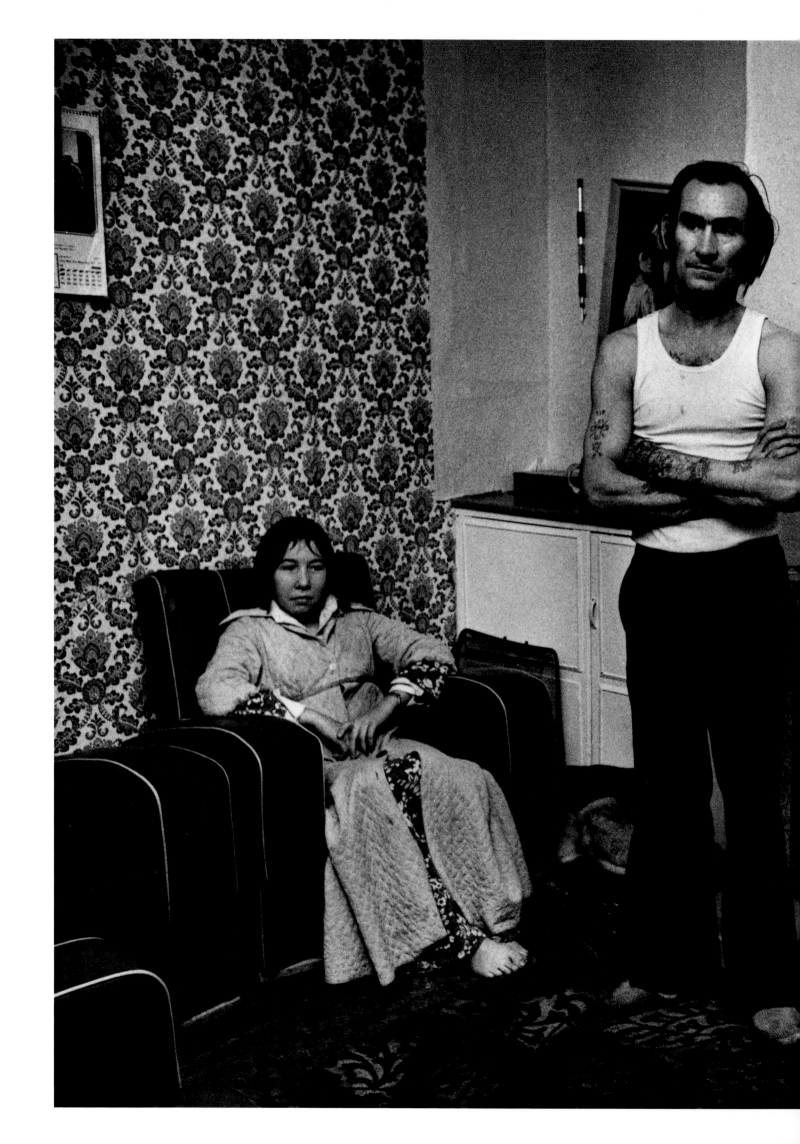

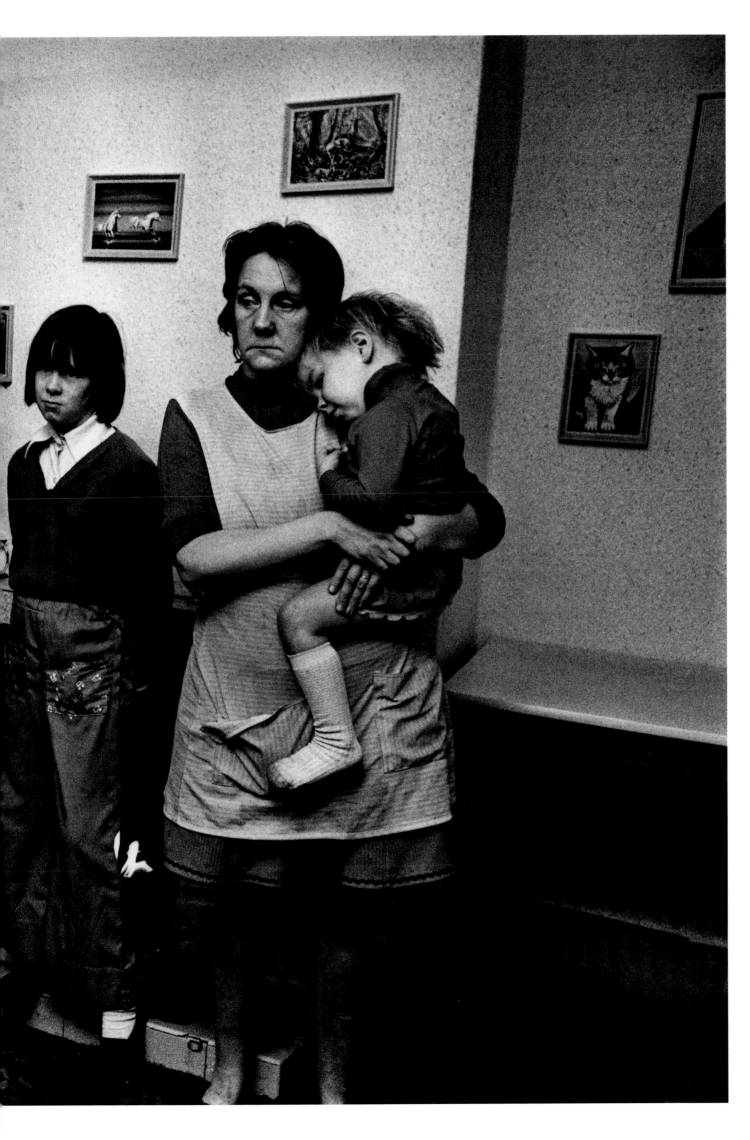

Bradford, early 1970s

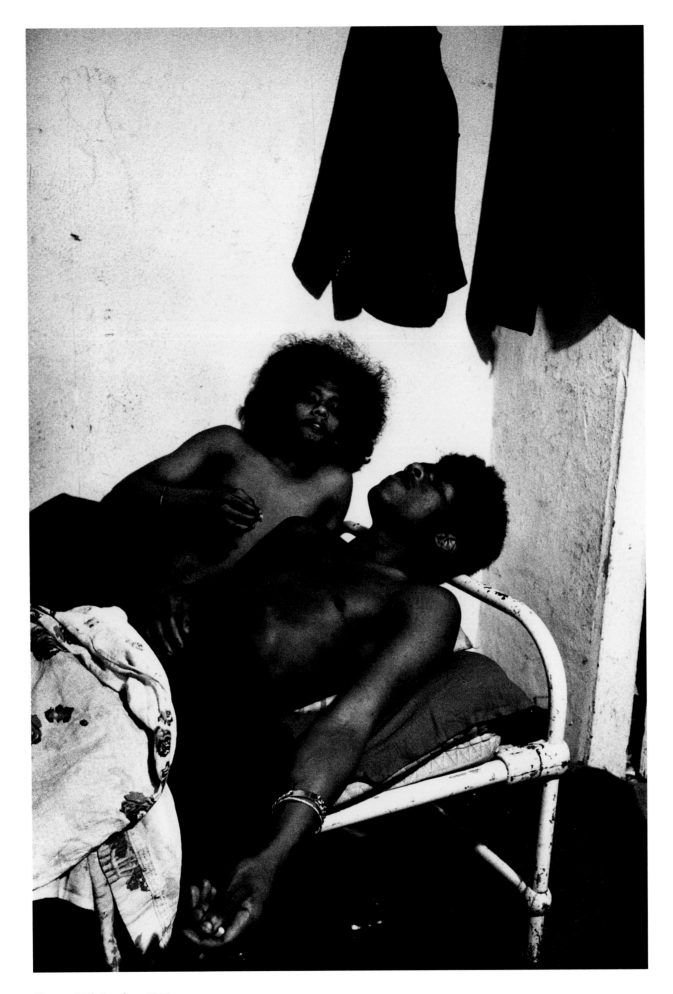

Notting Hill, London, 1982

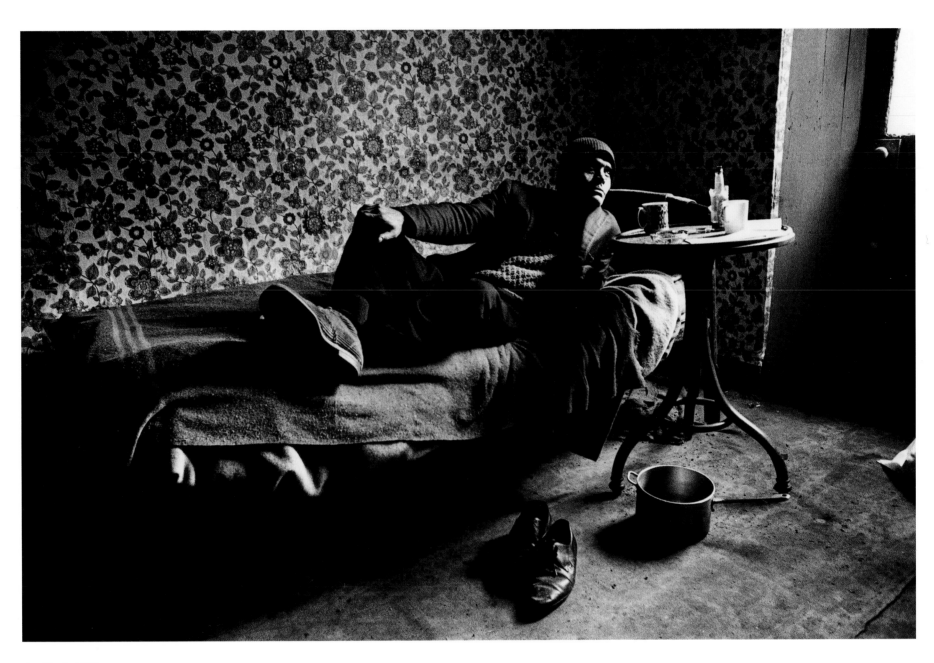

Bradford, 1978

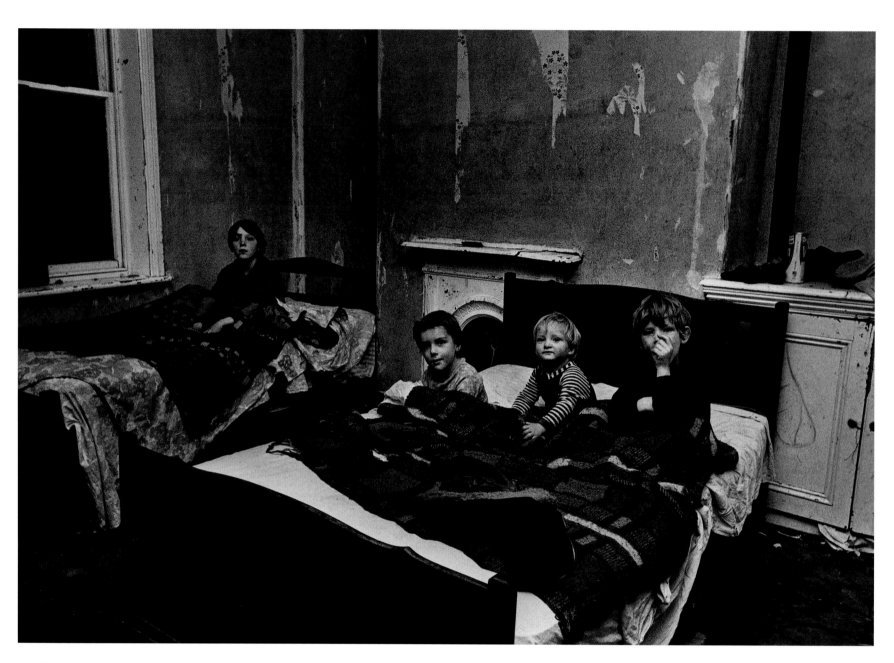

Bradford, 1978

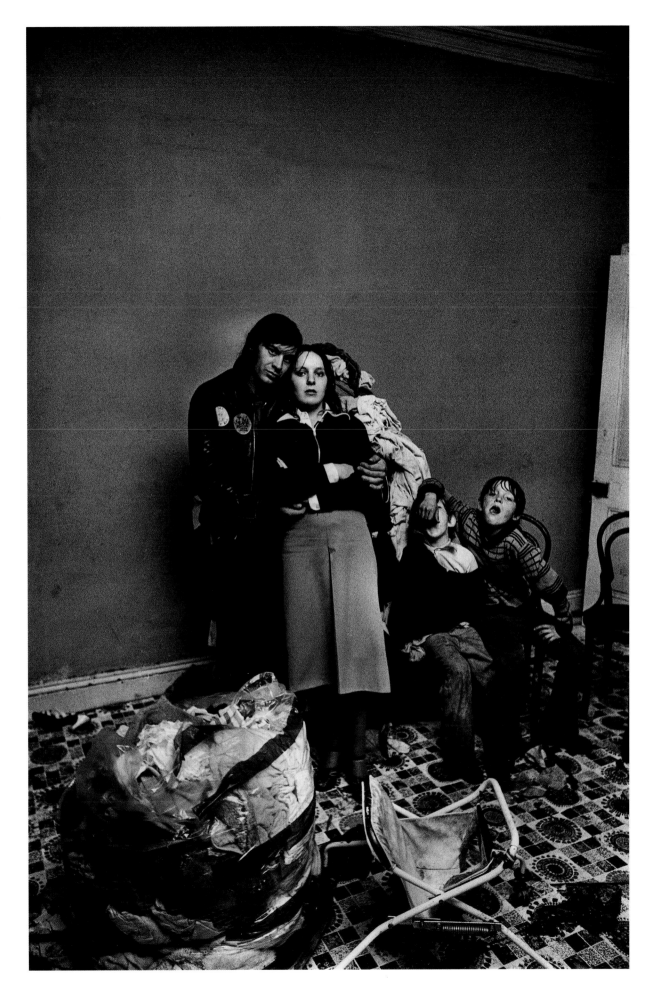

Bradford, 1978

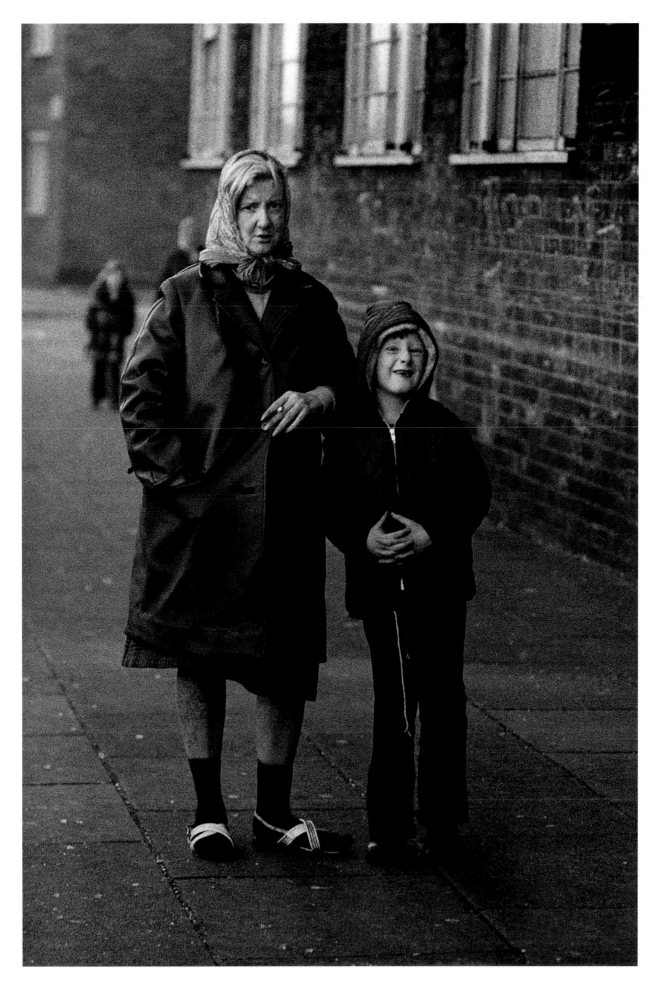

Liverpool 8, early 1970s

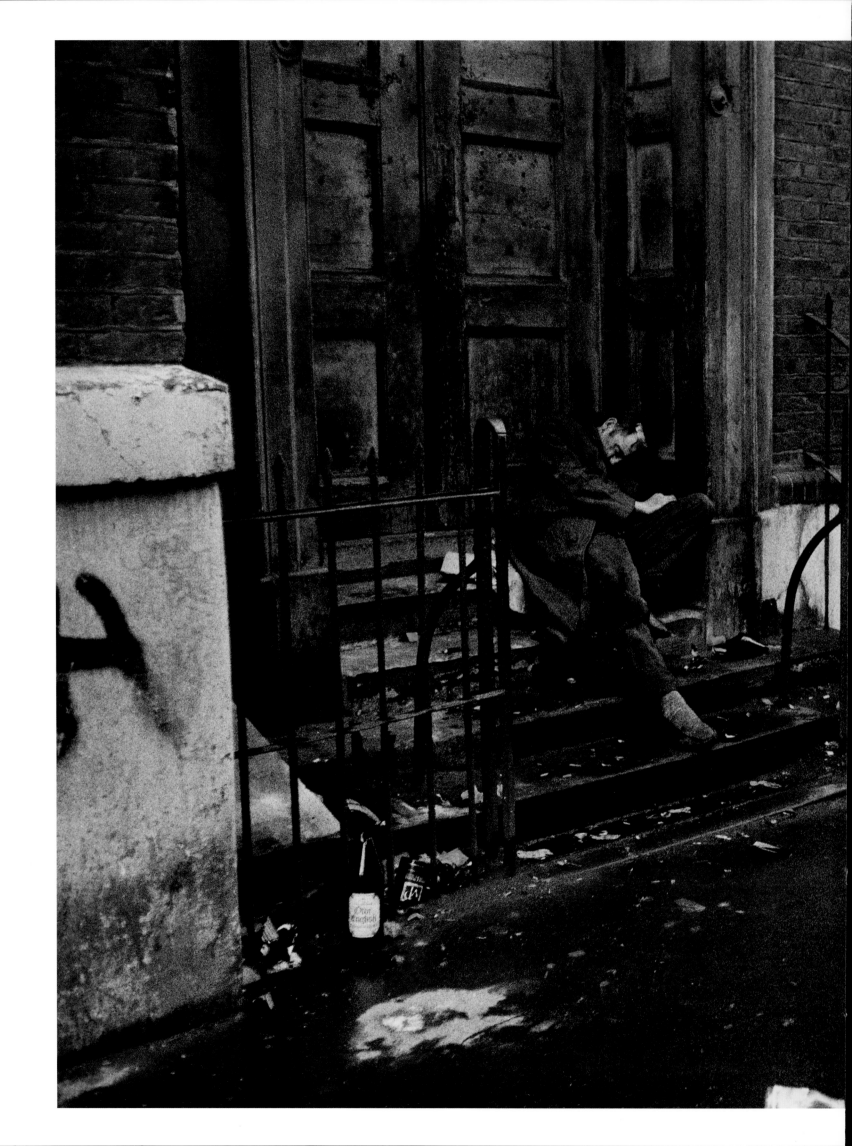

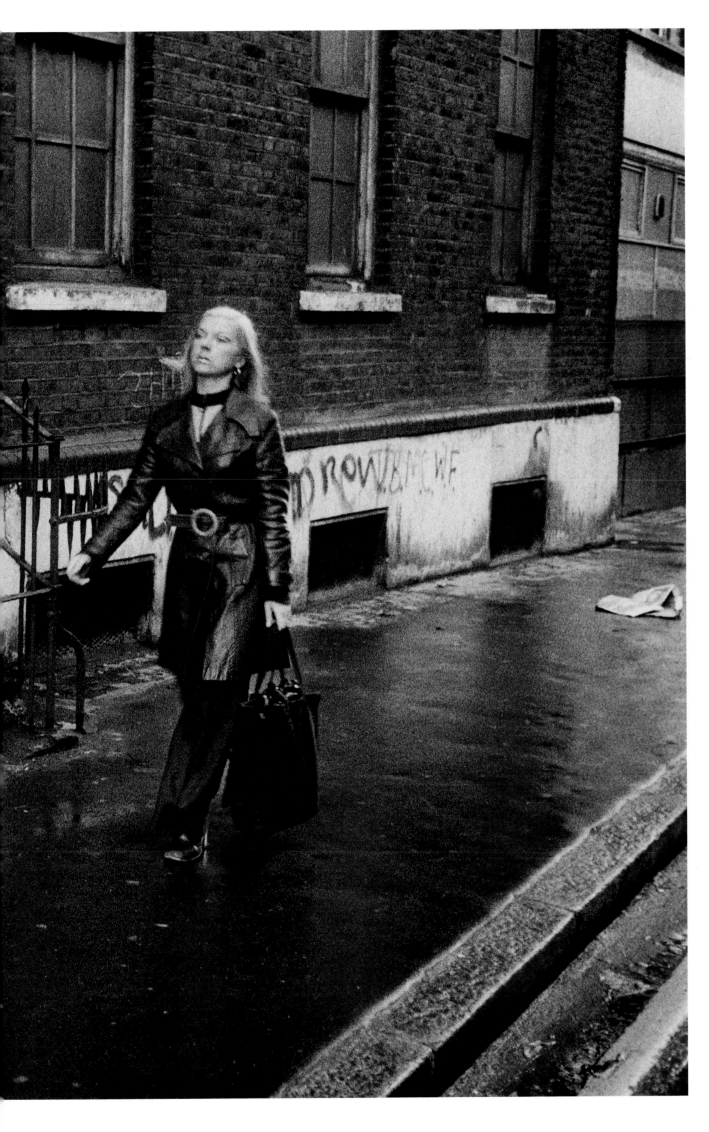

Brick Lane, Whitechapel, London, 1970s

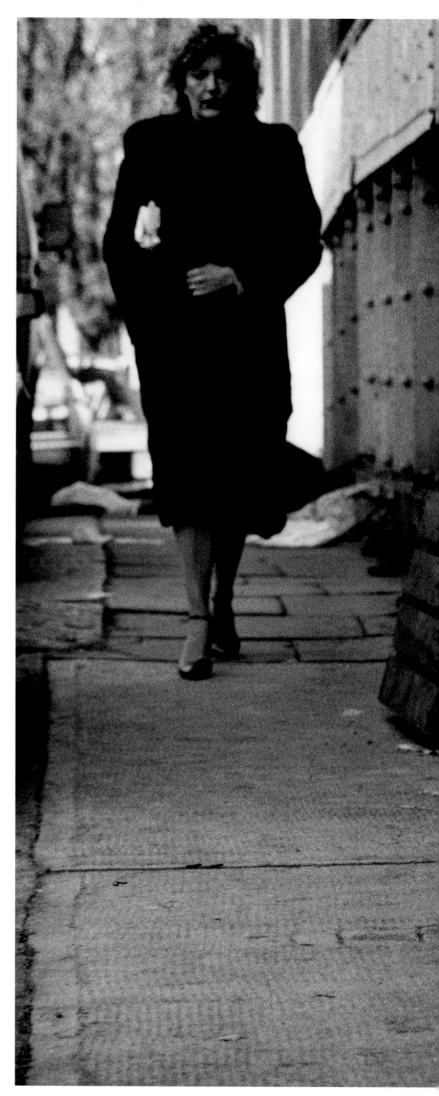

Whitechapel, London, 1970s

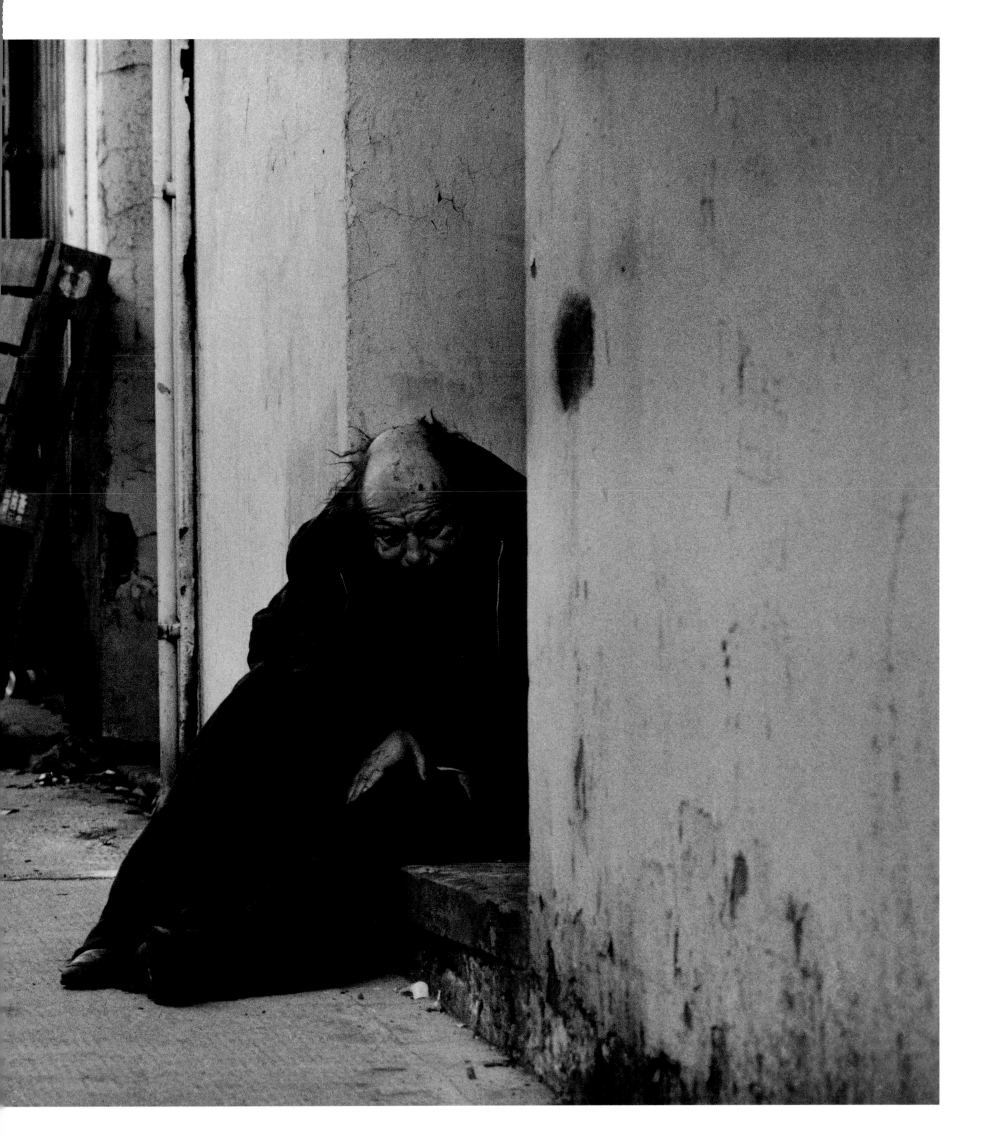

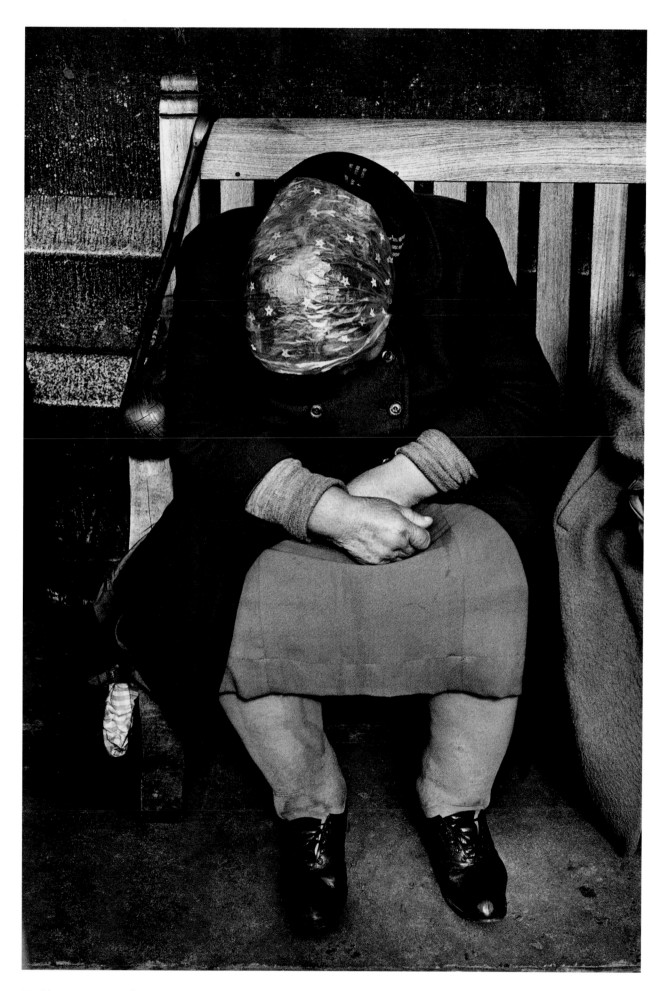

Trafalgar Square, London, 1970s

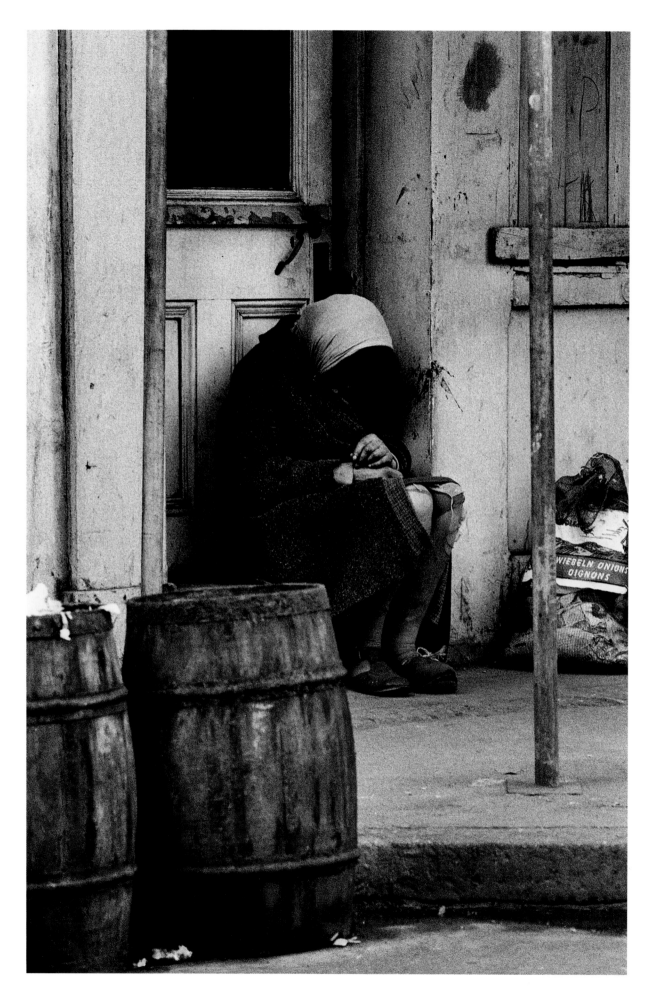

Whitechapel, London, 1969

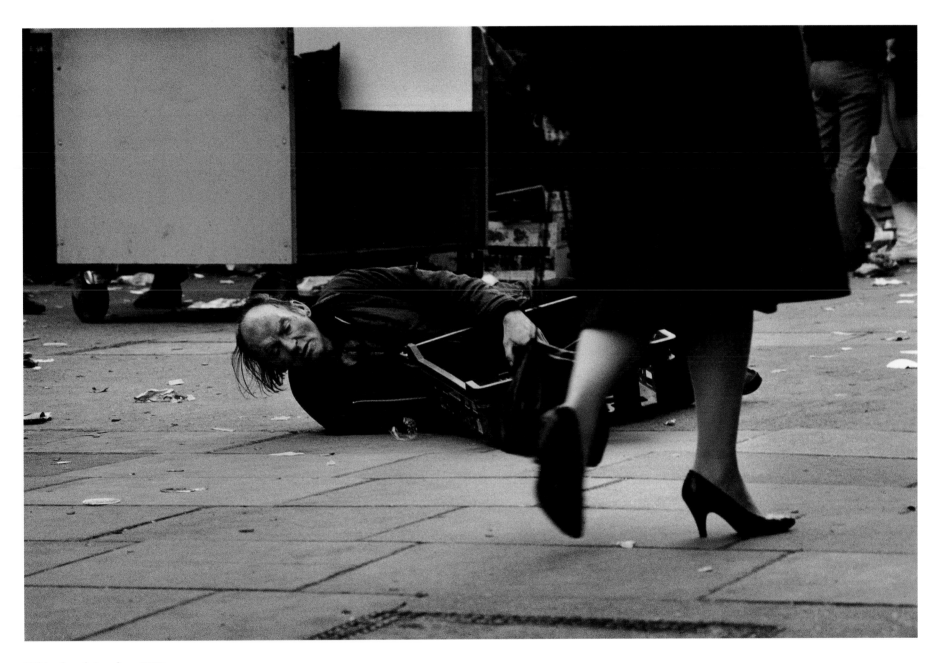

Whitechapel, London, 1970s

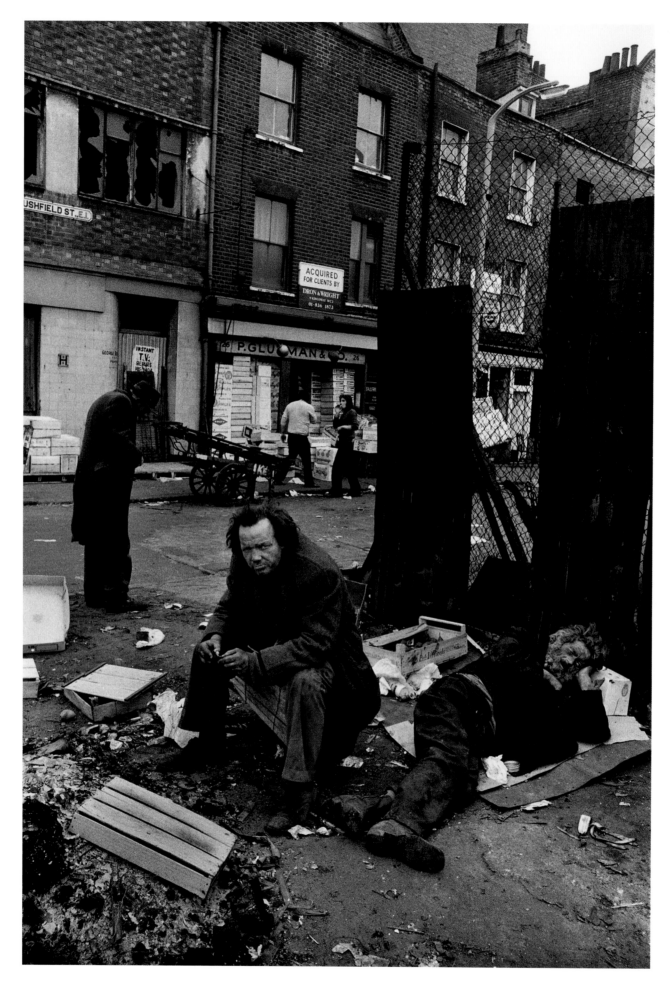

Aldgate, London, 1969

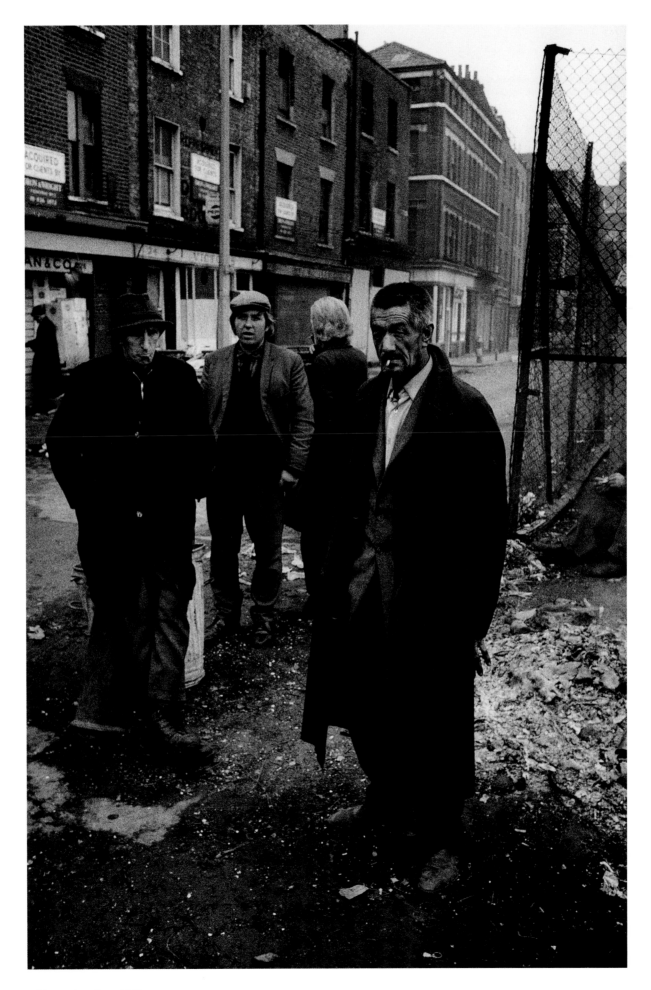

Aldgate, London, 1969

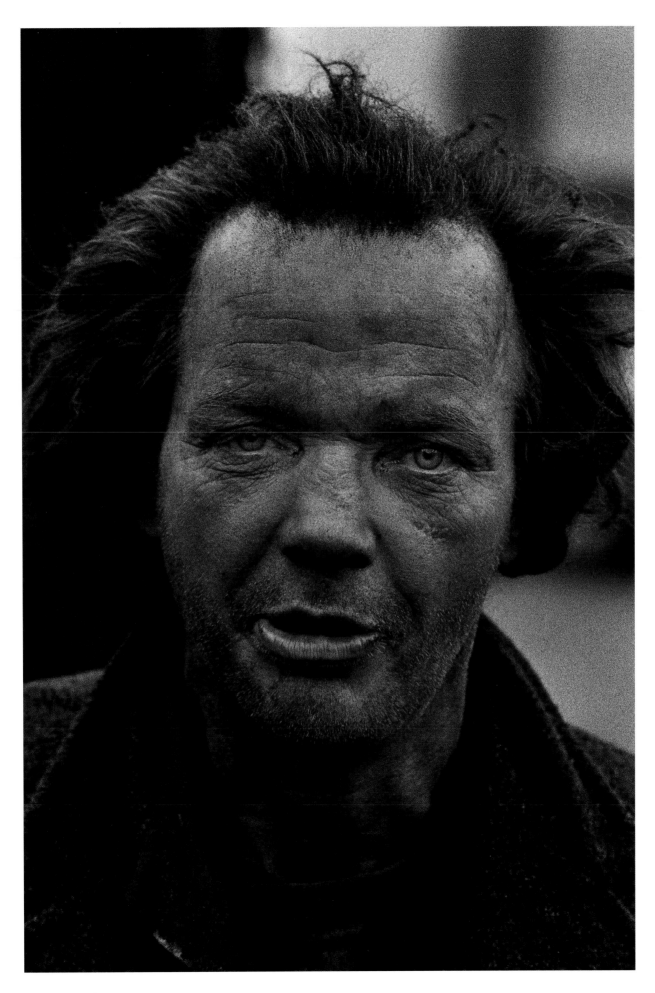

Aldgate, London, 1969

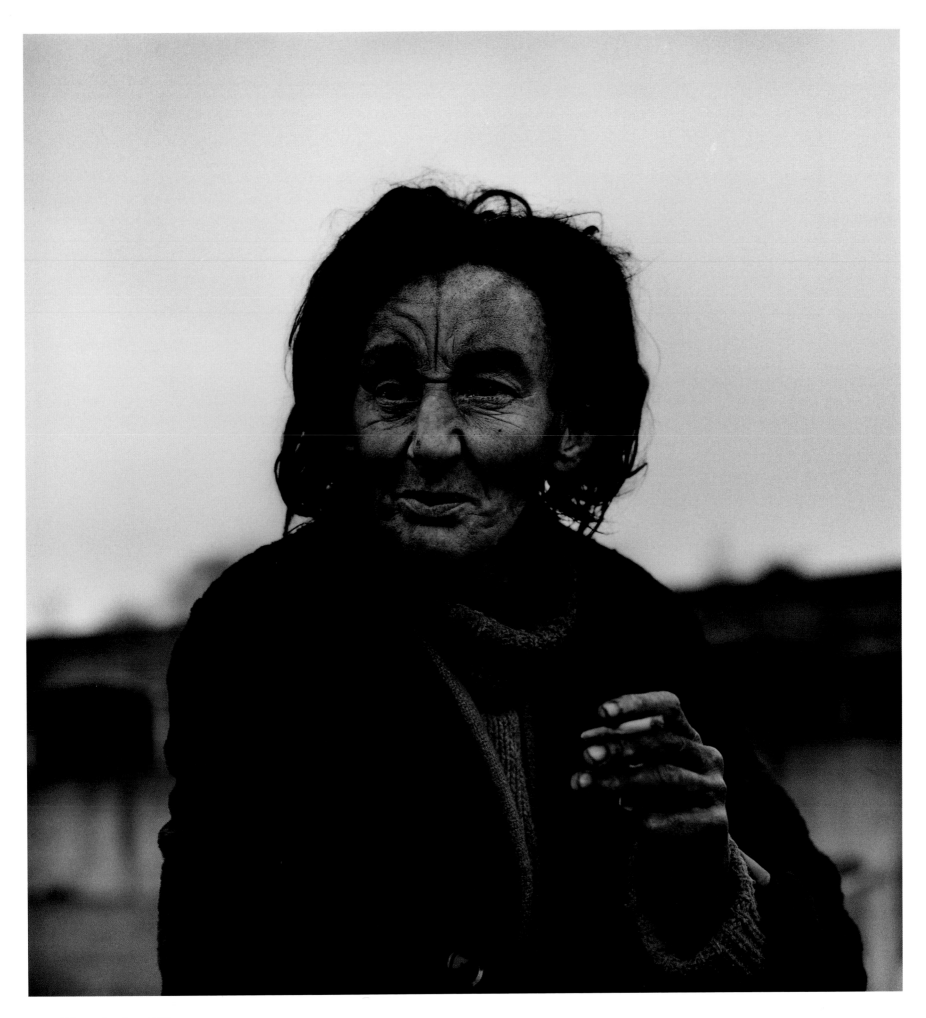

Jean, Aldgate, London, 1970s

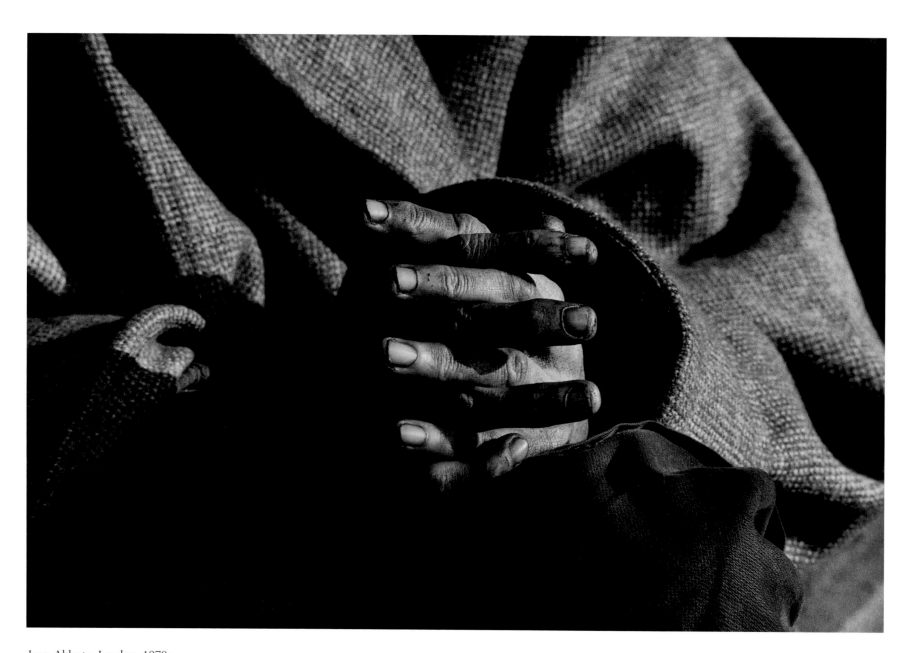

Jean, Aldgate, London, 1970s

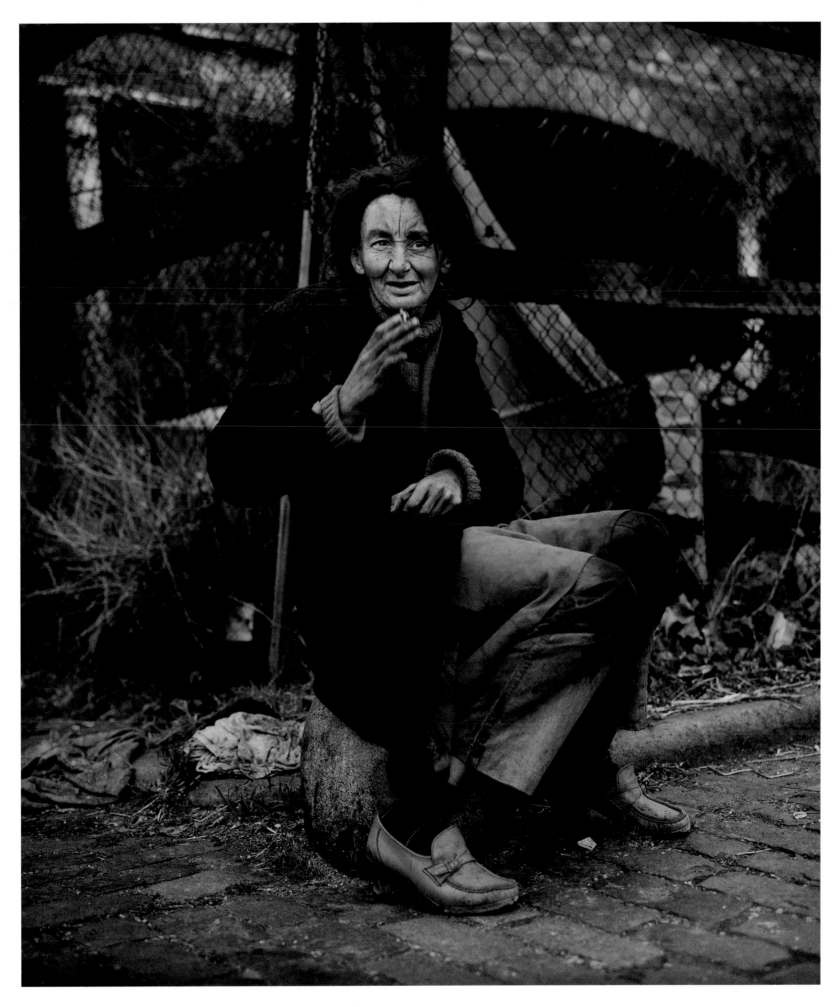

Jean, Aldgate, London, 1970s

Jean, Aldgate, London, 1970s

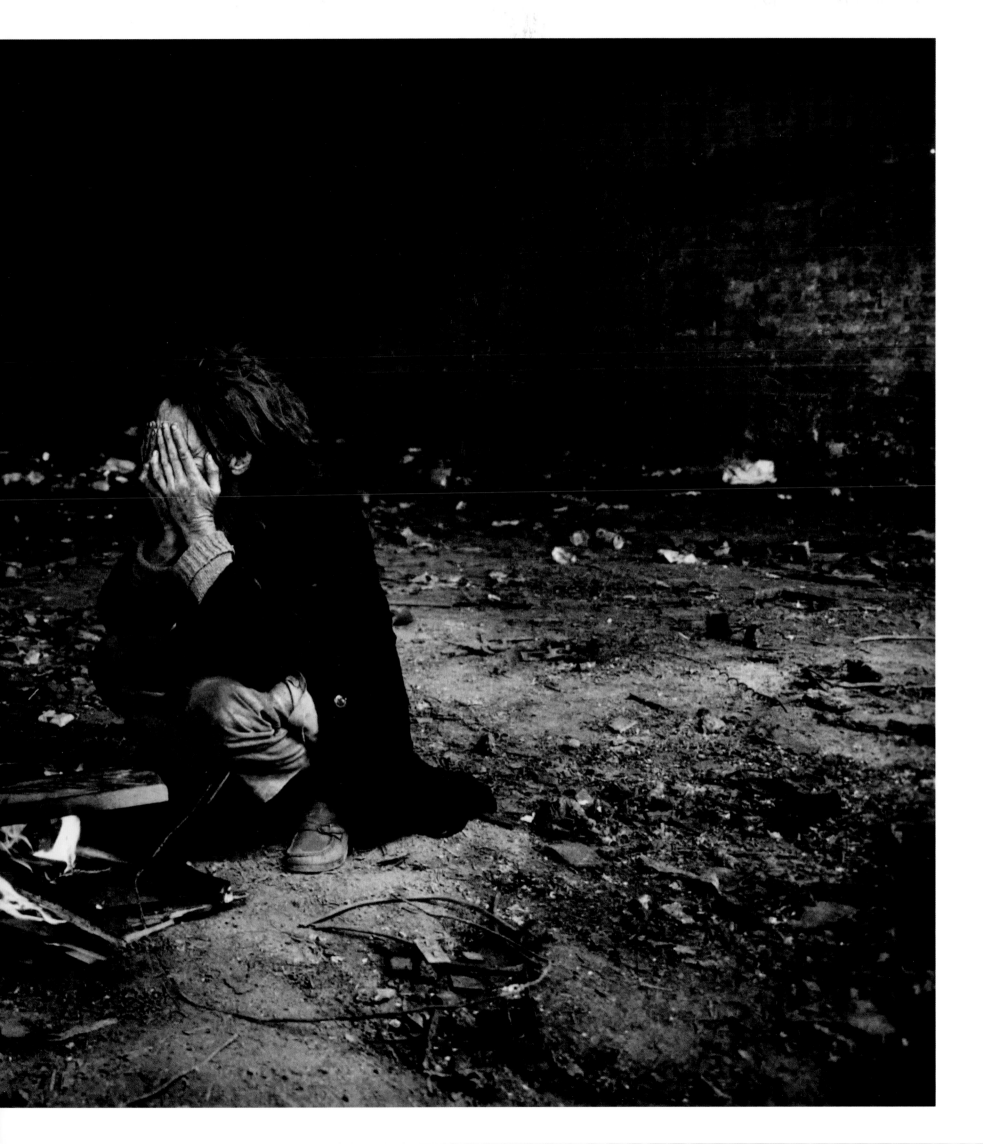

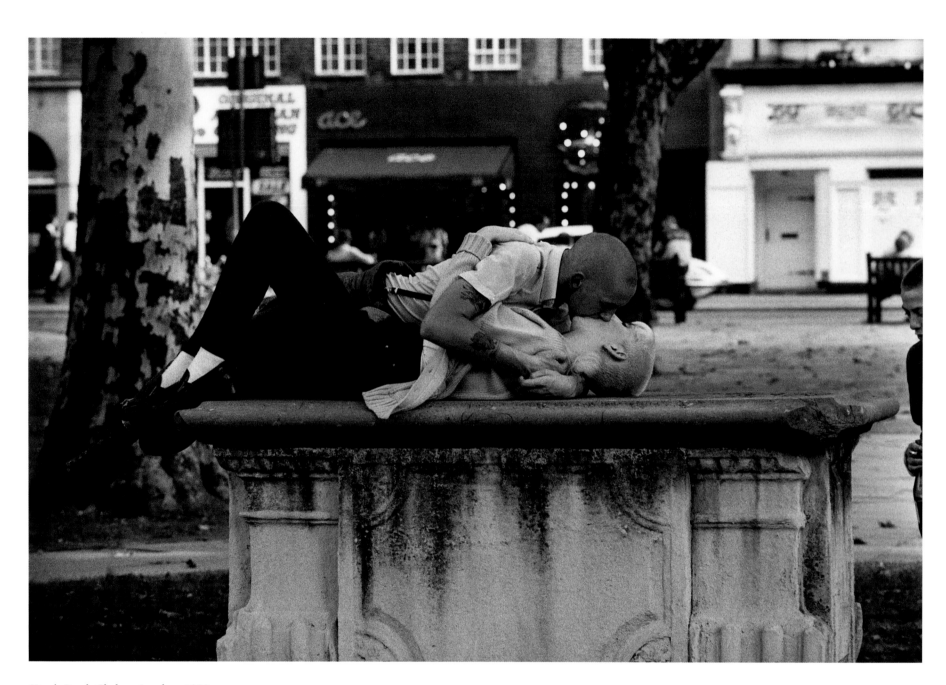

King's Road, Chelsea, London, 1970s

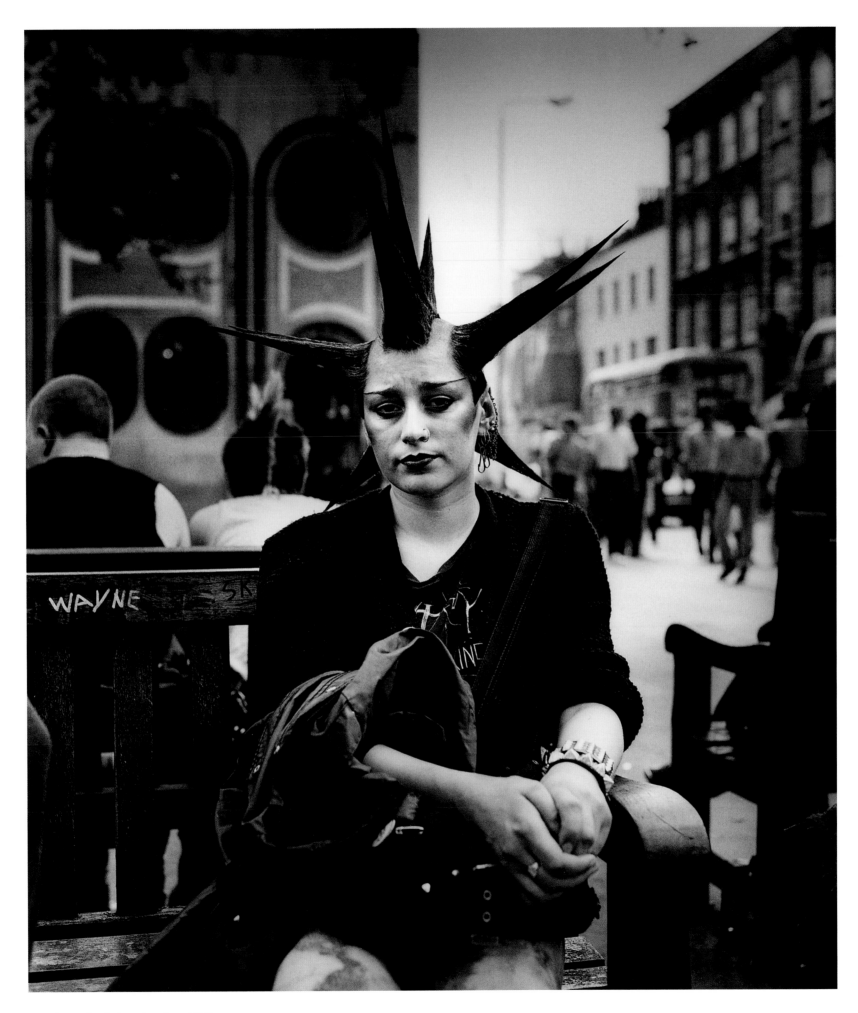

King's Road, Chelsea, London, 1970s

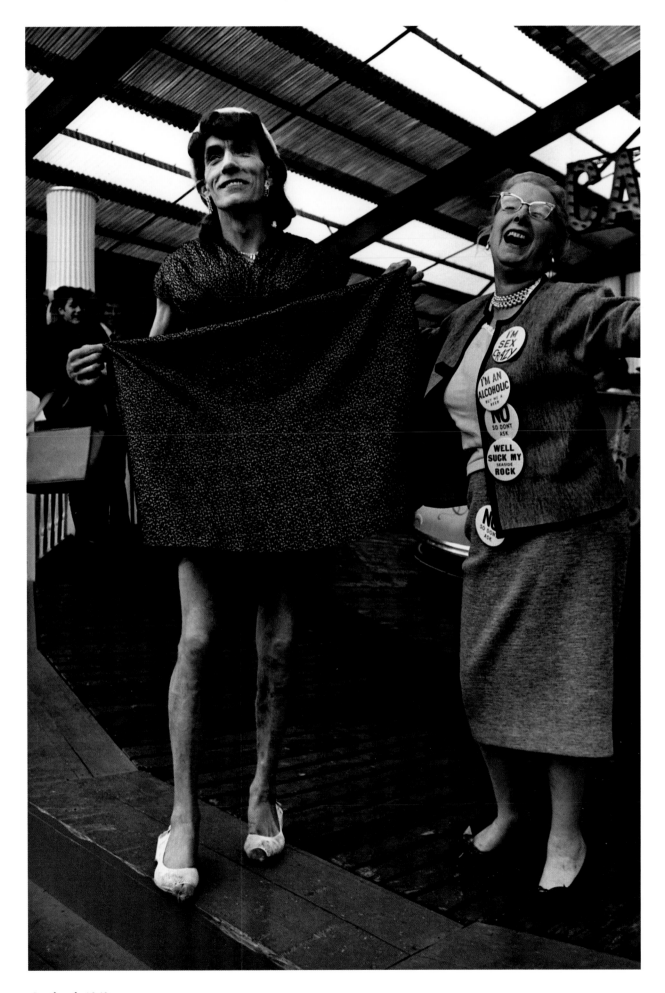

Southend, 1960s

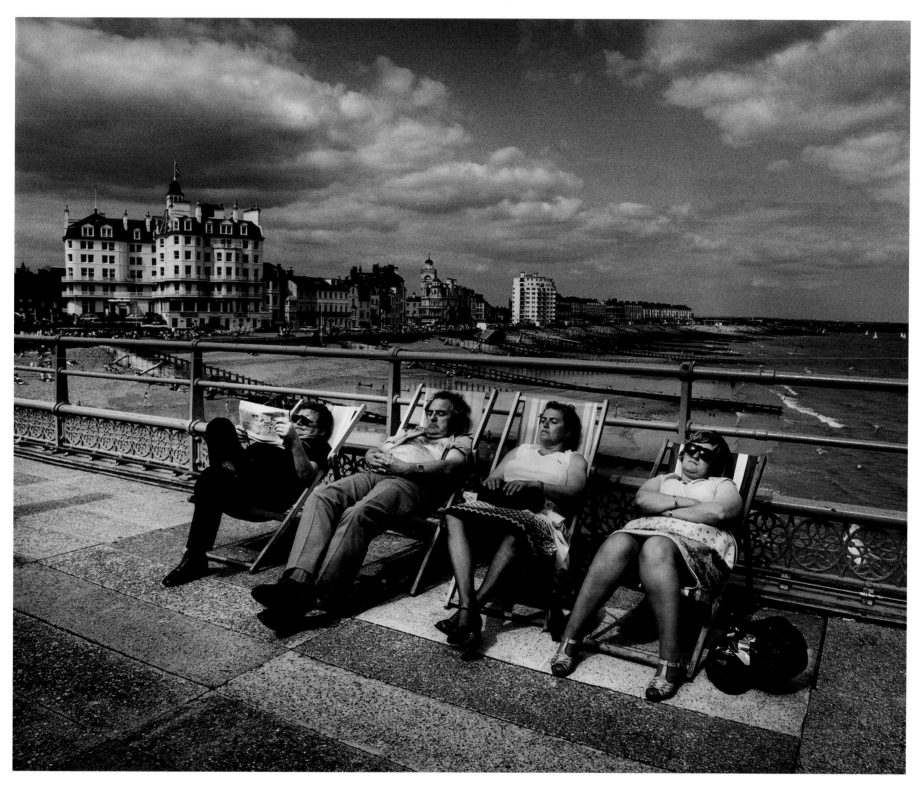

1970s

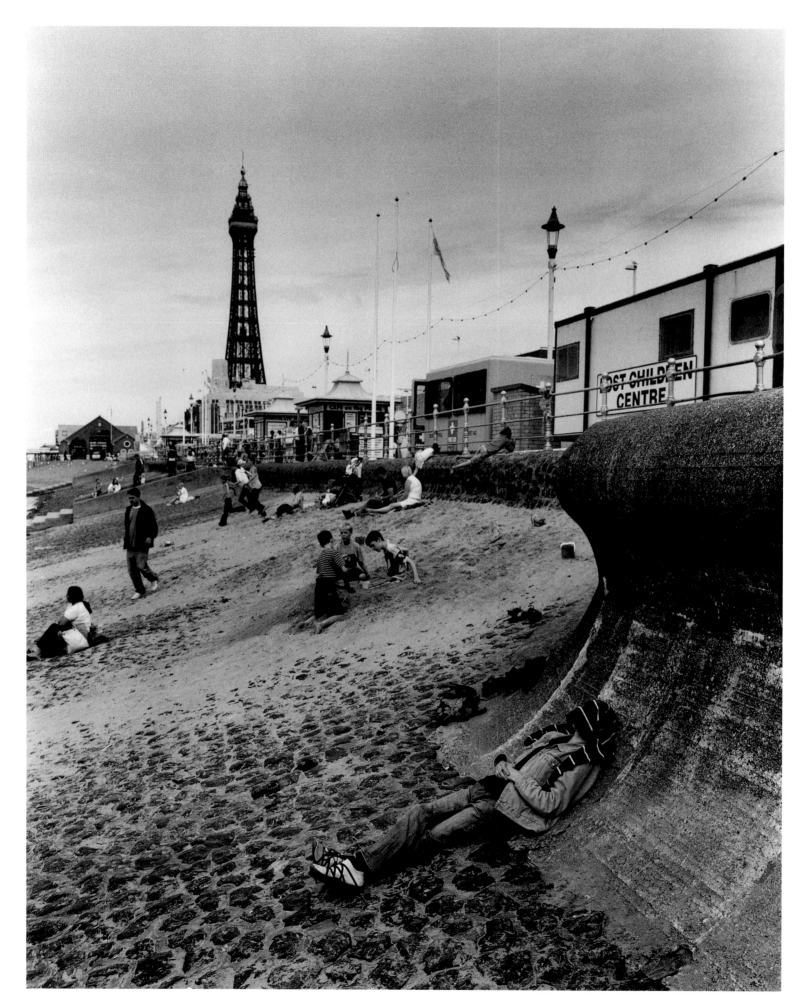

Blackpool, 2006

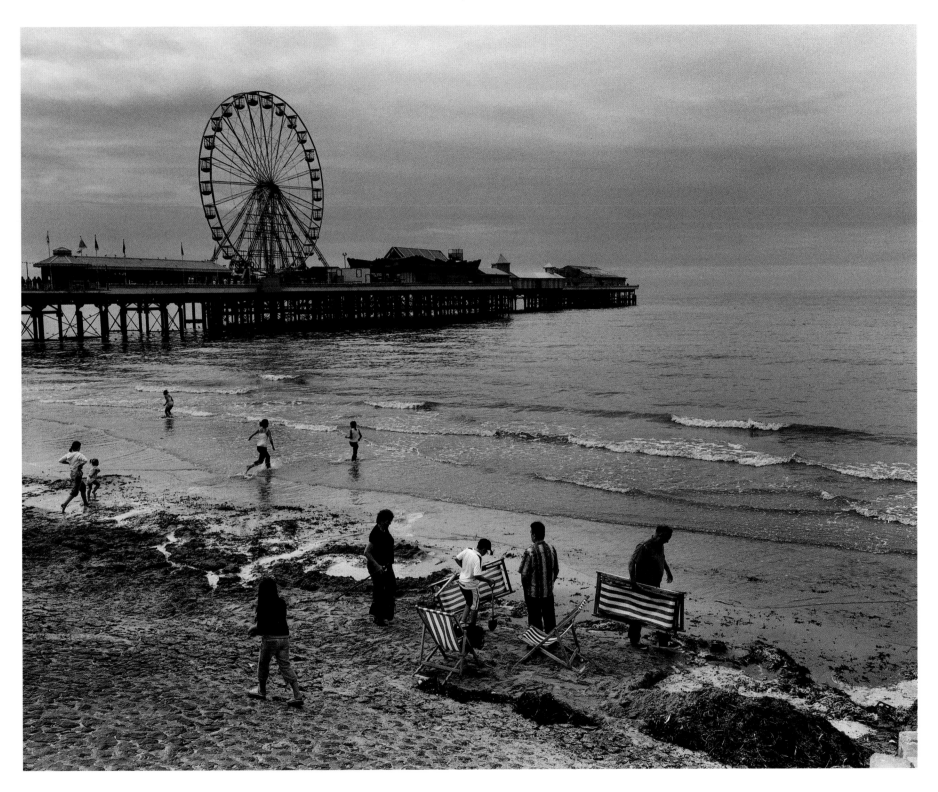

Blackpool, 2006

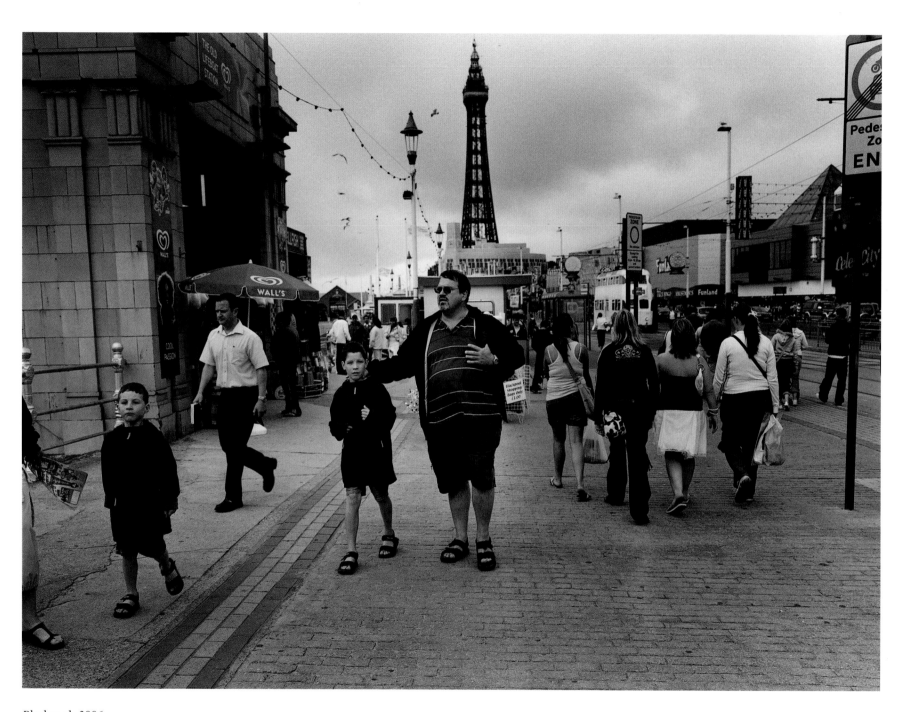

Blackpool, 2006

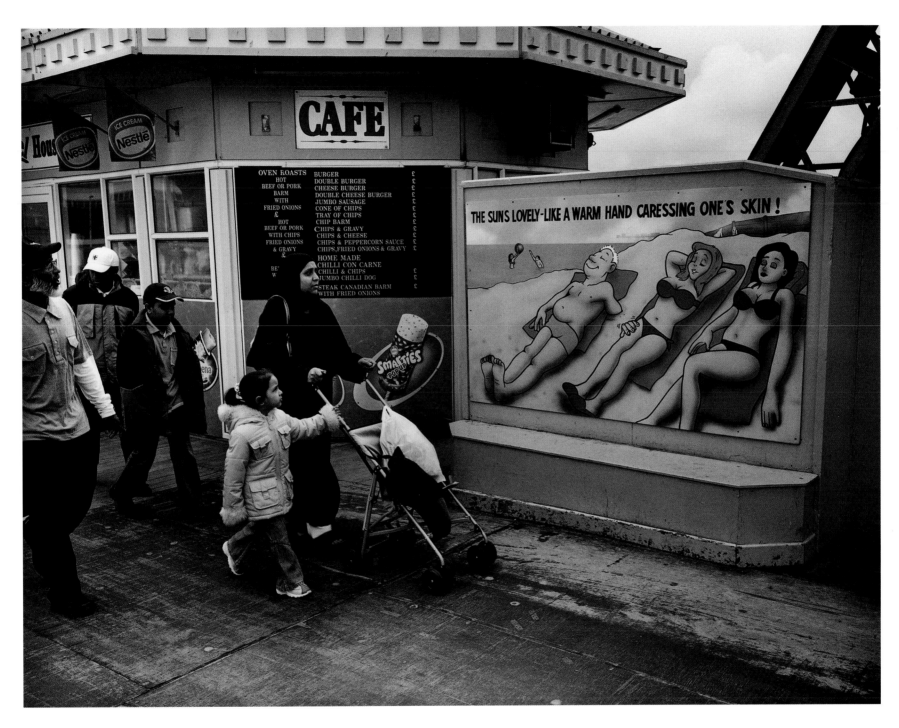

Blackpool, 2006

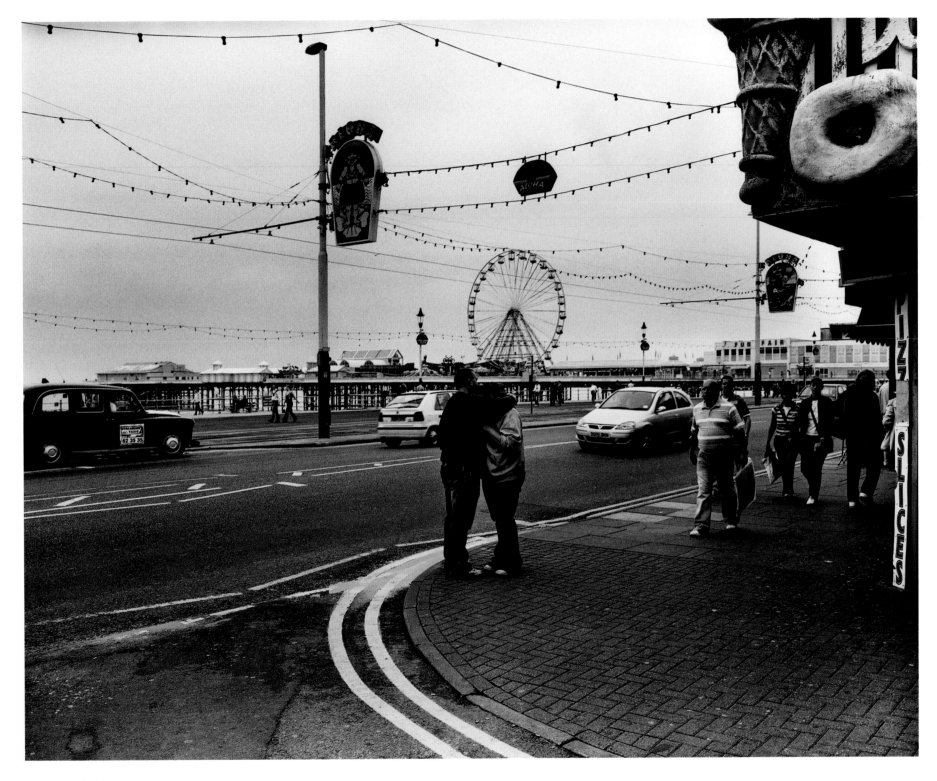

Blackpool, 2006

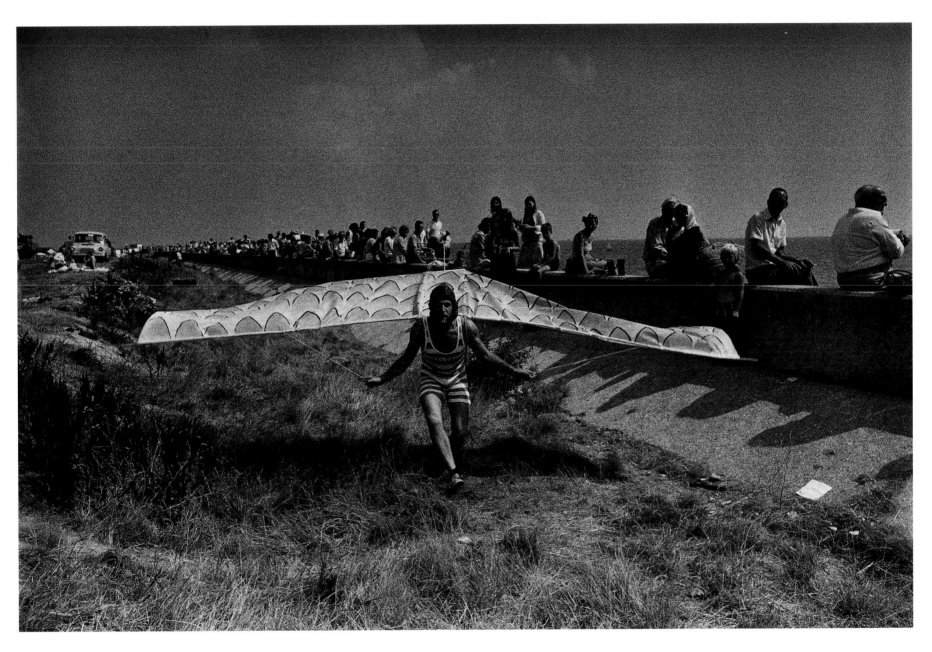

Birdman Competition, Selsey, Sussex, 1970s

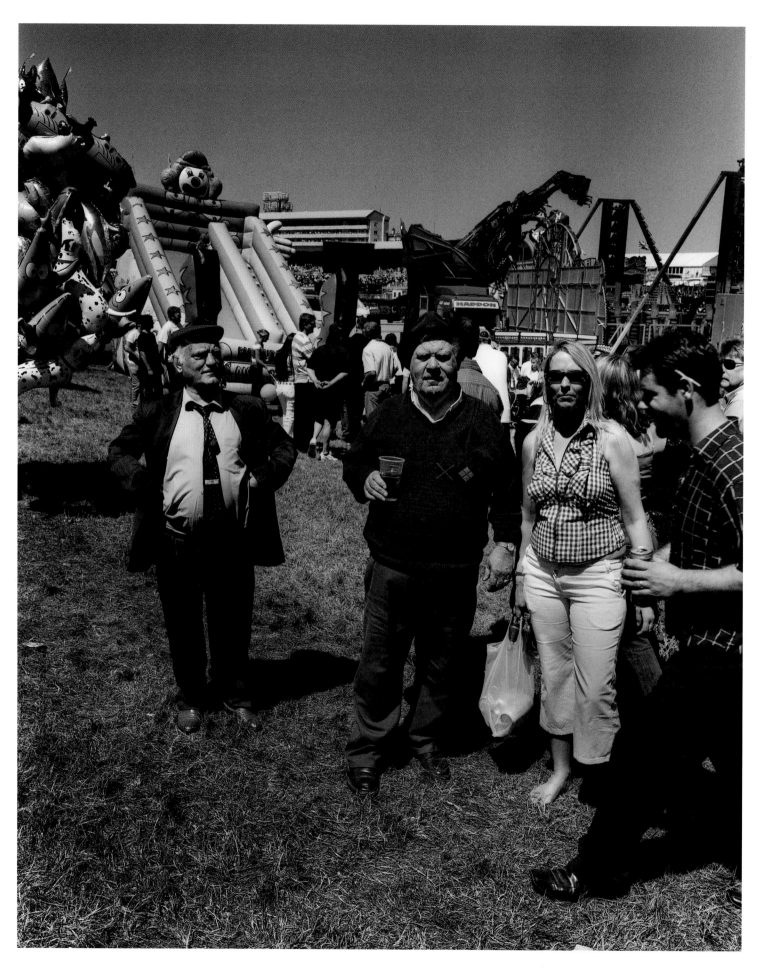

Derby Day, Epsom, Surrey, 2006

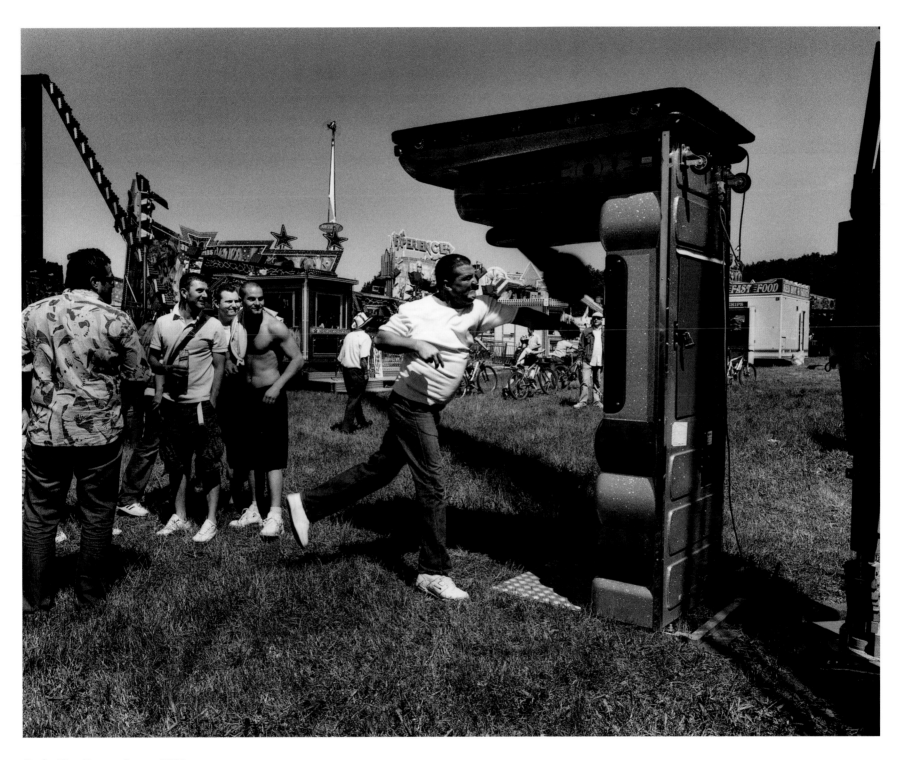

Derby Day, Epsom, Surrey, 2006

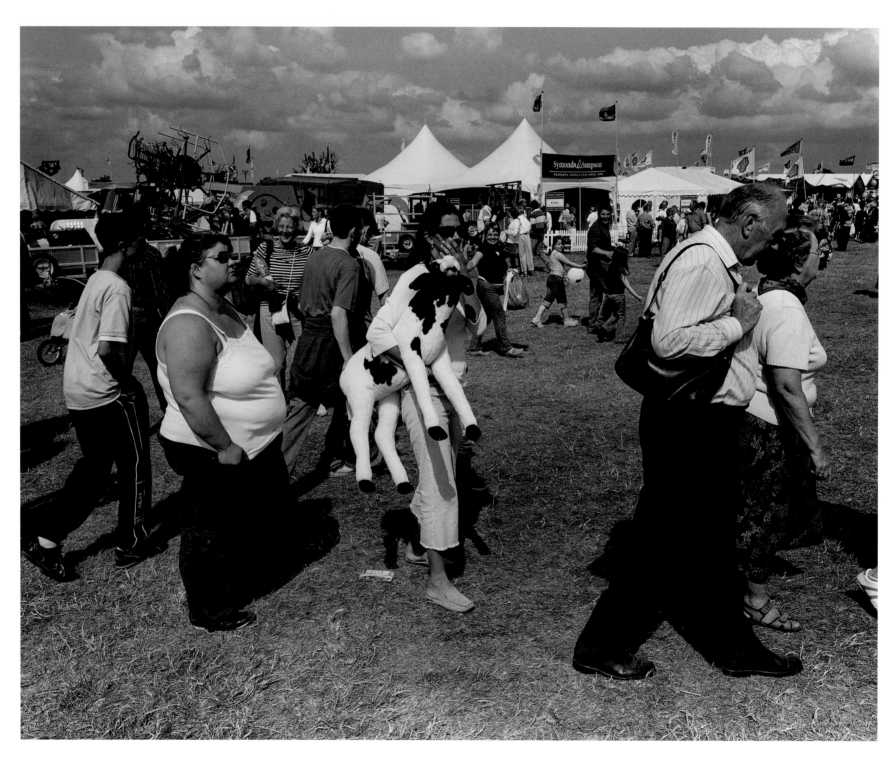

Gillingham Fair, Dorset, 2006

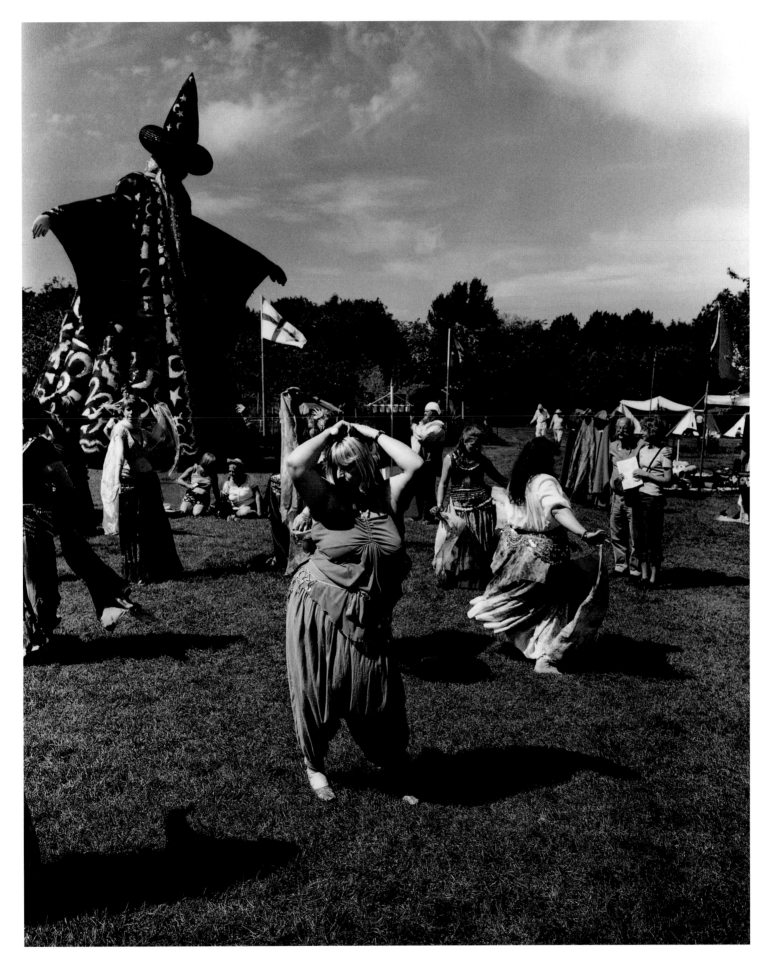

Gillingham Fair, Dorset, 2006

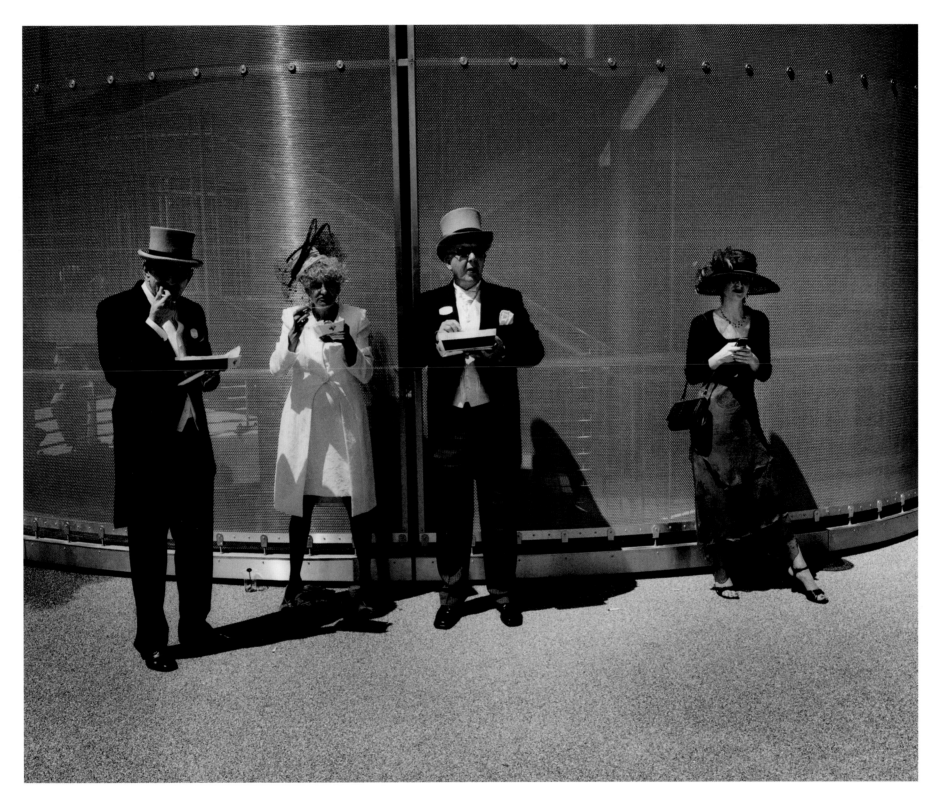

Ladies' Day, Royal Ascot, 2006

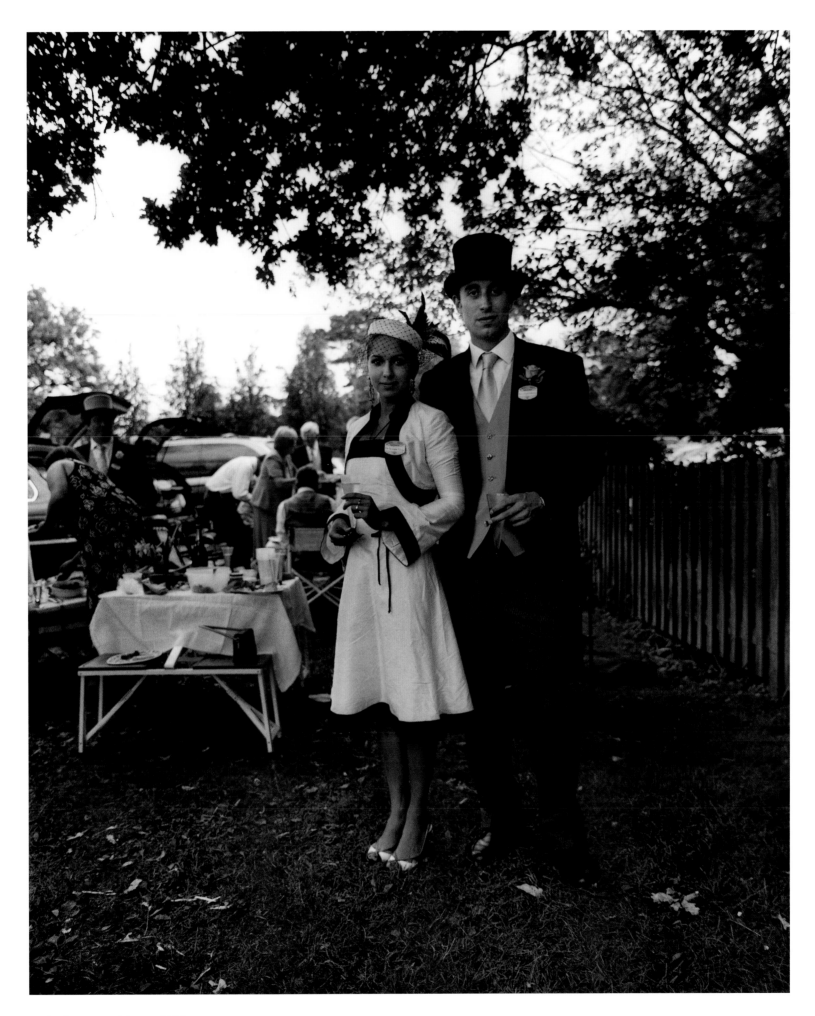

Ladies' Day, Royal Ascot, 2006

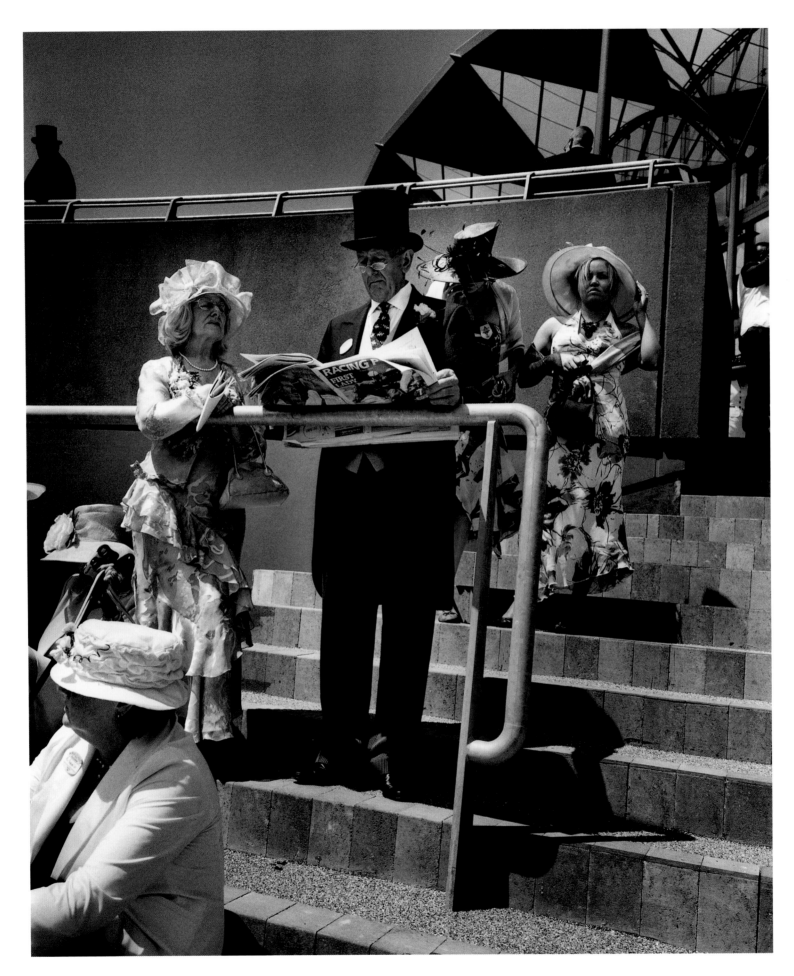

Ladies' Day, Royal Ascot, 2006

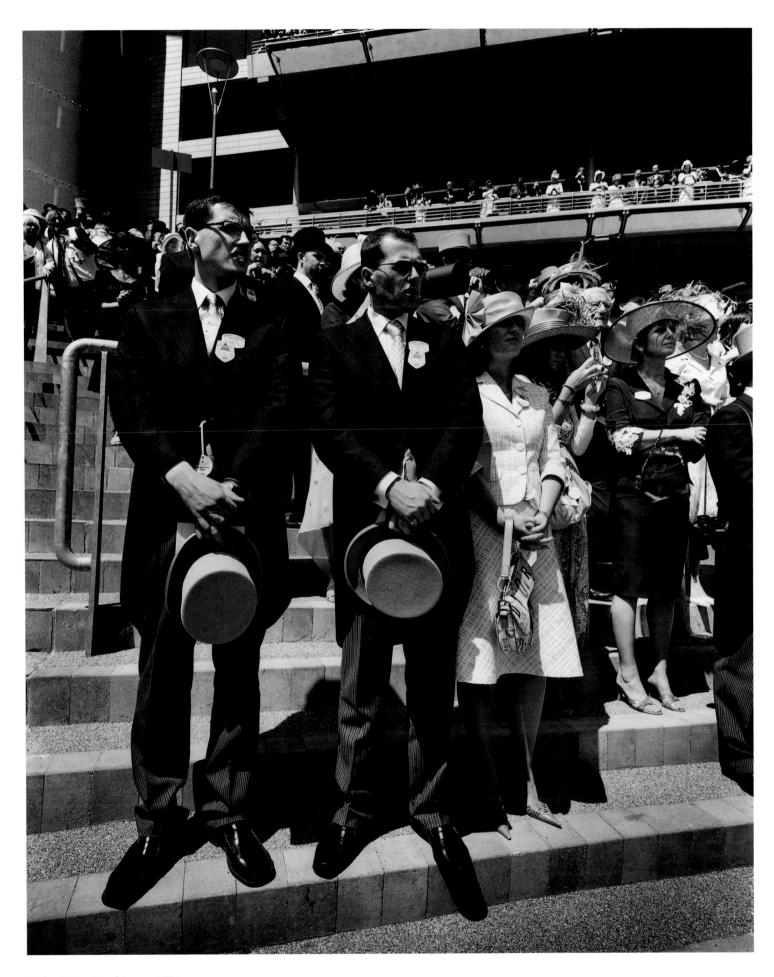

Ladies' Day, Royal Ascot, 2006

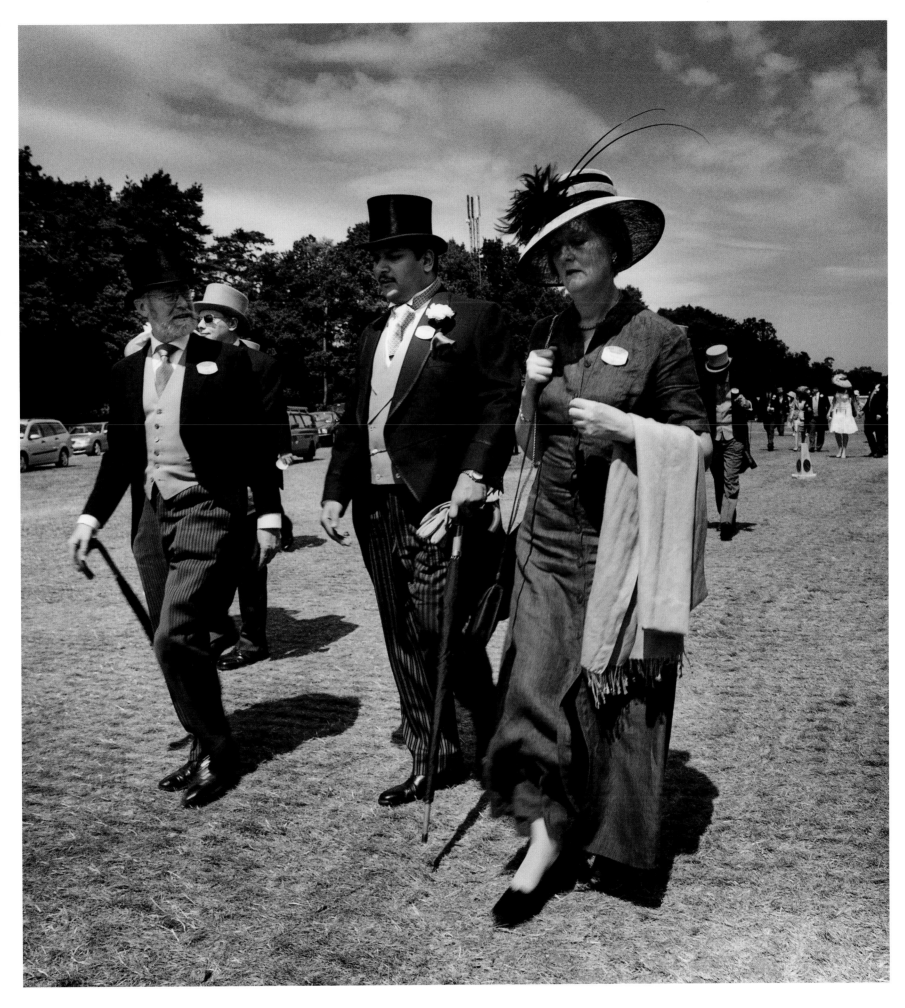

Ladies' Day, Royal Ascot, 2006

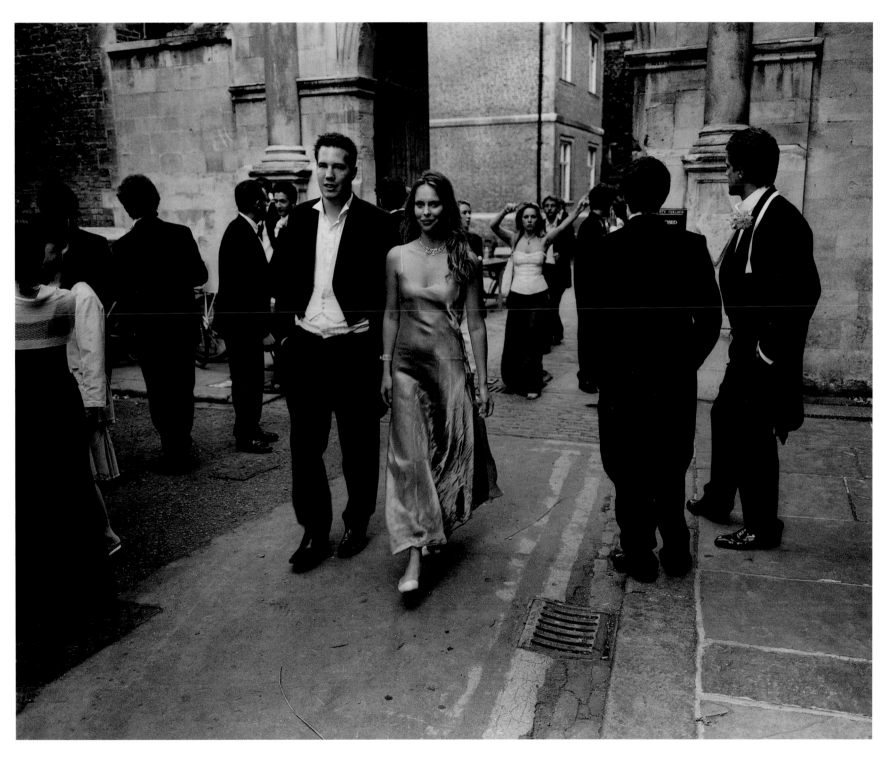

Dawn after May Ball, Cambridge, 2006

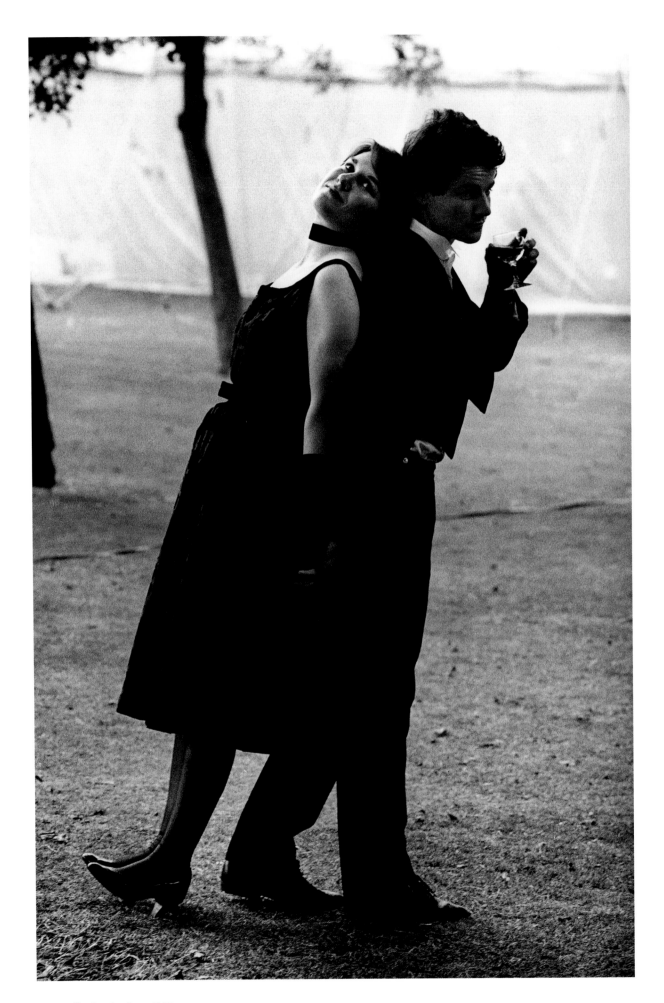

May Ball, Cambridge, 1982

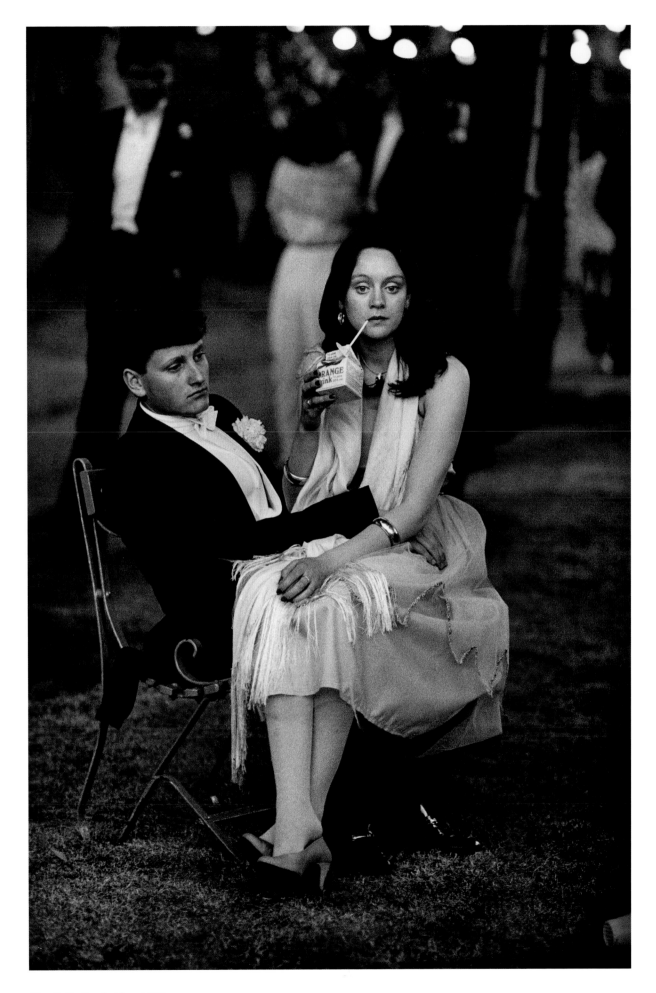

May Ball, Cambridge, 1982

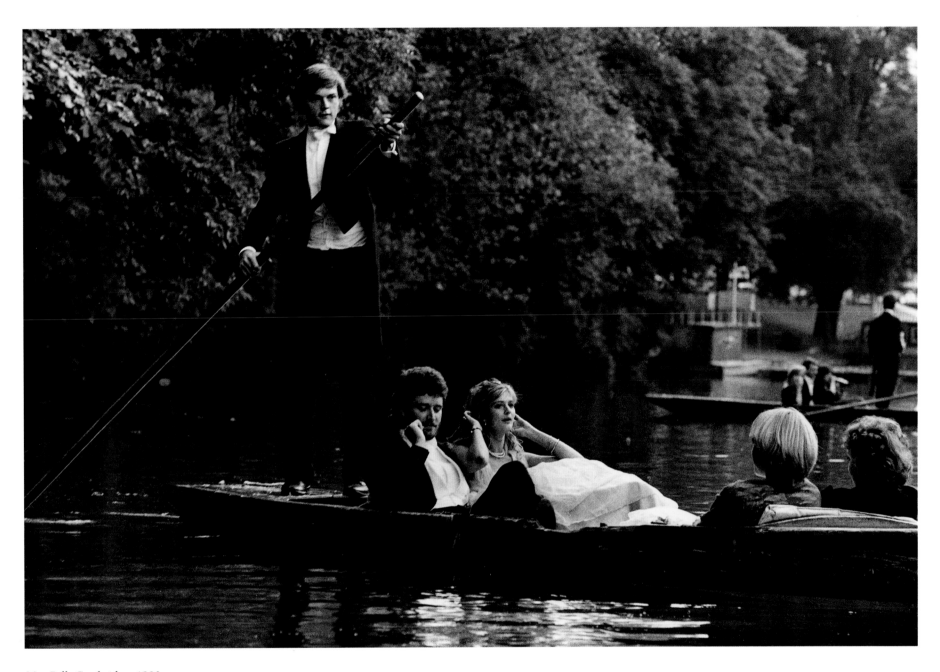

May Ball, Cambridge, 1982

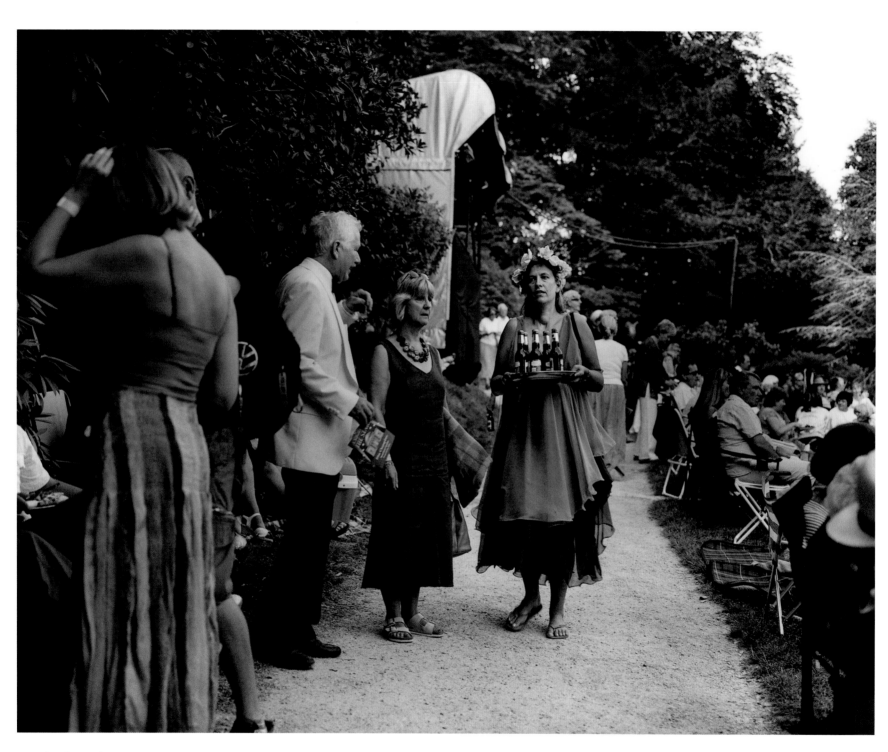

Stourhead, Wiltshire, 2006

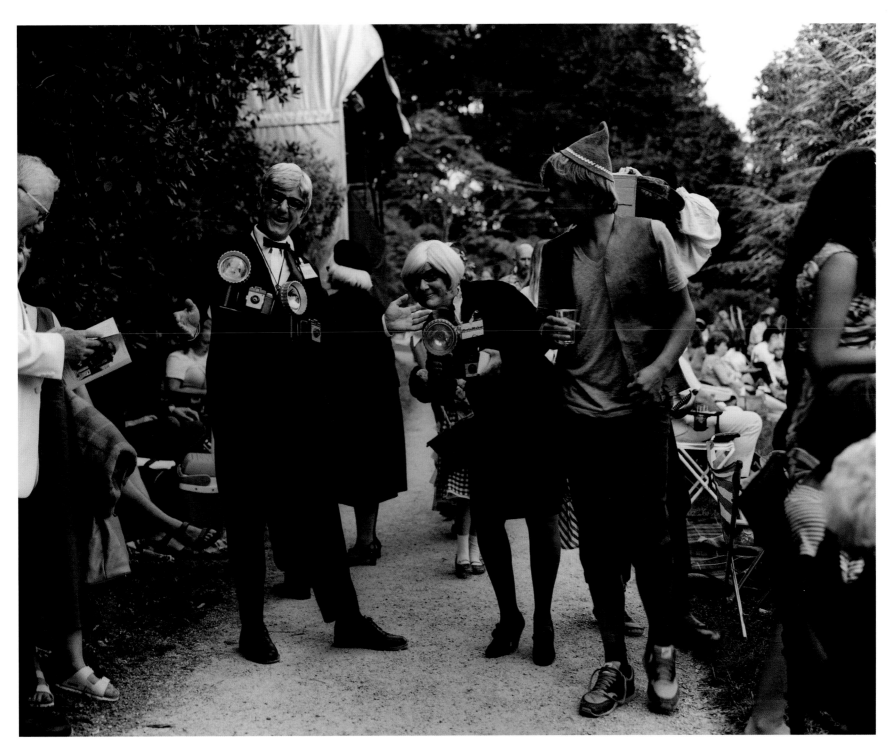

Stourhead, Wiltshire, 2006

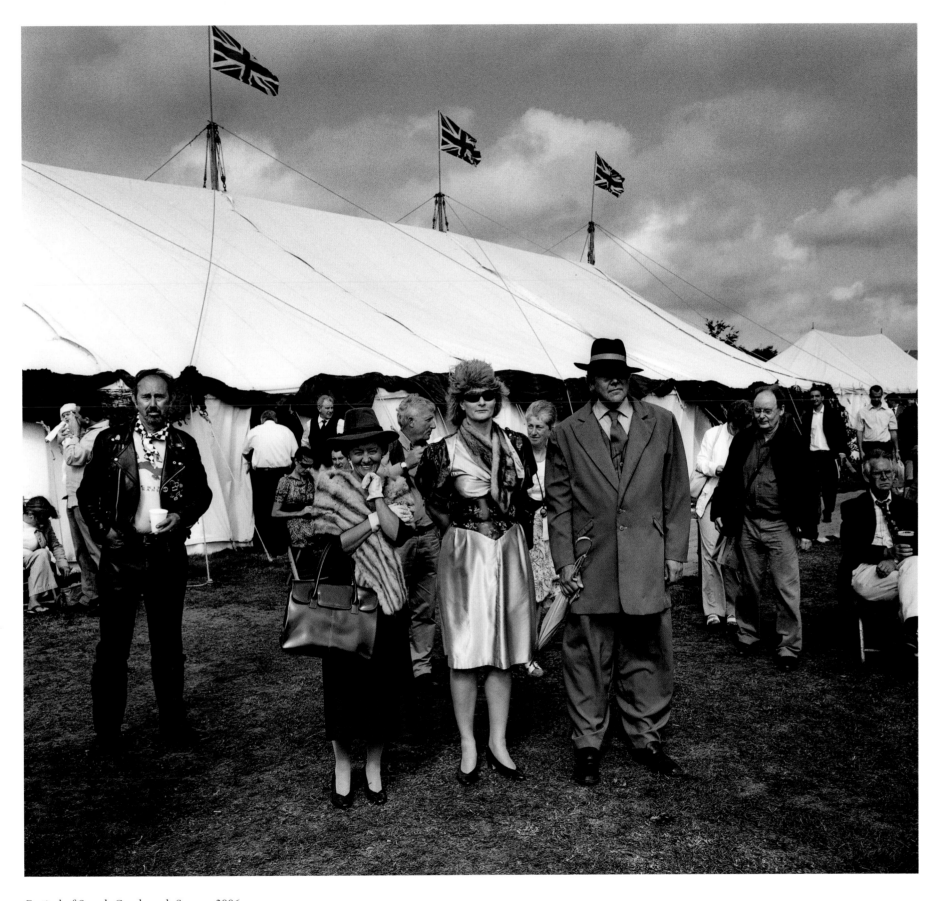

Festival of Speed, Goodwood, Sussex, 2006

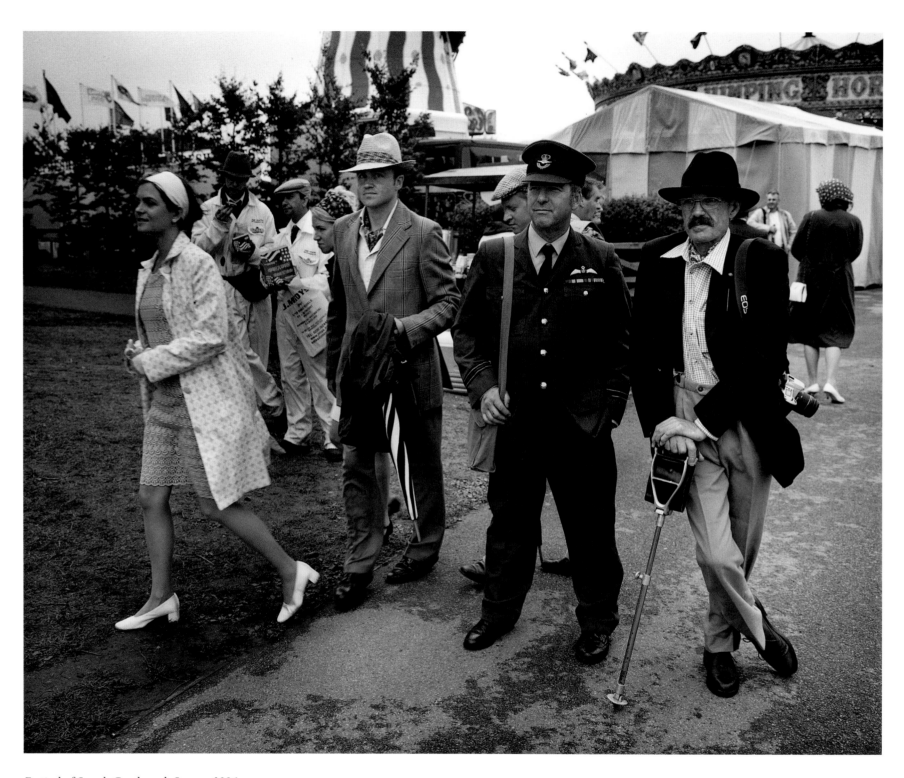

Festival of Speed, Goodwood, Sussex, 2006

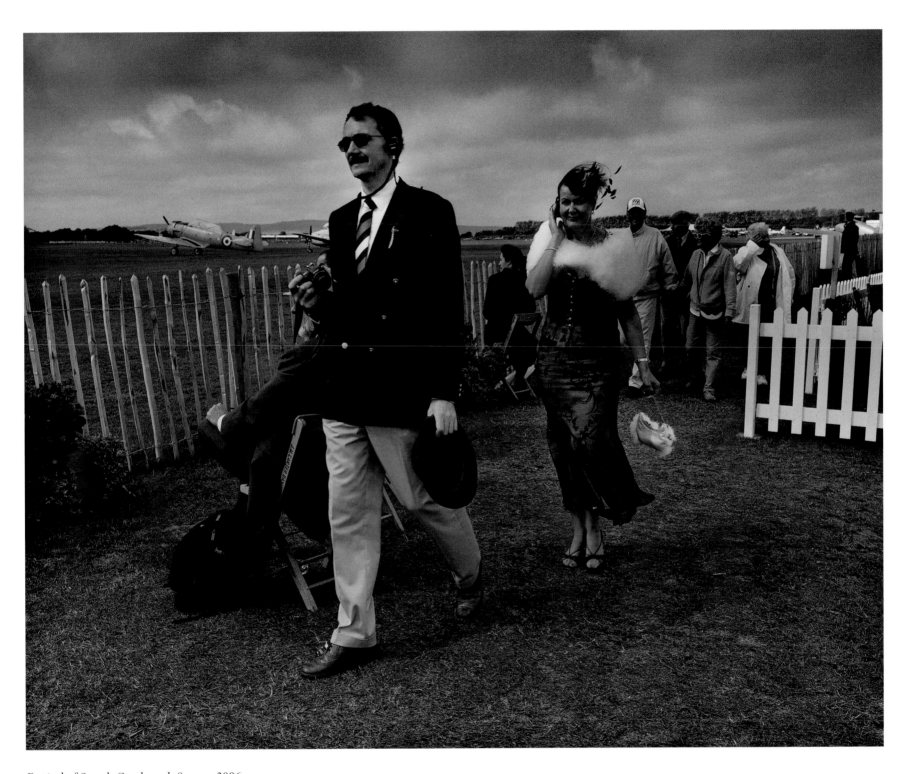

Festival of Speed, Goodwood, Sussex, 2006

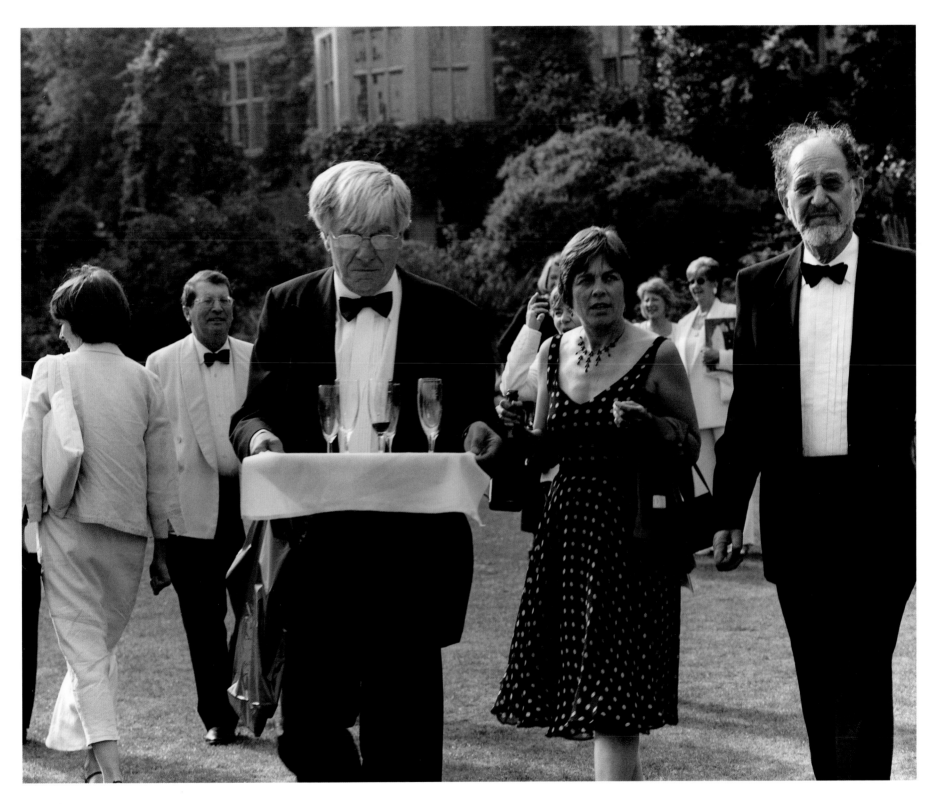

Glyndebourne, Sussex, 2006

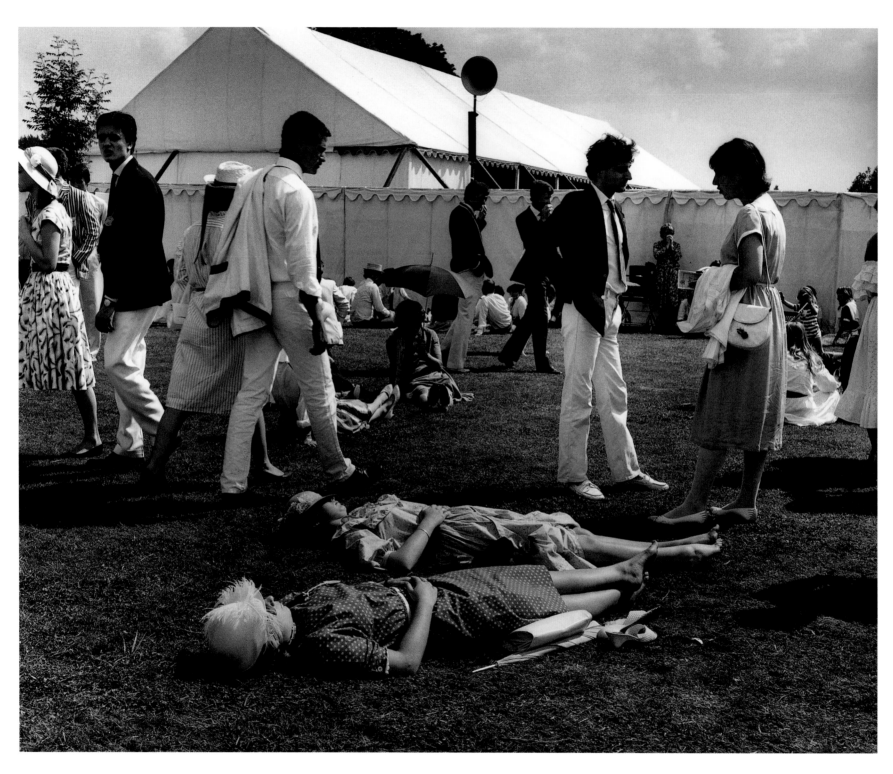

Henley Regatta, late 1970s

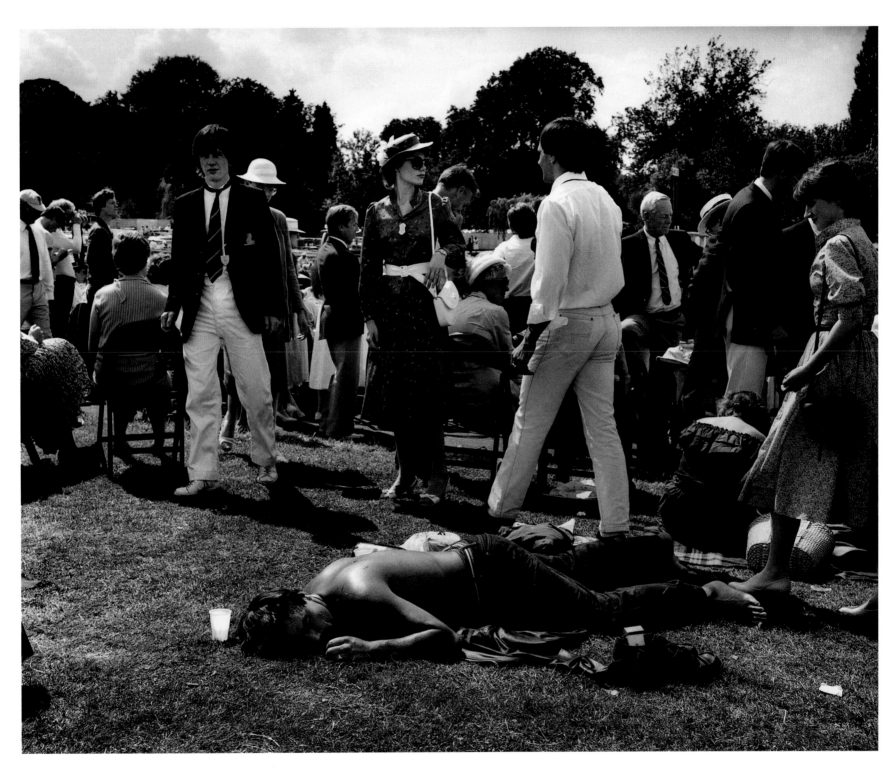

Henley Regatta, late 1970s

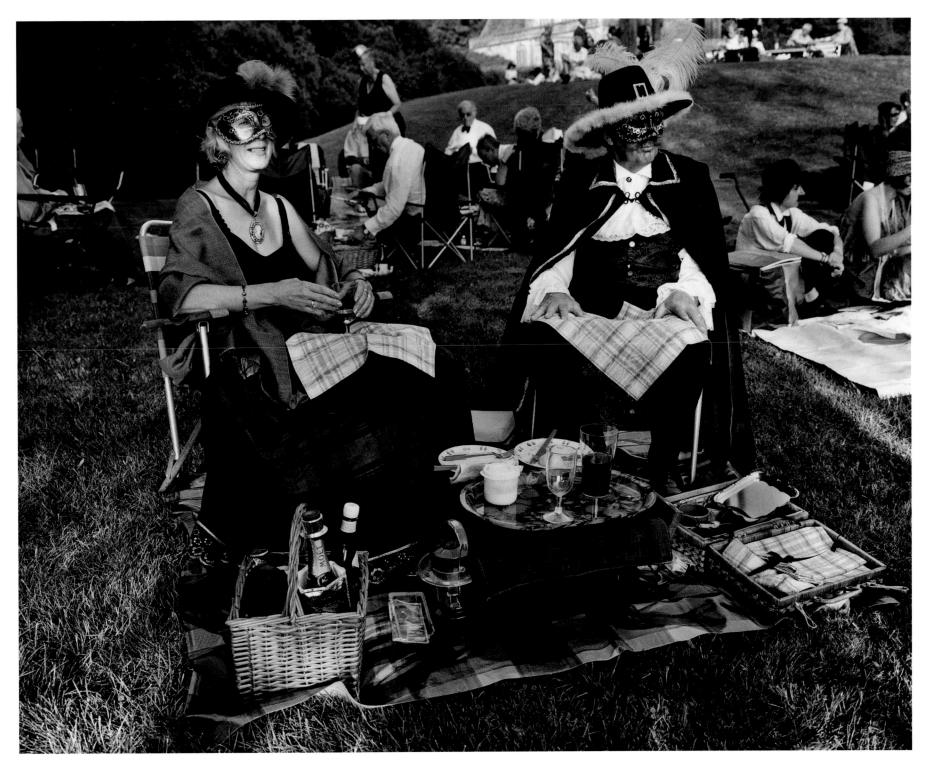

Stourhead, Wiltshire, 2006

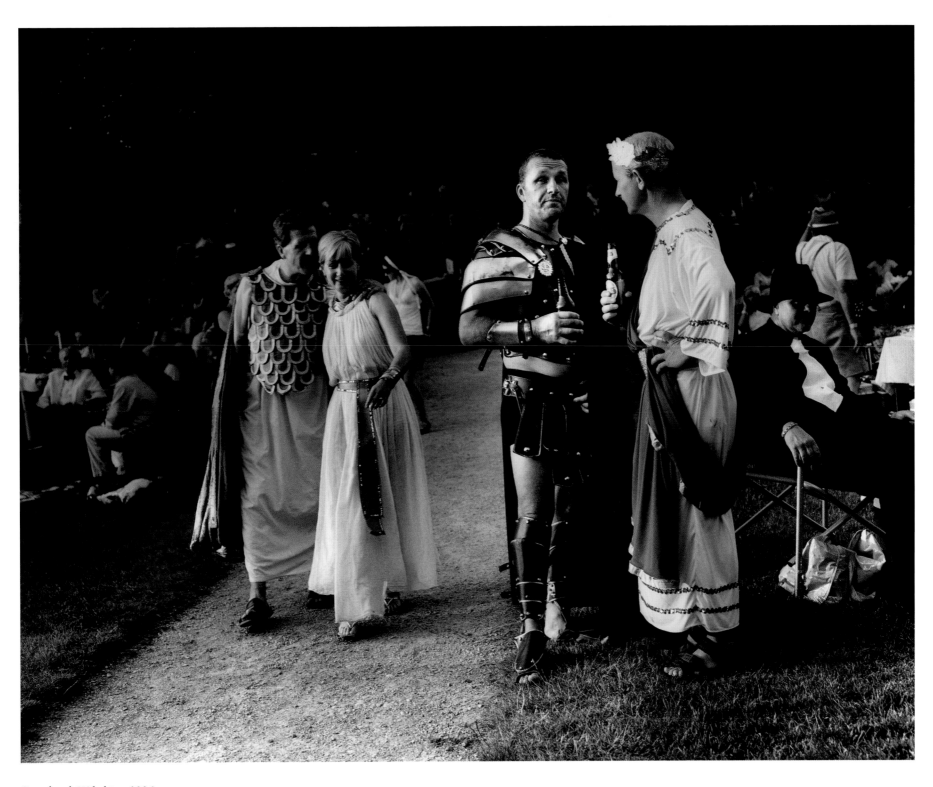

Stourhead, Wiltshire, 2006

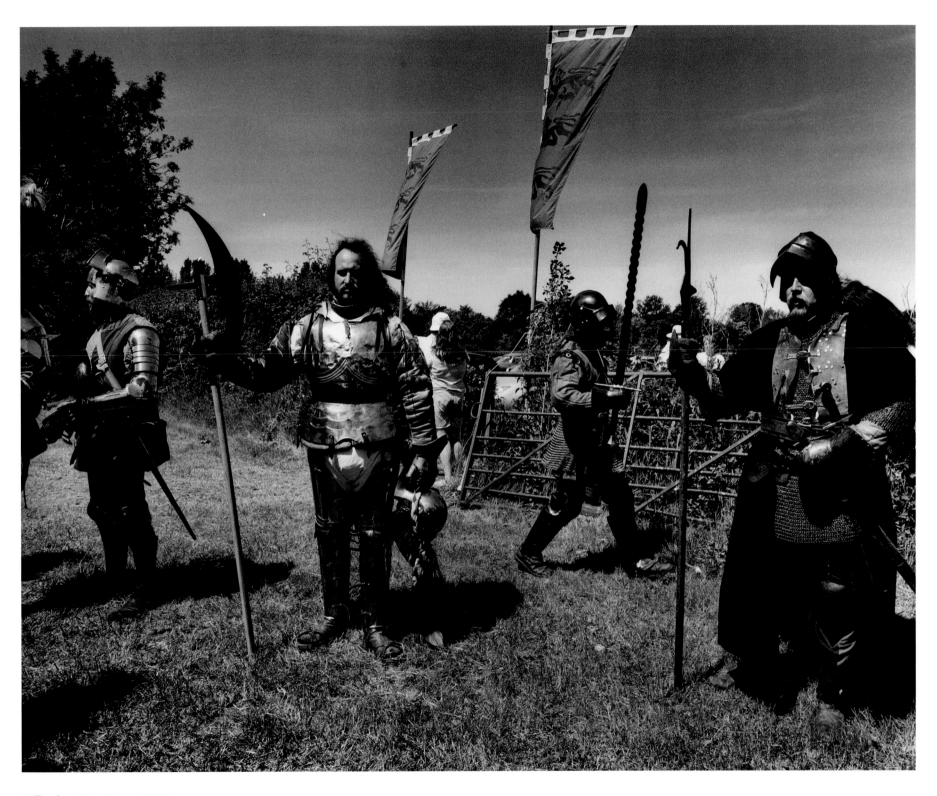

Gillingham Fair, Dorset, 2006

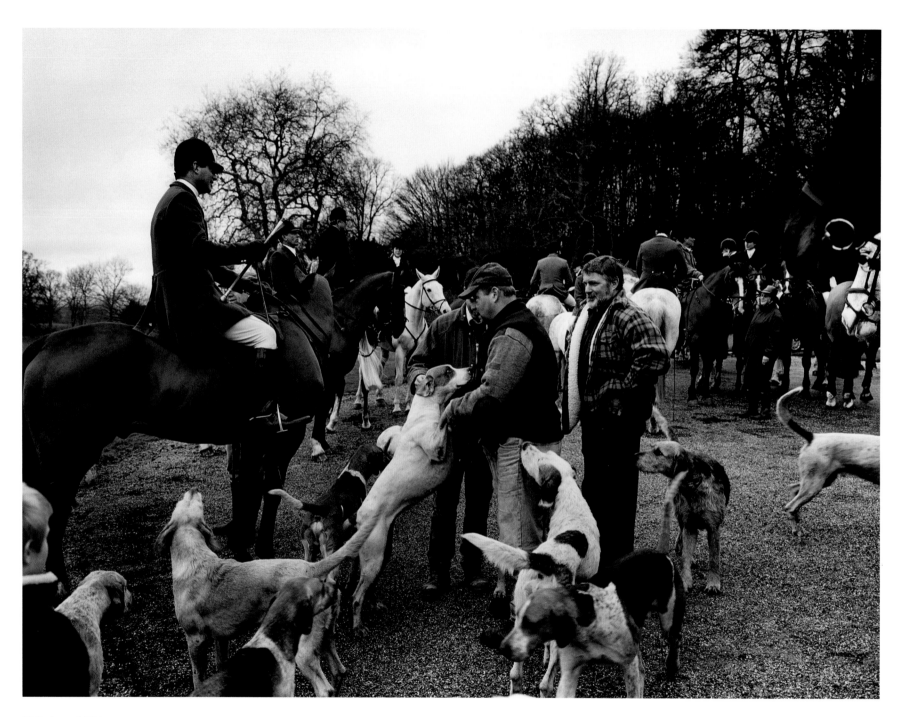

Wiltshire, 2007

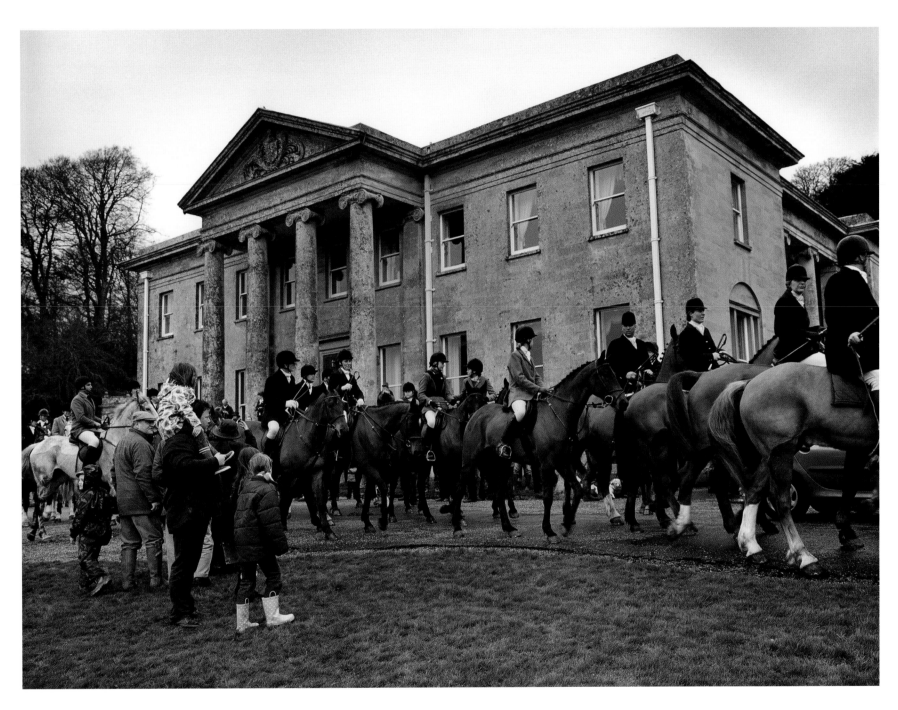

Pitt House, Wiltshire, 2007

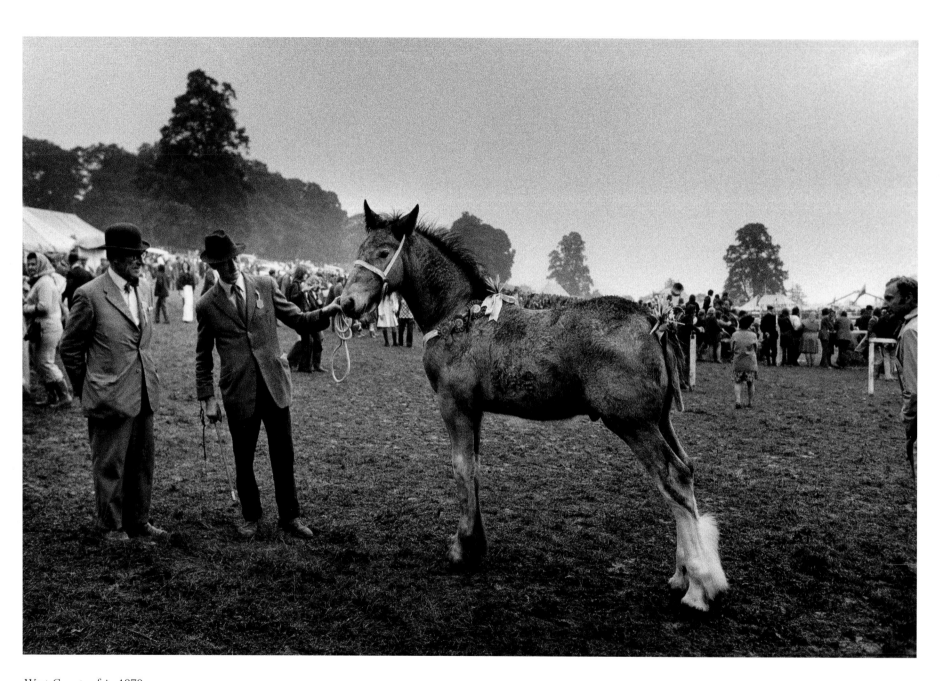

West Country fair, 1970s

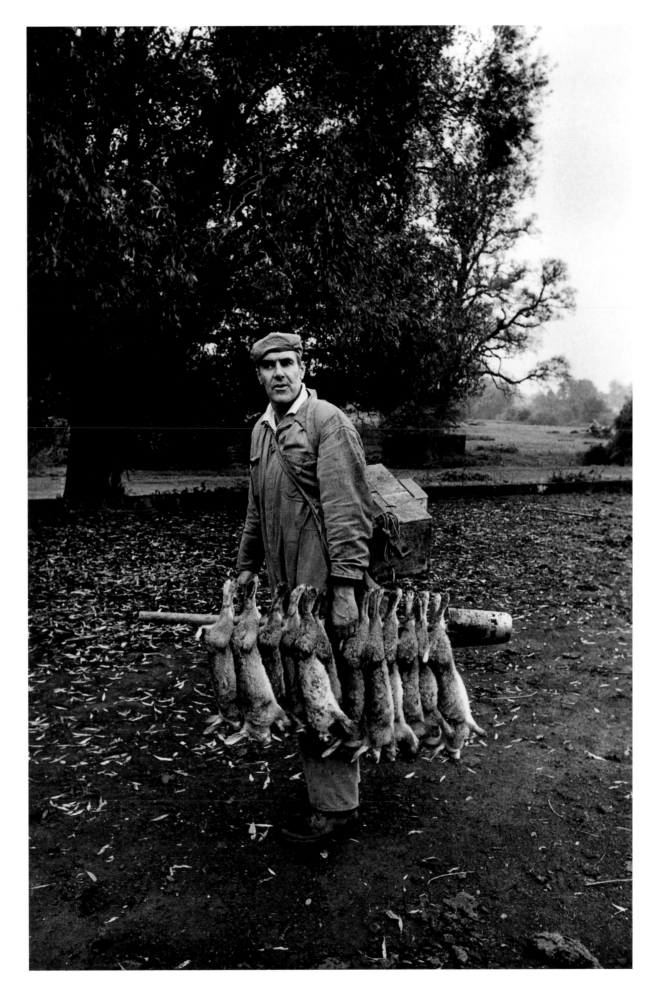

Rabbit catcher, Hertfordshire, 1970s

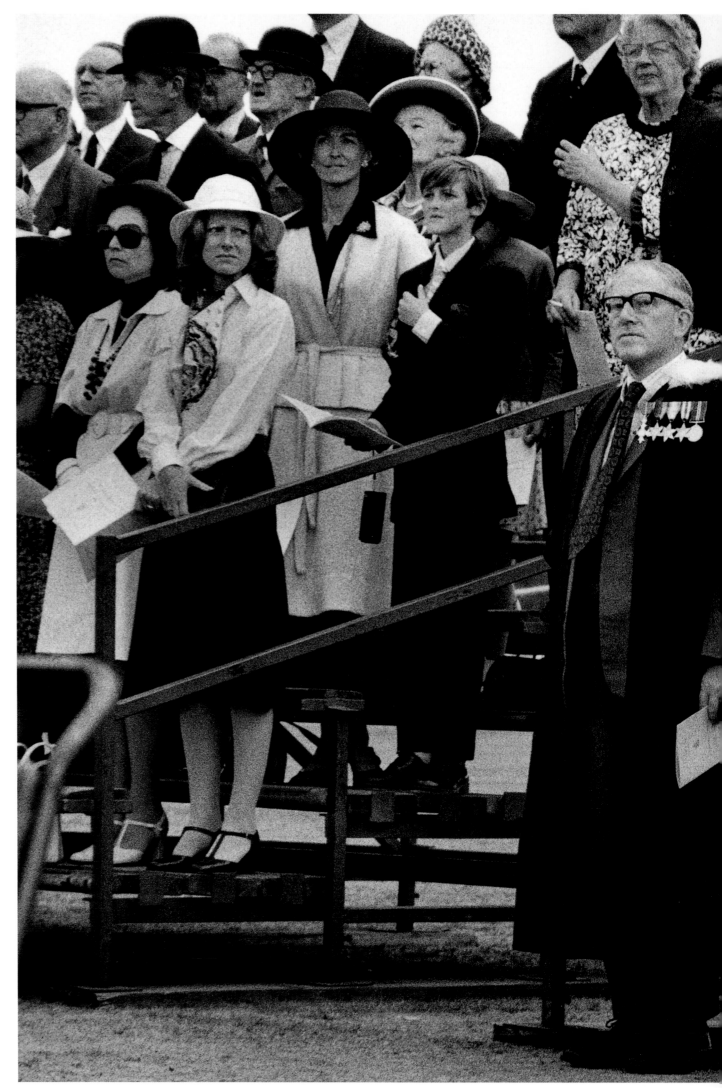

Passing-out parade, Sandhurst, 1970s

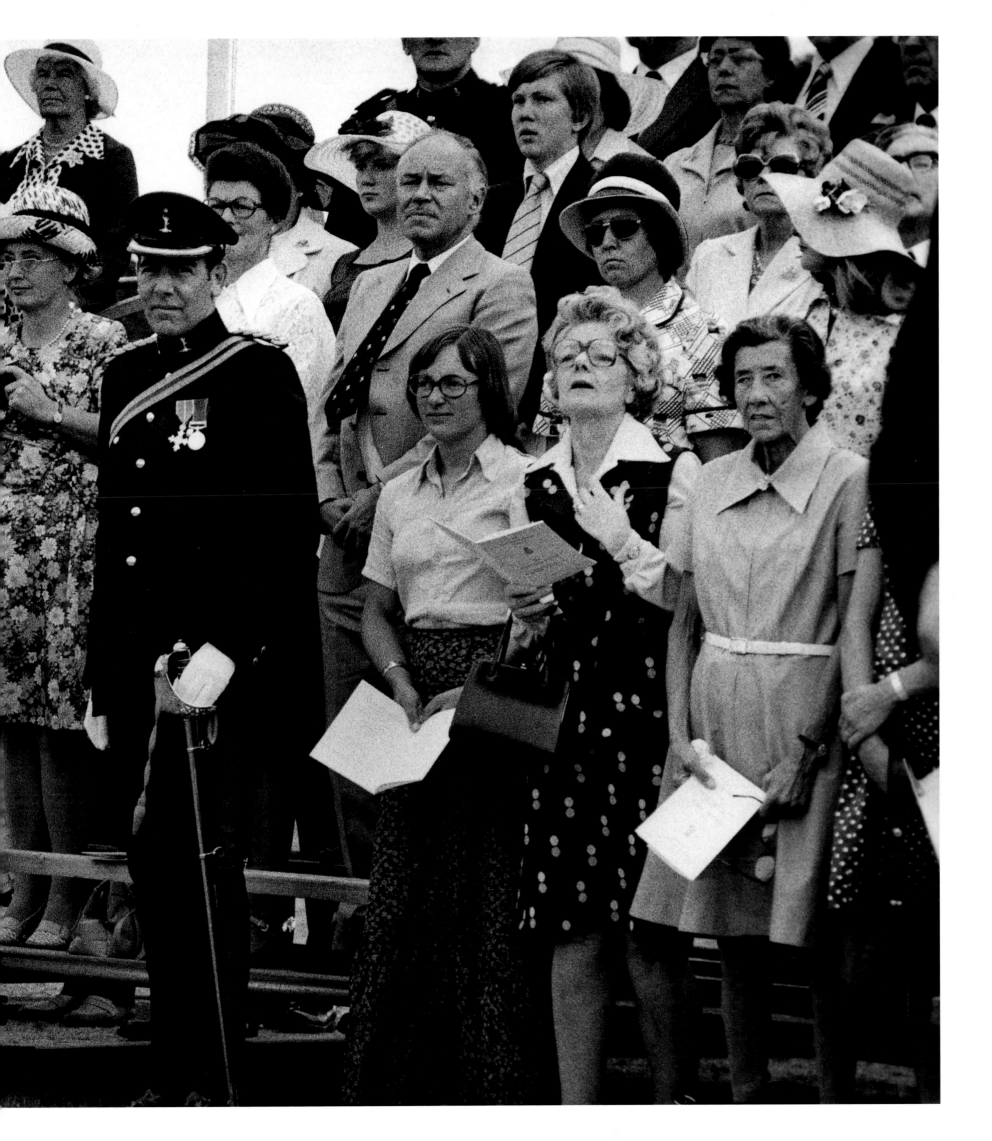

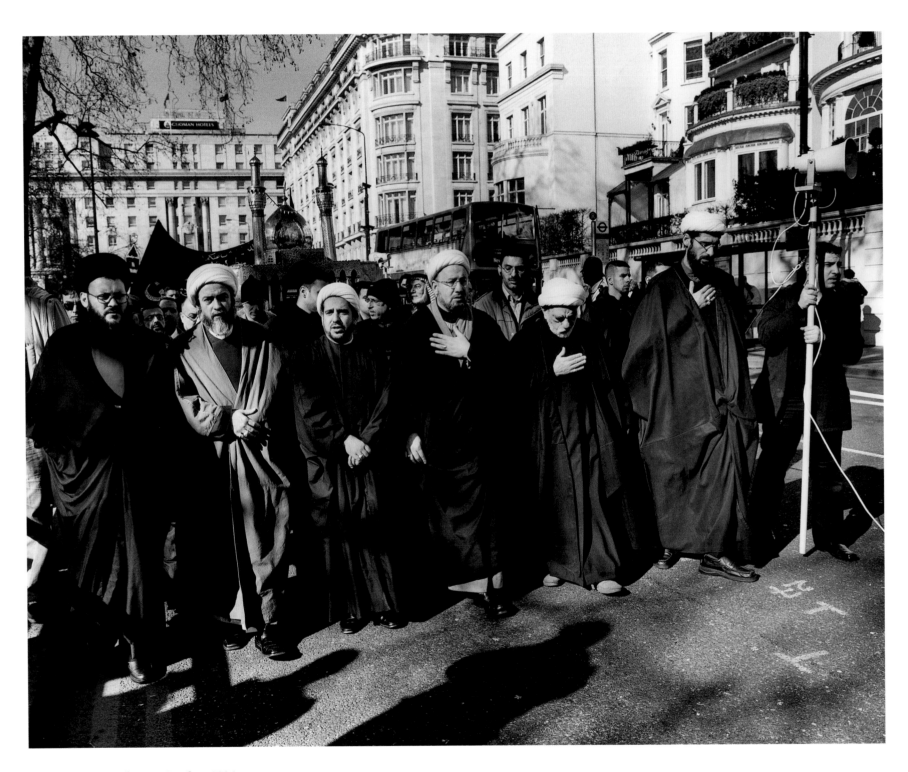

Shia procession, Park Lane, London, 2006

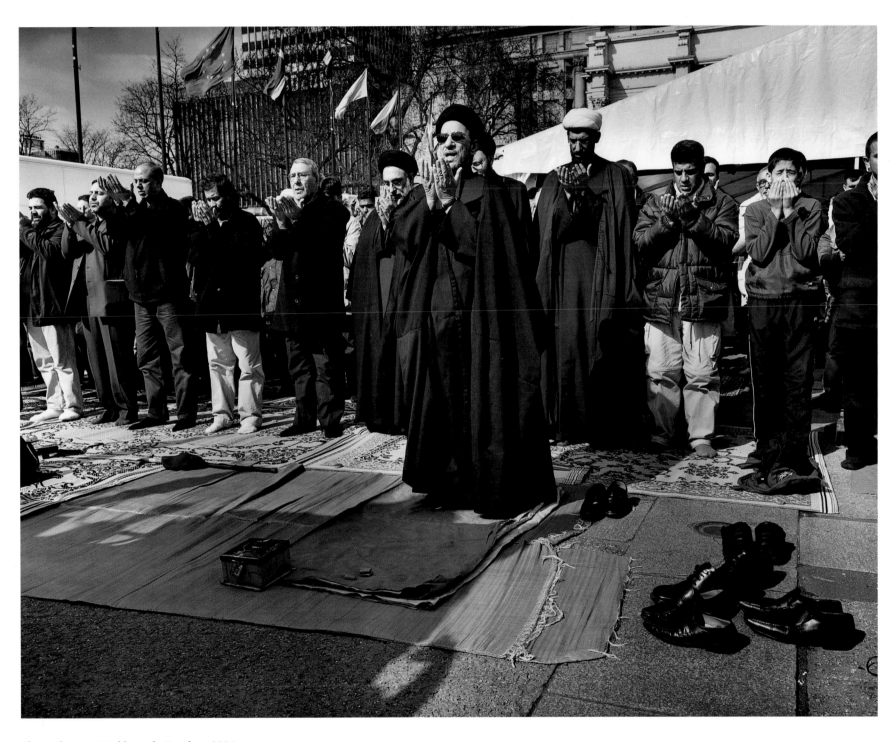

Shia gathering, Marble Arch, London, 2006

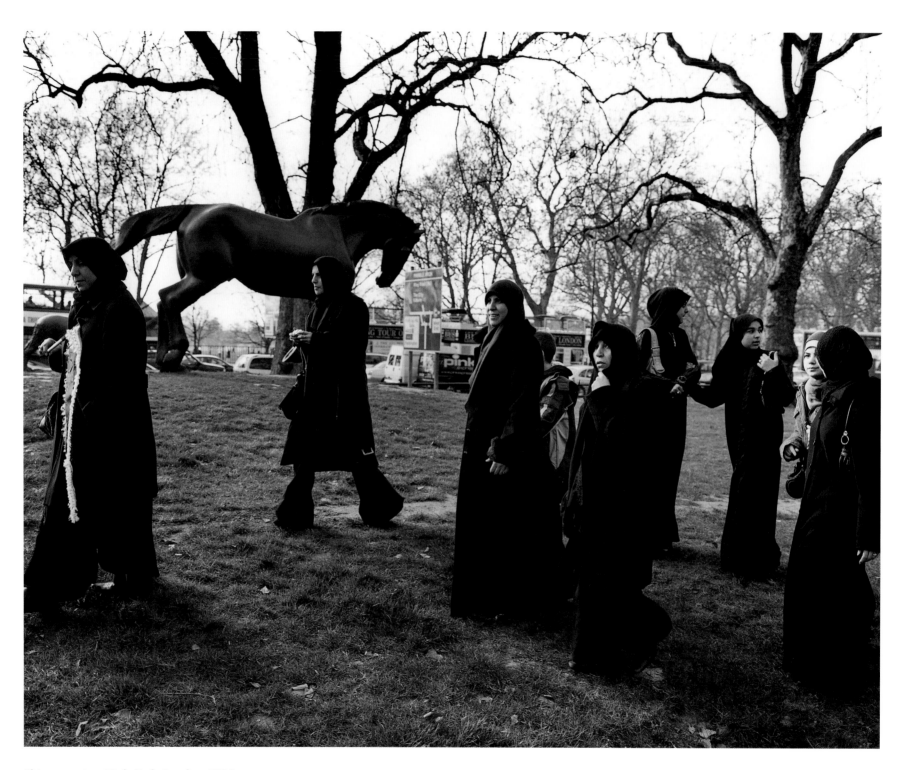

Shia procession, Hyde Park, London, 2006

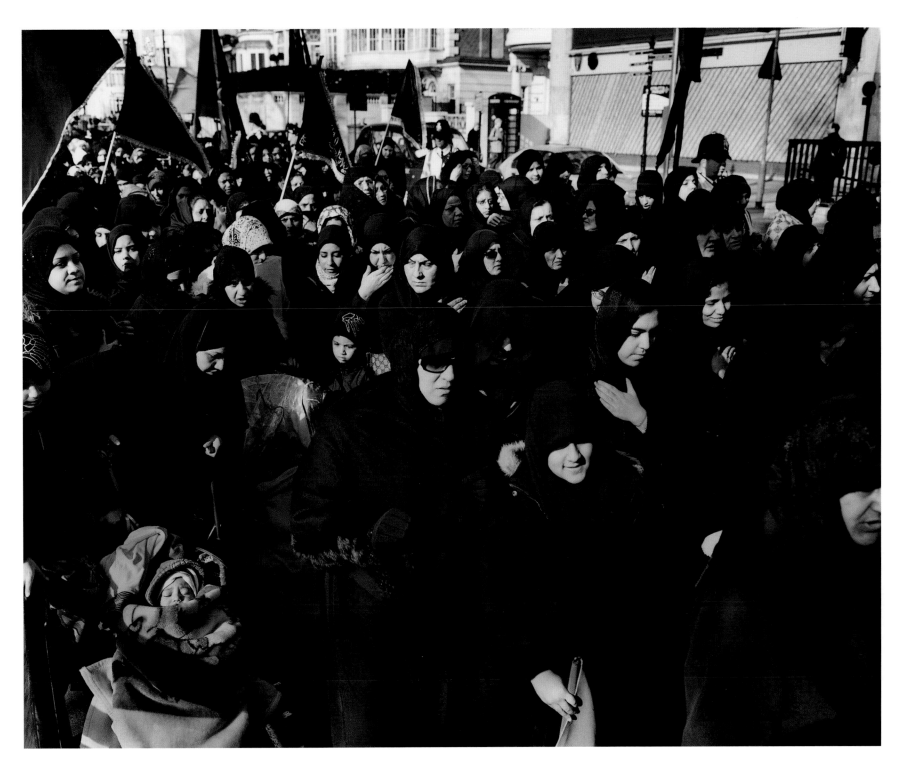

Shia procession, Park Lane, London, 2006

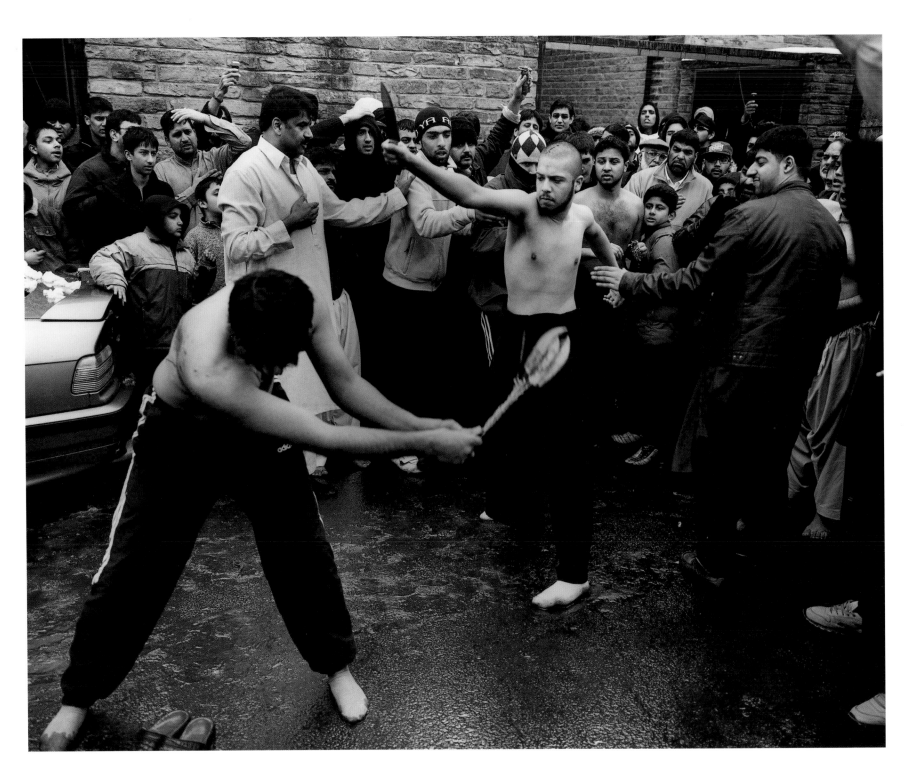

Day of Ashura, Bradford, 2006

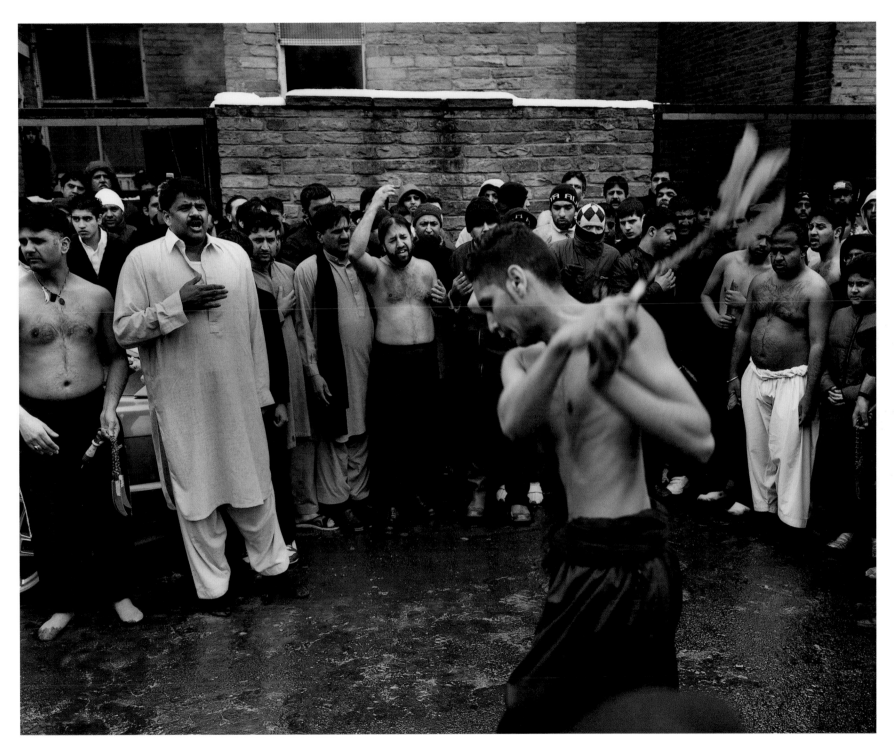

Day of Ashura, Bradford, 2006

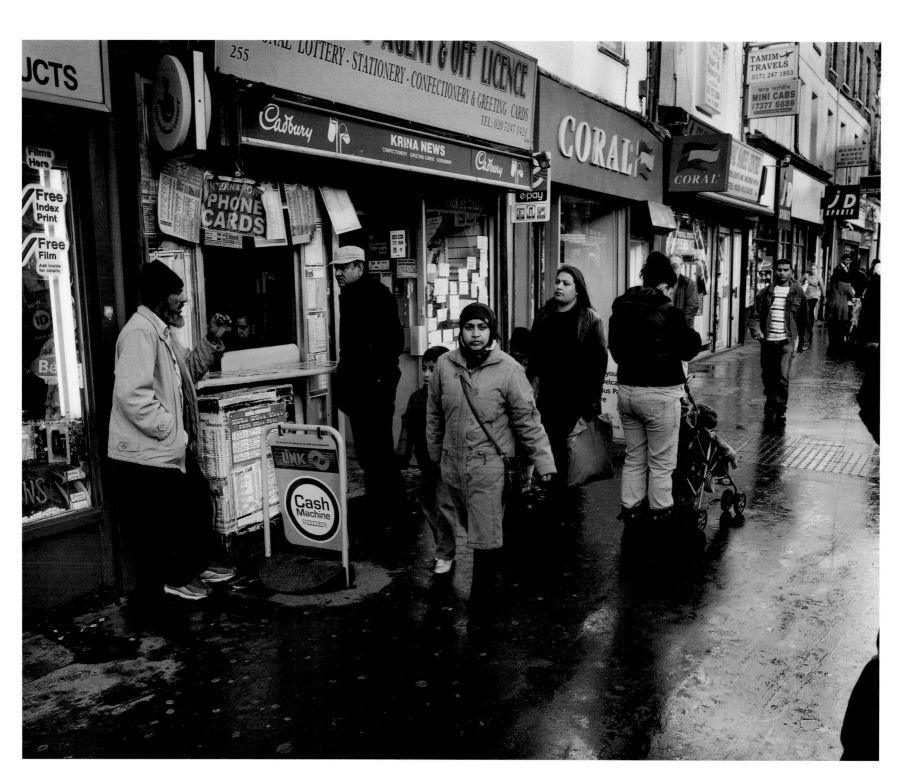

Whitechapel, London, 2006

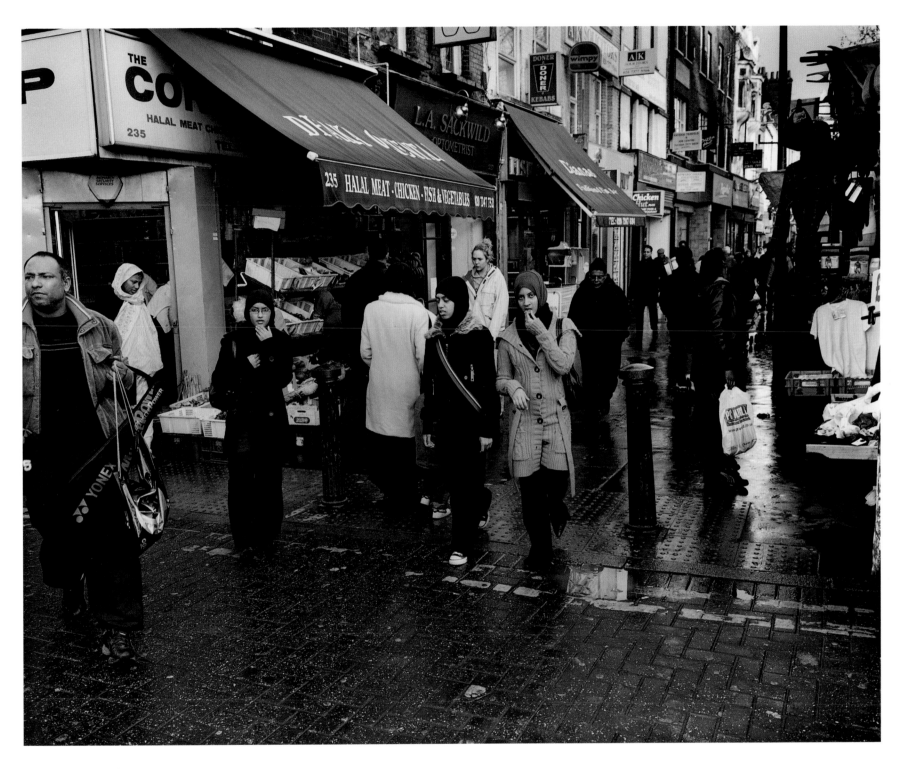

Whitechapel, London, 2006

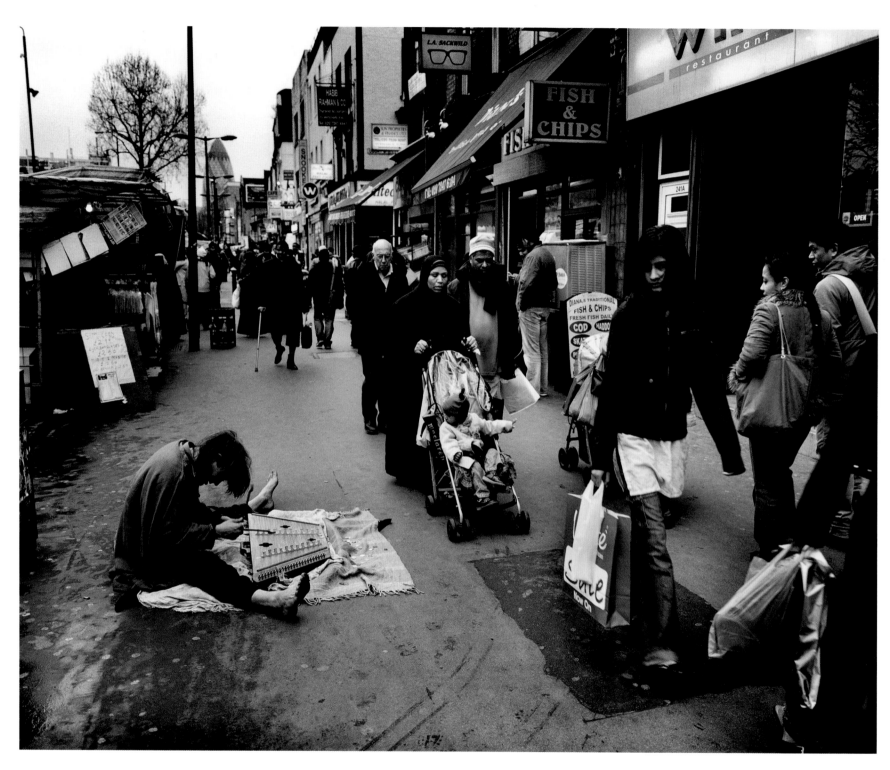

Whitechapel, London, 2006

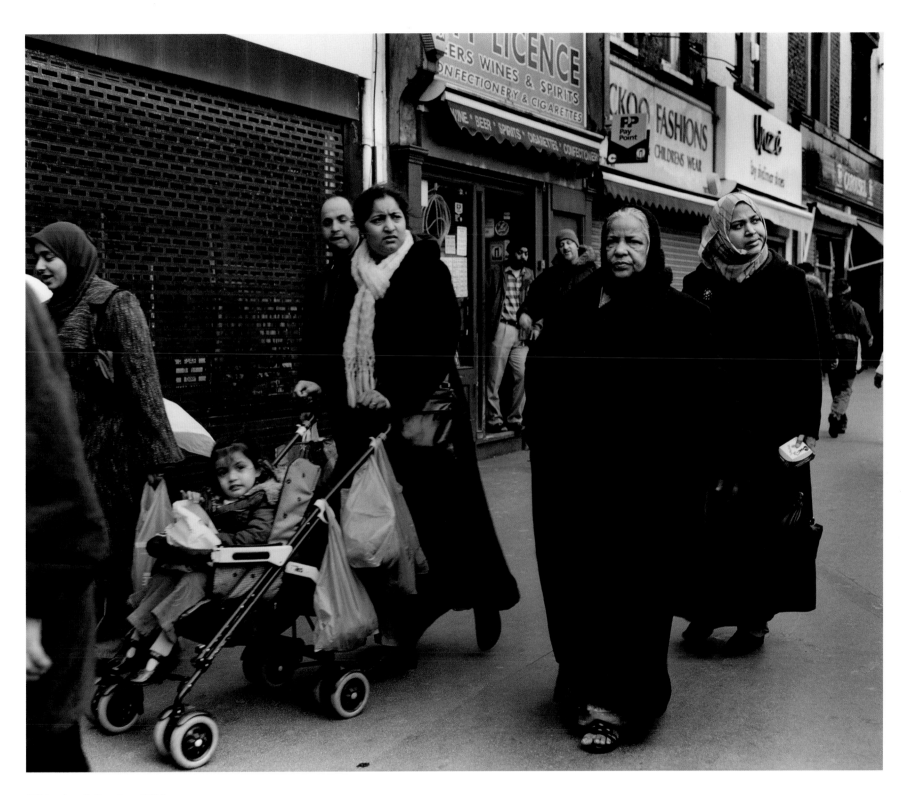

Whitechapel, London, 2006

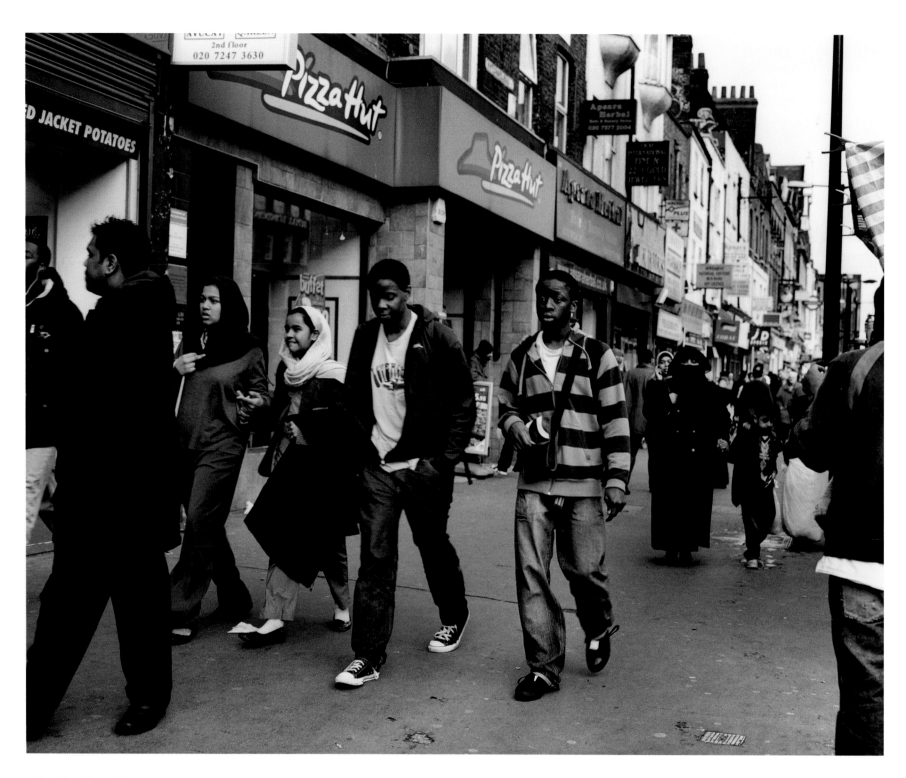

Whitechapel, London, 2006

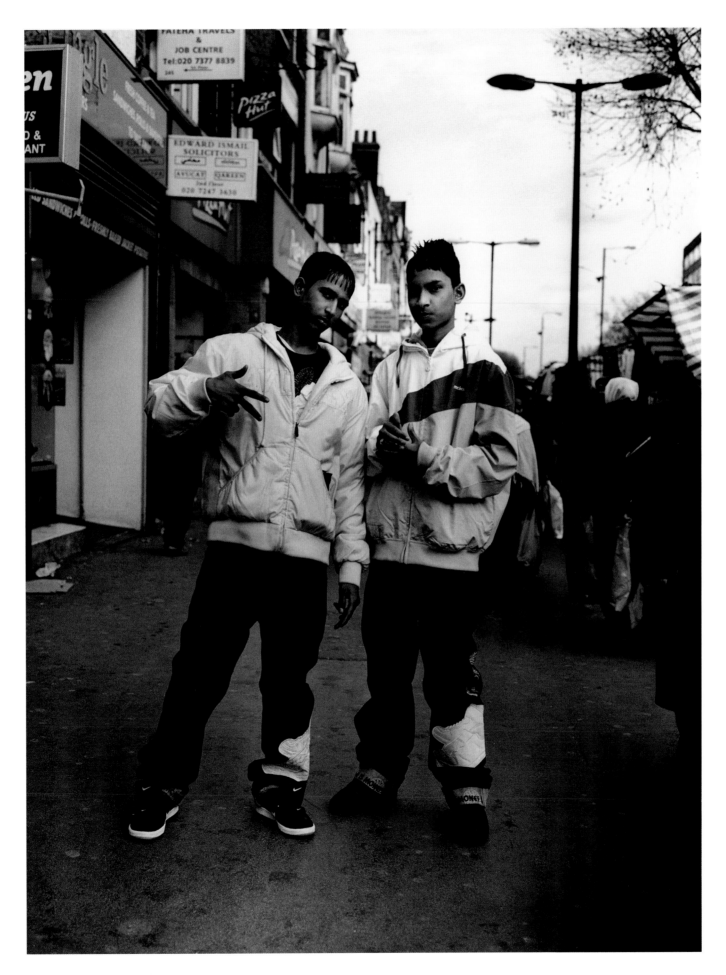

Whitechapel, London, 2006

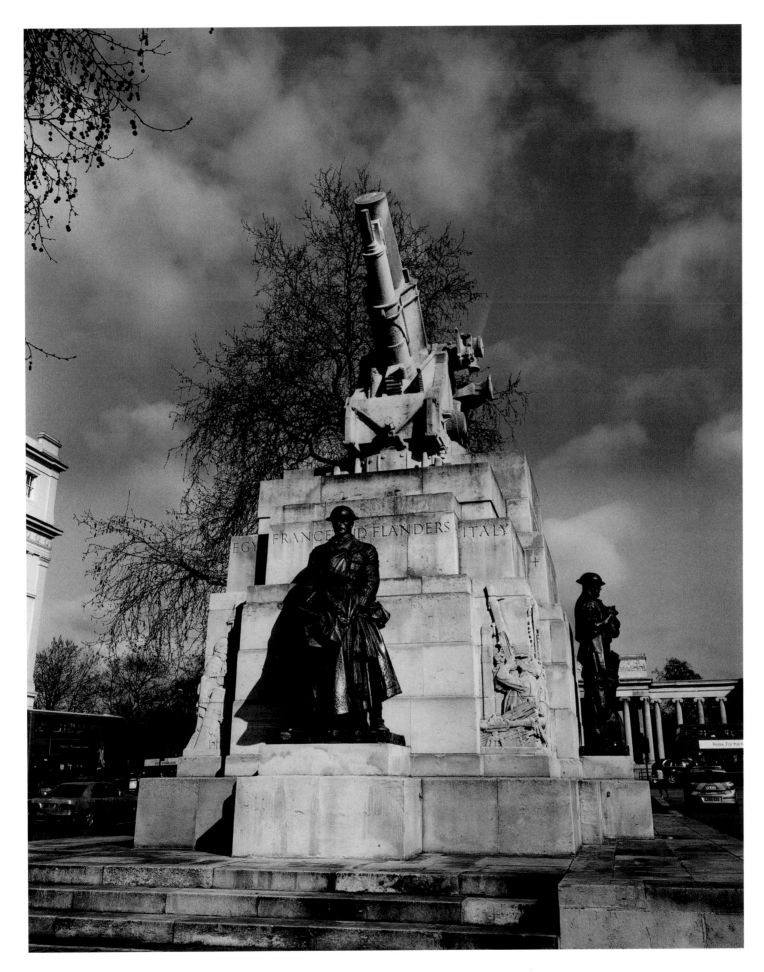

Royal Artillery Memorial, Hyde Park Corner, London, 2006

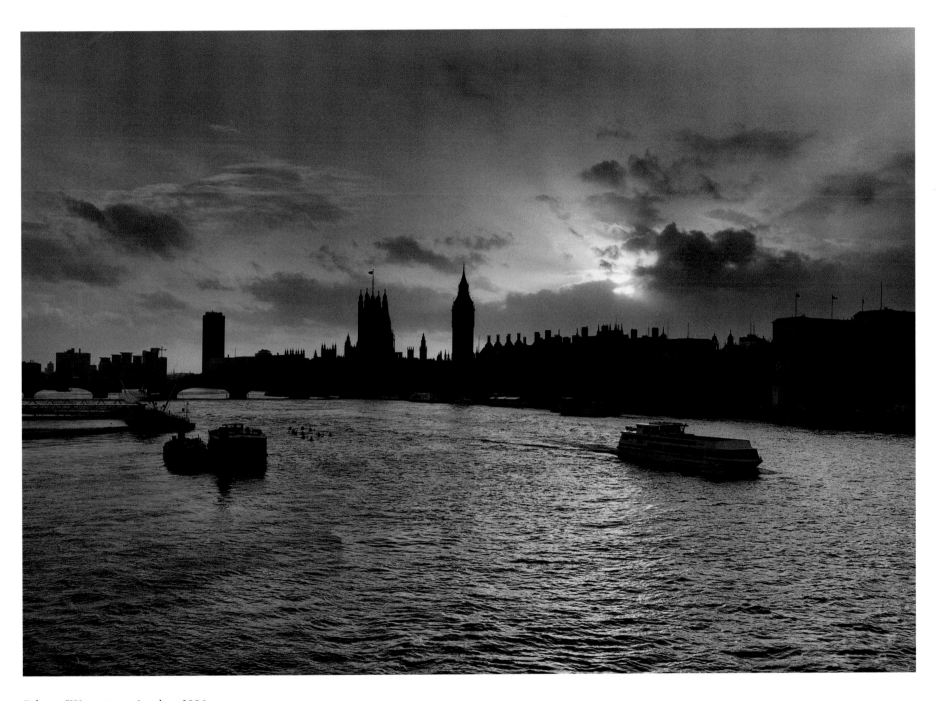

Palace of Westminster, London, 2006

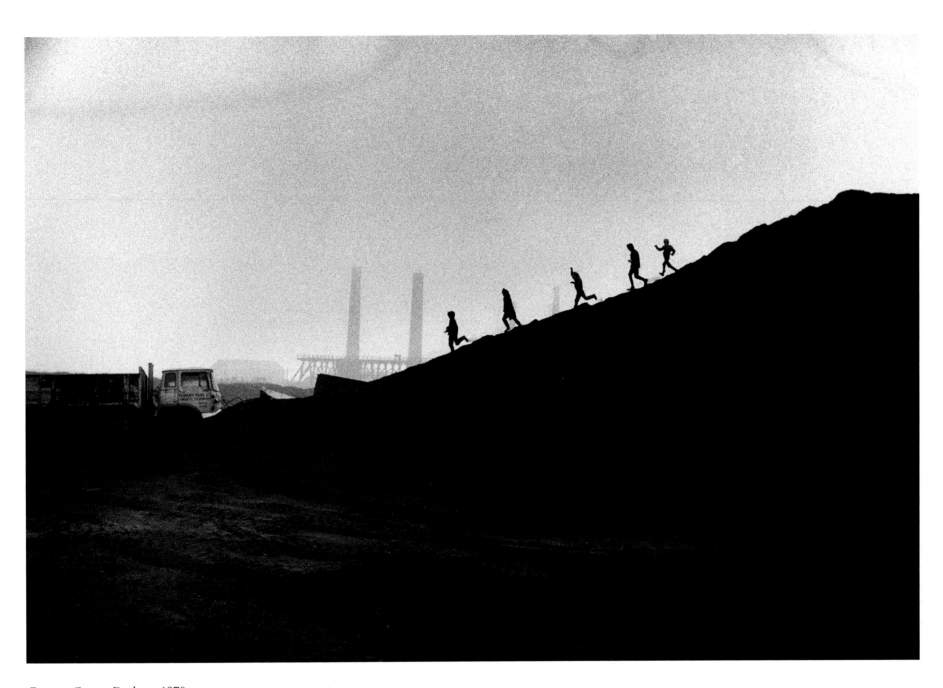

Consett, County Durham, 1970s

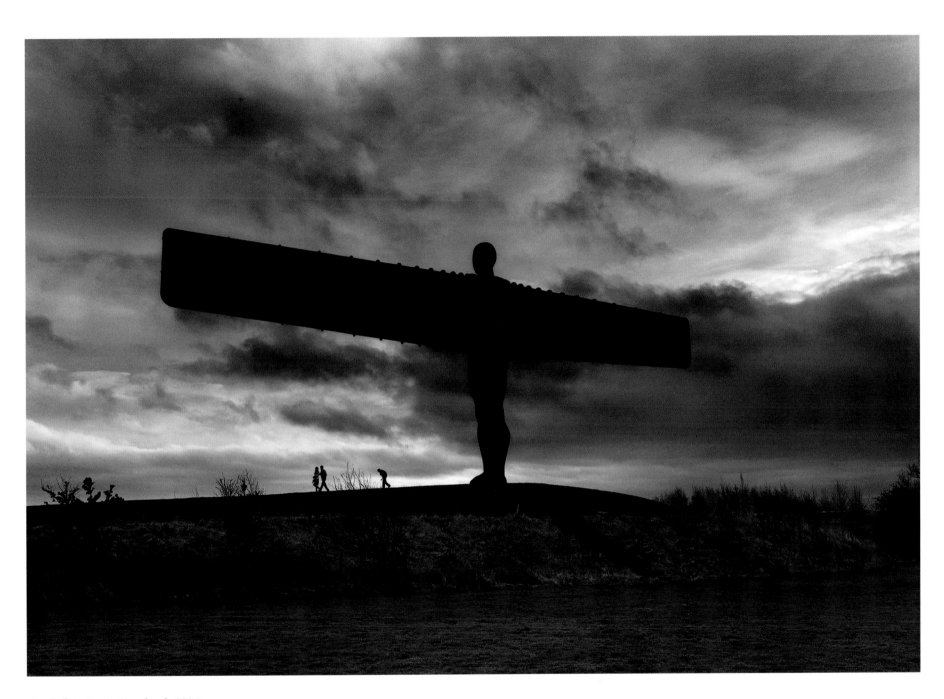

Angel of the North, Gateshead, 2006

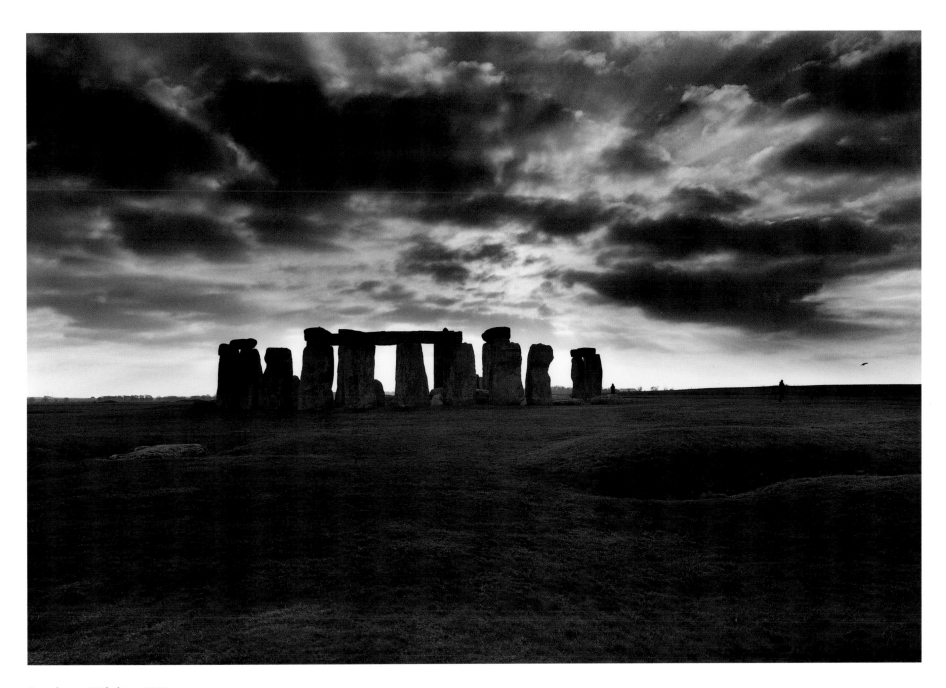

Stonehenge, Wiltshire, 2007

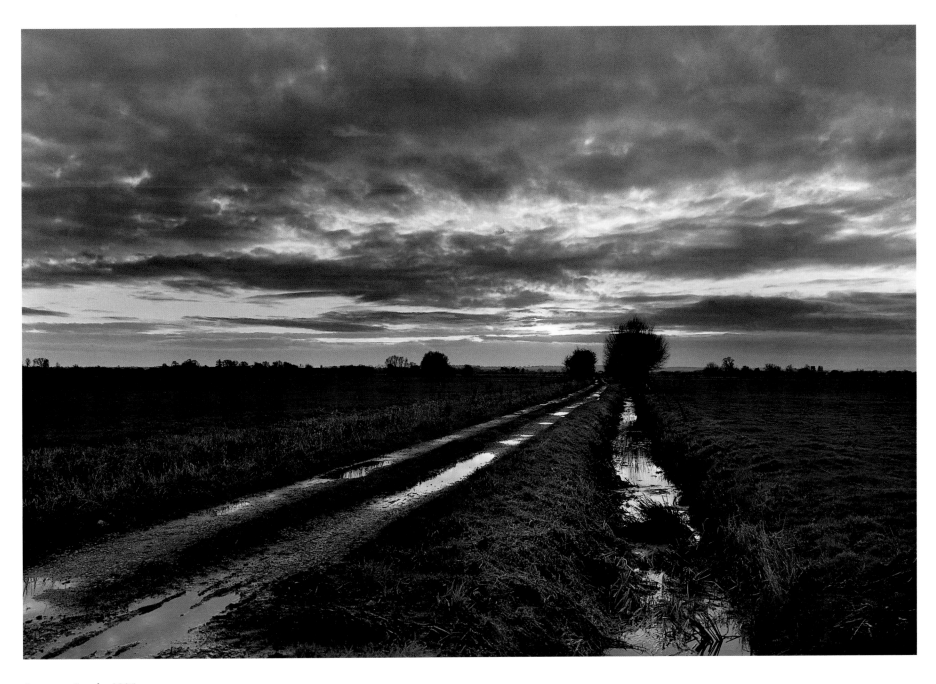

Somerset Levels, 2006

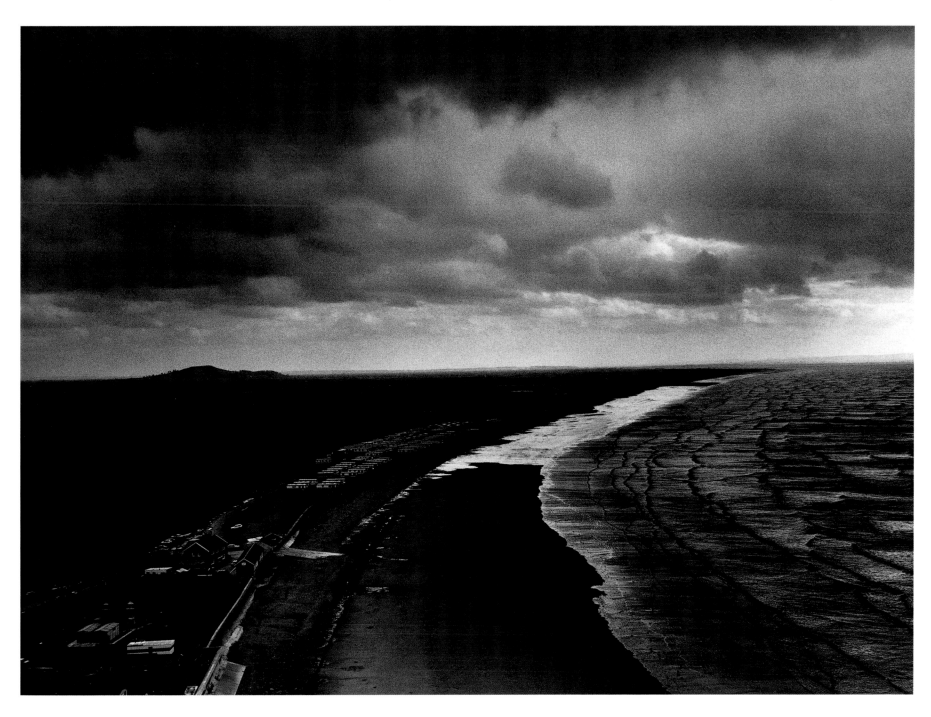

Brean, Somerset, 1970s

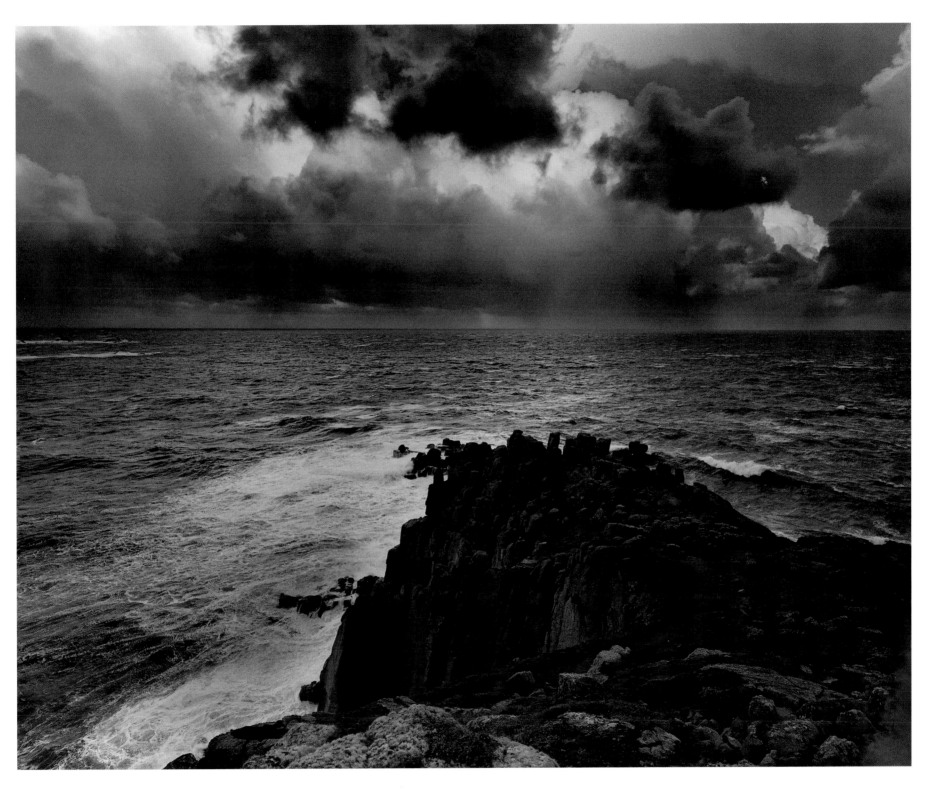

Land's End, Cornwall, 2006

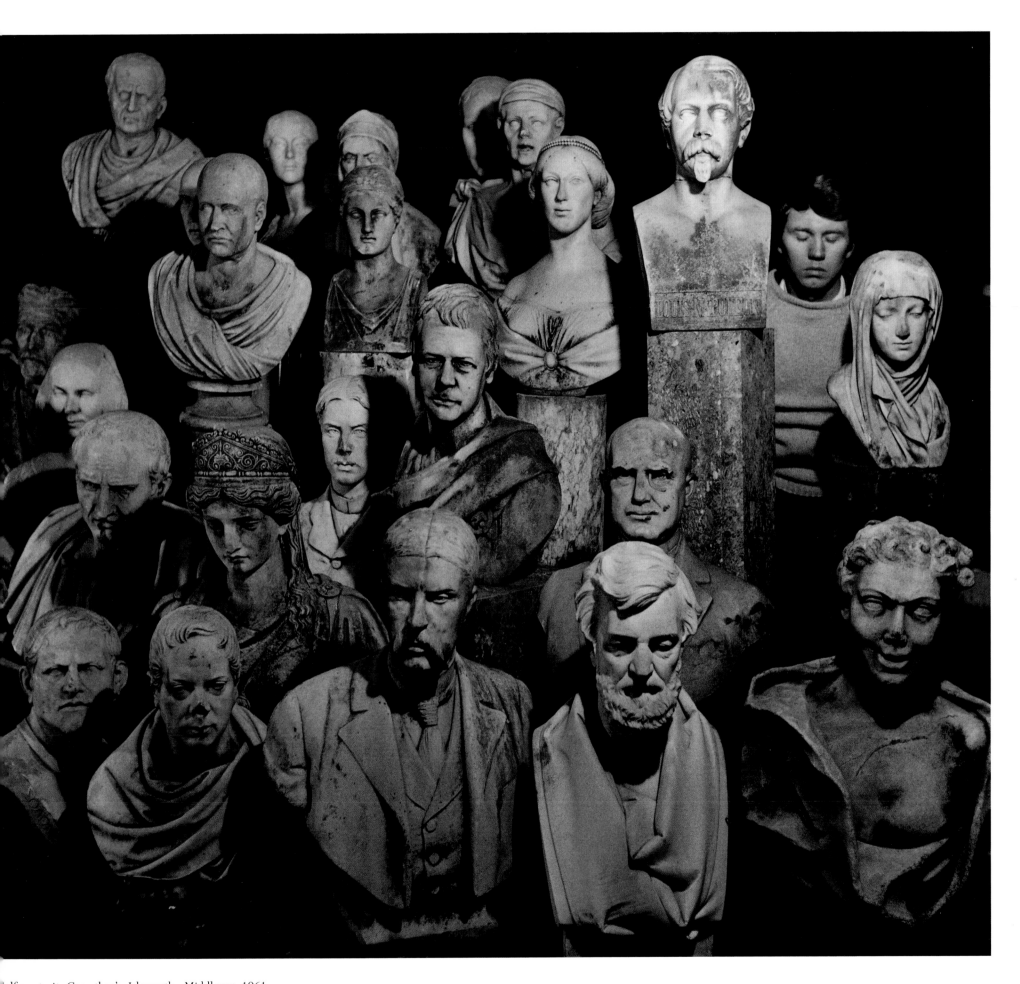

Self-portrait, Crowther's, Isleworth, Middlesex, 1961

Published by Jonathan Cape

6 8 10 9 7 5

Copyright © Don McCullin 2007

First published in Great Britain in 2007 by
Jonathan Cape
Random House, 20 Vauxhall Bridge Road,
London SW1V 2SA

www.randomhouse.co.uk

Addresses for companies within The Random House Group Limited
can be found at: www.randomhouse.co.uk/offices.htm

The Random House Group Limited Reg. No. 954009

A CIP catalogue record for this book is available from the British Library

ISBN 9780224078702

The Random House Group Limited makes every effort to ensure that the papers used in its books
are made from trees that have been legally sourced from well-managed and credibly certified forests.
Our paper procurement policy can be found at: www.randomhouse.co.uk/paper.htm

Editor: Mark Holborn
Designed by Friederike Huber and Mark Holborn
Production Director: Neil Bradford

Printed and bound in China by C&C Offset Printing Co. Ltd